Larry Ra

CUBISM

CUBISM

Edward F. Fry

NEW YORK AND TORONTO
OXFORD UNIVERSITY PRESS

To my father and mother

Translations from French and German by Jonathan Griffin
This edition © 1966 Thames and Hudson Ltd, London
Reprinted 1978

© 1966 DuMont Schauberg, Cologne

Library of Congress Cataloging in Publication Data
Fry, Edward F
 Cubism.

 (The World of art)
 Reprint of the ed. published by Thames & Hudson,
London.
 Bibliography: p.
 Includes index.
 1. Cubism. 2. Art, Modern – – 20th century.
I Title. II. Series
N6494.C8F77 1978 759.06 78–7541

ISBN 0–19520069–1

Back cover: 0-500-20047-5

Printed in Germany

Contents

Foreword

The documents and texts surrounding any great artistic achievement have little importance except in relation to the works of art themselves. But taken together, the written and the visual records of an epoch reinforce each other; and through the verbal reflections of an artistic period we may approach its painting and sculpture directly on the grounds of the issues, problems, and dominant ideas of that period, instead of making judgments based on our own contemporary prejudices and interests.

Nowhere is such perspective more to be welcomed than in the study of cubism, a movement which in its historical, formal, and aesthetic complexity continues to be misconstrued and misinterpreted even today by an often baffled public. Because cubism is one of the foundations of twentieth-century art much, perhaps too much, has been written about it, leaving the subject more muddled than ever. It is the purpose of this book to clarify matters by presenting in a chronological order the original documentary texts concerning cubist painting. Much of this material has previously been known only to specialists and is either rare or totally inaccessible in the original. As a result of publishing these texts it is hoped that both students of modern painting and the interested general public may find it easier to understand and appreciate one of the great artistic achievements of our century.

I wish to thank the following individuals for their assistance in the preparation of this volume:

M. Marcel Adéma, the late Mr Alexander Archipenko, the late Mrs Albert Barnes, Mr Alfred Barr, Miss Inge Bodesohn, Mr Leroy Breunig, M. Marcel Brion, Mr William Camfield, M. Louis Carré, M. Francois Chapon, Mr Douglas Cooper, M. Josef Csaky, Professor Frederick Deknatel, Mme Sonia Delaunay, Mme Alice Derain, the late M. Geo-Charles, M. Waldemar George, Mme Juliette Gleizes, Dr John Golding, M. Fernand Graindorge, M. Guy Habasque, Professor Dr A. M. Hammacher, M. Maurice Jardot, M. Daniel-Henry

Kahnweiler, M. Jean Laude, M. Claude Laurens, MM. Jacques and Rubin Lipchitz, MM. and Mmes Antoine and Jean Masurel, Mme Jean Metzinger, the late M. Amédée Ozenfant, Mme Germaine Raynal, M. Alfred Reth, Mr Daniel Robbins, Professor Robert Rosenblum, M. André Salmon, Jhr. W. J. H. B. Sandberg, Dr Jiri Setlik, the late M. Gino Severini, M. Leopold Survage, Mr Justin K. Thannhauser; and most especially Miss Martine Franck, whose assistance in research and in many other ways was an invaluable contribution to this book.

Princeton, 1964–6.

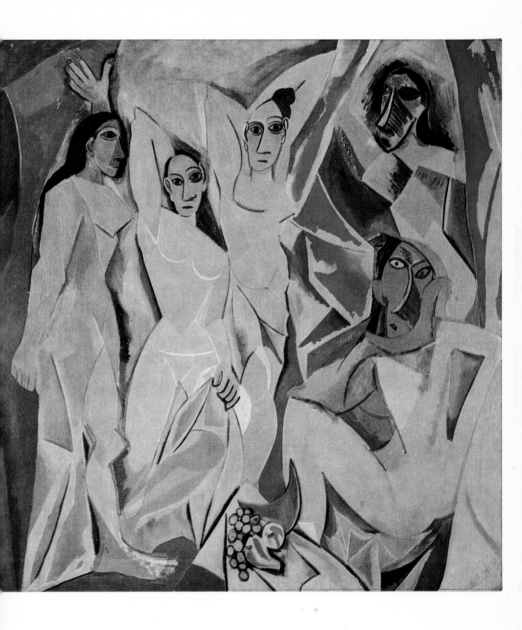

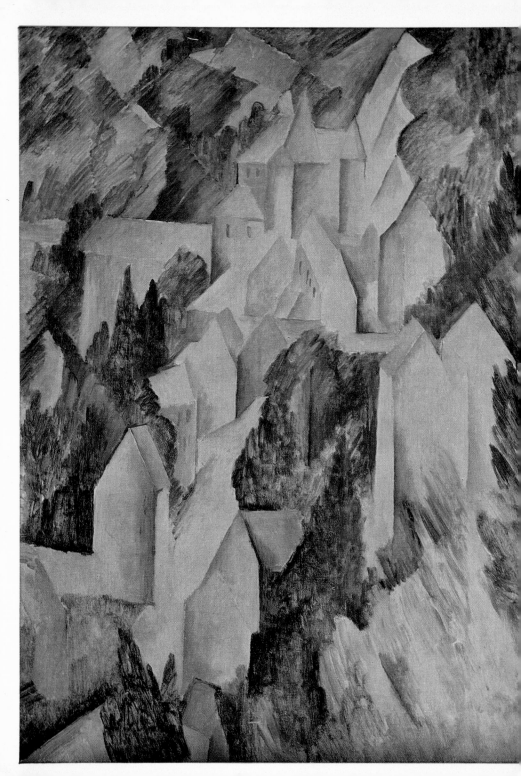

Introduction

The effects of cubism are reverberating still throughout modern culture, but today at a distance of half a century it is possible to view with a certain clarity this extraordinary moment in history. For we are now becoming aware of the seminal quality of the decade ending in 1914, during which fundamental new ideas and methods were established in painting, sculpture, architecture, literature, music, science, and philosophy. In many of these fields the radical innovations of the pre-World War I years are still operative, or at least they remain as important influences against which more recent ideas must be tested. It was a period which saw the emergence of Mann, Proust, Apollinaire, Gertrude Stein; of Gropius and Frank Lloyd Wright; of Stravinsky and Schoenberg; of Planck, Rutherford, Einstein, Bohr; and of Croce, Poincaré, Freud, Bergson, and Husserl. In painting and sculpture these same years produced Matisse, Picasso, Braque, Gris, Léger, Delaunay, Duchamp, Mondrian, Malevich, Kandinsky, Brancusi, Archipenko, Boccioni, and Lipchitz, to name only the most prominent of a brilliant galaxy of artists[1]; the aesthetic innovations and achievements of these years were fully as important and as far-reaching as the work of scientists and intellectuals. It was, as will one day be recognized, one of the golden ages of Western civilization.

The evolution of painting, and of cubism in particular, shared with science the common characteristic of drawing upon late nineteenth-century achievements, but, in so doing, of intensifying and transforming them. The result was the overthrow of much of the heritage of the nineteenth and earlier centuries. In certain respects cubism brought to an end artistic traditions that had begun as early as the fifteenth century. At the same time, the cubists created a new artistic tradition that is still alive, for they originated attitudes and ideas that spread rapidly to other areas of culture and that to an important degree underlie artistic thought even today. Cubism first posed, in

works of the highest artistic quality, many of the fundamental questions that were to preoccupy artists during the first half of the twentieth century; the historical and aesthetic importance of cubism, therefore, renders it worthy of the most serious attention.

The study of cubist art, however, presents difficulties of several kinds. As a style first of all it evolved very rapidly through a series of complex stages. Thus it is necessary to follow its development chronologically and in precise detail, for crucial changes, particularly in Picasso, often took place during a period of months or weeks, as opposed to years or decades in older historical styles. This accelerated rate of stylistic change seems to have become the rule in twentieth-century art, and it may well be the effect of increased rates of change in other areas of a culture, particularly in the speed of communications. In the case of cubism, however, it is quite possible that certain critical steps, once taken, implied if not determined subsequent developments, and that the genius of Picasso himself simply forced the pace of stylistic evolution.

Problems of chronology, therefore, are of the greatest importance in the study of cubism. The very density of interaction at that time among a relatively large number of extremely gifted artists makes it necessary to consider dates most carefully. The central figure, Picasso, usually did not put a date on his paintings during the cubist period, sometimes only giving a place name on the back of the canvas. Although an invaluable catalogue of his works has been maintained and is being published in a series of volumes[2], it is not complete and contains numerous errors of fact. Hence one must often turn to such biographical evidence as summer vacation trips in order to date Picasso's works, as is true also, to a lesser extent, of Braque and other cubists. Neither Braque nor Picasso exhibited extensively before 1914, but other cubists did so widely, and one must frequently turn to the now rare exhibition catalogues of the period for documentation of their works. Problems of chronology in cubist collages are, however, occasionally simplified when identifiable and datable newspaper clippings appear in them.

As for the theoretical background of cubism, Picasso and Braque, the two most important cubists, have left us few if any written statements from before 1914 of their artistic ideas and intentions. Their ideas were their paintings, from which fact has arisen the cloud of theories and interpretations surrounding cubism, a process which began with the frequently misleading writings of Guillaume Apollinaire and which has continued to the present day. Every generation looks at the past in a new way, according to the

needs of its time or in order to find justification for its own art. Thus lasting works of art inevitably gather around themselves layer upon layer of successive reinterpretations; often it is only from a long distance in time that a work of art may be seen disinterestedly and more or less whole. But cubism belongs to the relatively recent past, of which the present is still a part, and we cannot yet hope to situate it completely either in relation to its own time or to Western culture in general. For the present, therefore, it is perhaps most useful for us that we become more fully aware of what the cubists and their friends thought were their original intentions, not forgetting at the same time that great works of art possess qualities and implications which surpass the ideas and forces that accompanied their birth.

The first part of this book is devoted to an account of the evolution of cubism as a style, followed by a brief discussion of possible interpretations of the movement as a historical phenomenon. In the second section is an annotated selection of the theoretical and critical texts of the cubist period, followed by a bibliography.

The History of Cubism

Cubism developed with extraordinary rapidity between the years 1907 and 1914. From 1914 until about 1925 there were a great many artists painting in a cubist mode, but this later phase produced relatively few stylistic innovations that had not already been anticipated to some extent during the pre-war years. By the mid-1920s, a crisis emerged in cubism as in European art generally, bringing to an end a period of almost twenty years during which cubism had been the predominant force behind an entire artistic generation.

In its beginnings, however, and until about 1912, cubism was an exclusively Parisian phenomenon, and it probably could not have been born elsewhere, for reasons of history, geography, and culture. No other city in the world in the early years of the twentieth century could boast of a comparable century-long history of outstanding artistic activity; and the relatively central location of Paris in western Europe served only to facilitate the migration of the most gifted young artists and writers from Spain, Italy, Germany, Russia, and the Low Countries toward this cultural mecca. Paris offered them not only the challenge of their most gifted contemporaries, but

also its great art museums; it offered a tradition of moral and intellectual freedom, and an artistic bohemia in which they could live cheaply at the edge of society without suffering the ostracism inflicted by the bourgeoisie in smaller, more conservative, and less cosmopolitan European cities. In retrospect it is not surprising that, by the early part of the twentieth century, Paris contained an astonishing number of young men of genius, whose presence constituted an intellectual 'critical mass' that soon produced a series of revolutionary cultural explosions.

In painting the first of these was 'fauvism', a derogatory label given to the work of Henri Matisse (1869–1956) and his followers who, starting in about 1904, used colour with an unprecedented freedom, intensity and arbitrariness. No less important was the discovery, and appreciation for the first time on aesthetic grounds, of African and Oceanic art; this discovery was made by several of the fauve painters, notably Vlaminck, Derain, and Matisse himself (see the notes to text 2). 'Primitive' sculpture was shortly to play a brief but important role in the evolution of cubism.

But fauvism on the whole did not mark a decisive advance beyond the innovations of late nineteenth-century painting. Rather, it was a recapitulation and intensification of such previous developments as the modified pointillism of Signac, the brilliant colouristic achievements and expressive brushwork of Van Gogh, and Gauguin's decorative colour patterns. The masterpiece of fauvism, Matisse's *The Joy of Life (Ill. 1)* of 1906, epitomizes the essentially conservative nature of the fauvist enterprise in its consummate summing up of tendencies in late nineteenth-century painting, combined with a lingering flavour of *Jugendstil* arabesque. Above all *The Joy of Life* does not put forth any new conceptions of space, although depth is compressed somewhat in the manner of Manet's *Luncheon on the Grass,* and curiously enough the composition itself is remarkably akin to that of Ingres' *The Golden Age.*

It is only in relation to this contemporary fauvist context that the radical qualities of Pablo Picasso's (1881–1973) *Demoiselles d'Avignon* (Pl. I) emerge most clearly (see text 18). Finished by the middle of 1907[1], it is probably the first truly twentieth-century painting. For whereas fauvism marked a summing-up of late nineteenth-century art, *Les Demoiselles* contained new approaches both to the treatment of space and to the expression of human emotions and states of mind. It is not difficult to imagine that twentieth-century art as we know it today might have developed along far different lines without this first revelation of Picasso's genius.

In *Les Demoiselles* Picasso posed and attacked many problems at once, some of which he was to resolve only during the course of the following seven years. The subject, a brothel scene, recalls Picasso's interest, during his previous blue and pink periods, in episodes from the lives of those on the margin of society, as in fact he himself lived during his years in Montmartre, beginning in 1904. But while the brothel as a theme appeared frequently in late nineteenth- and early twentieth-century painting, as for example in Toulouse-Lautrec and Rouault, Picasso's version is as far removed from the spirit of irony or pathos of his predecessors as it is from the empathy and restrained lyricism of his own earlier painting.

But what makes *Les Demoiselles* a truly revolutionary work of art is that in it Picasso broke away from the two central characteristics of European painting since the Renaissance: the classical norm for the human figure, and the spatial illusionism of one-point perspective. During the year previous to the completion of *Les Demoiselles*, Picasso had turned to various sources in his search for a new approach to the human figure, the most influential of these being Iberian sculpture, El Greco, and the work of Gauguin, particularly his carved sculpture. But the decisive influence on his thinking was African sculpture, which, despite his published denial[2], he must certainly have discovered by the winter of 1906–7 if not before (see text 2). The examples of sculpture from the Ivory Coast and other French colonies in West Africa, which he saw either at the Trocadéro Museum (today the Musée de L'Homme), in the private collections of his friends, or at the shops of second-hand dealers, undoubtedly inspired Picasso to treat the human body more conceptually than was possible in the Renaissance tradition (*Ill. 3*). This new approach appears most clearly in *Les Demoiselles* in such details as the reduction of human anatomy to geometrical lozenges and triangles, as well as in the abandonment of normal anatomical proportions. African influence is even clearer in the mask-like faces of the two right-hand figures, which were probably finished later than the rest of the painting[3] (compare the African mask in *Ill. 3*).

These departures from classical figure style are more than simply a variation on an existing tradition; they mark the beginning of a new attitude toward the expressive potentialities of the human figure. Based not on gesture and physiognomy but on the complete freedom to re-order the human image, this new approach was to lead to the evocation of previously unexpressed states of mind, particularly in the hands of the surrealists and above all by Picasso himself in his great works of the 1930s and later 1920s.

The treatment of space is, however, by far the most significant aspect of *Les Demoiselles,* especially in view of the predominant role of spatial problems in the subsequent development of cubism. The challenge facing Picasso was the creation of a new system of indicating three-dimensional relationships that would no longer be dependent on the convention of illusionistic, one point perspective. To help him he had little but the tentative solution offered by Paul Cézanne (1839–1906), whose work had recently been shown in several large retrospective exhibitions in Paris, beginning in 1904[4]. Although as a result of his associations with the impressionist genera-tion there always remained in Cézanne's art a strong residue of optical empiricism, by the mid-1880s he had developed a way of denying illusionism by means of integrating surface and depth in his paintings, particularly by *'passage'*—the running together of planes otherwise separated in space—and other methods of creating spatial ambiguity; at the same time, however, one must remember that Cézanne's intentions were very different from those to which the cubists would later apply his methods.

In addition Cézanne had broken with the Renaissance tradition of com-position by which forms were disposed harmoniously within the illusionistic stage-space of one-point perspective. Cézanne, instead, had gone a step be-yond the break with tradition represented by the impressionists' optical realism, to a realism of the psychological process of perception itself. Thus in painting a motif Cézanne would, by the 1880s, organize his subject accord-ing to the separate acts of perception he had experienced; houses and other solid objects were depicted as the artist had conceptualized them after a long series of perceptions *(Ill. 26).* And, in the overall composition of a painting, Cézanne would organize parts of the whole into perceptual areas, within which 'distortions' occurred in the interests of formal contrast and the realization of a visual *gestalt* of the highest possible unity, as is particularly noticeable in his still-lifes *(Ill. 2).*

The art of Cézanne contains yet further complexities, particularly with regard to his use of colour; but, when Picasso was studying him in the years between 1906 and 1910, what he found of greatest interest must have been the tentative suggestion of an alternative to Renaissance perspectival space. In *Les Demoiselles* one finds Cézannian *'passage'* linking together foreground and background planes, just as there is a precedent for Picasso's schematic treatment of human anatomy as much in Cézanne's houses and nudes as in the figures of African sculpture. But in using his stylistic means Picasso went far beyond Cézanne. The grouping of figures in *Les Demoiselles* exceeds in

its arbitrary boldness the most audaciously structured of Cézanne's *Bathers* compositions; and Picasso combines multiple viewpoints into a single form to a degree which Cézanne, with his heritage of impressionist fidelity to the visual world, would never have attempted. During the summer of 1906, at Gosol in Spain, Picasso had begun to combine the profile view of a nose with the frontal view of a face, as he did in the two central figures of the *Demoiselles;* but the figure in the lower right-hand corner of the painting shows a far more radical application of the same idea. In what was probably the last part of the painting to be executed, Picasso created a female nude whose mask-like face (compare with African mask, *Ill. 3*), back, and breasts are all visible at once; with this figure Picasso dismissed at once both one-point perspective and the classical tradition of figure style.

The role of colour in *Les Demoiselles* is no less significant than the treatment of space, to which it is in fact related. The predominant scheme of the painting is the strong pink and ochre which Picasso had been using during his pink period of the previous two years. But the figure in the upper right hand corner displays a modelling of the face and breast by means of striations in blue; and where the modelling of the nose would ordinarily be indicated with dark shadowing, Picasso has used bright, alternating bands of fauve-like green and red, the juxtaposition of which creates strong simultaneous contrast. Similarly, in the lower right hand nude, the schematically reshuffled features are modelled in blue.

These areas represent Picasso's first attempt to devise a workable alternative to the traditional system of modelling by *chiaroscuro* or its equivalent. Modelling by colour is of course not new in itself; it appears in Byzantine art, in much medieval art, in Sienese painting, in many Italian artists of the Quattrocento, in Grünewald and his contemporaries, in such mannerists as Rosso, in Rubens and Delacroix, and more recently in Cézanne and the fauves. But in *Les Demoiselles* Picasso utilizes colour modelling in conjunction with his abandonment of one-point perspective, thus freeing himself equally from the single vantage point and from a similarly specified, and therefore accidental, source of light (see text 17). Here again his only precursor since the Renaissance was Cézanne; and here as in other ways, Picasso, even while following Cézanne's lead, far surpassed him in exploring the radical possibilities of such an idea[5].

The problem of how to indicate the relation of volumes to each other without the use of *chiaroscuro,* and at the same time without the total suppression of local colour, was not to be resolved until the invention of

papier collé in 1912. The importance of *Les Demoiselles*, however, is that in it Picasso mounted a frontal attack not only on these but on almost all the other problems which were to preoccupy him and Braque for the following six years. Equally fascinating is the diversity of cultural elements which meet in *Les Demoiselles*, ranging from Cézanne and fauvism to Iberian sculpture, El Greco, Gauguin, and African art. *Les Demoiselles d'Avignon*, more than any other painting of its time, was a crossroads of aesthetic forces, which the prodigious gifts of its creator fused, if only imperfectly, into a great work of art and a turning point in the history of occidental painting.

Picasso was not to attempt so ambitious a work as *Les Demoiselles* until almost two years had passed. During the remainder of 1907 and the first part of 1908 he further explored the formal and expressive possibilities suggested by African sculpture; then, during the second half of 1908, he returned to another of the elements that had gone into *Les Demoiselles* with a series of landscapes and still-lifes that show a renewed and careful study of Cézanne *(Ills. 5, 6)*. These two interests were by no means divorced from each other, and in fact Picasso explored them both more or less concurrently during 1908; this ability to develop two or more ideas simultaneously has remained with Picasso throughout his career.

An event of decisive importance for the future history of cubism occurred toward the end of 1907, when the poet Apollinaire introduced to his friend Picasso the young painter Georges Braque (1881–1963)[6]. Braque, who was almost the same age as Picasso, had during the previous two years been one of the leading fauve painters, but during 1907 he had begun to give a more formal, almost Cézannian, structure to his paintings; now, this meeting with Picasso was to change his art completely. By the end of 1909 Braque and Picasso were seeing each other almost daily, and this close artistic association, which lasted until the War, was to become the fountainhead of cubism.

But when Braque first met Picasso and saw *Les Demoiselles*, he had had no preparation for the shock which this confrontation must have produced. His first reaction as a painter was the *Grand Nu (Ill. 9)*, begun in December 1907[7] and exhibited in the Salon des Indépendants of 1908[8]. A drawing which must have immediately preceded the *Grand Nu* gives us a revealing insight into Braque's first response to *Les Demoiselles*: Braque grasped the tremendous implications of the lower right-hand figure in Picasso's composition, and in his restatement of Picasso's ideas he arrived at the genesis of his own monumental nude (p. 54 and text 6). In the *Grand Nu* we can almost sense Braque's struggle to come to terms with Picasso's thinking, which he

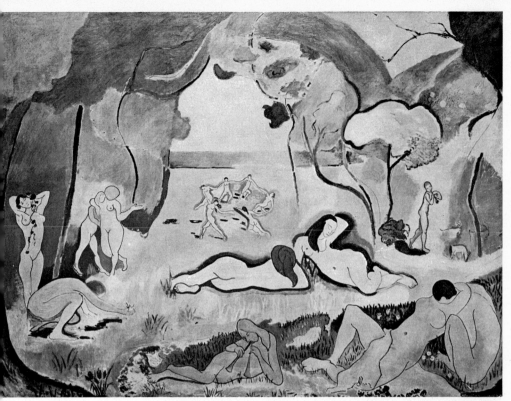

HENRI MATISSE, *The Joy of Life*, 1906

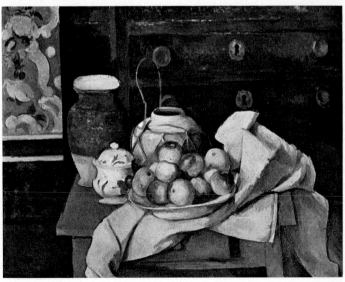

2 PAUL CÉZANNE, *Still-life*, 1883–7

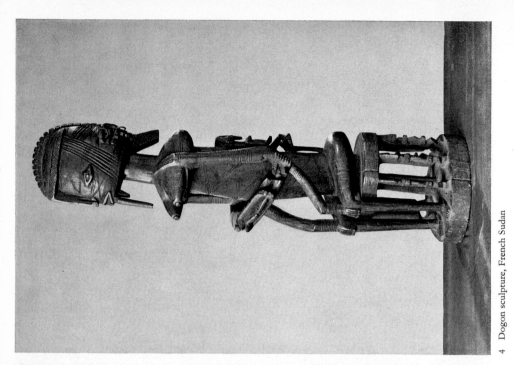

4 Dogon sculpture, French Sudan

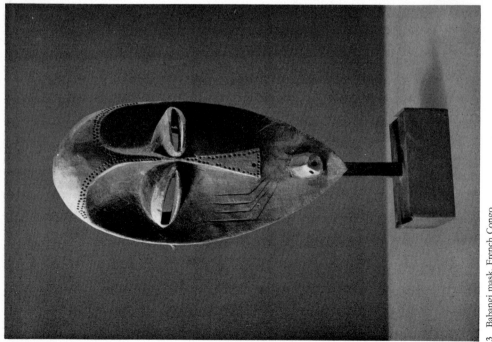

3 Babangi mask, French Congo

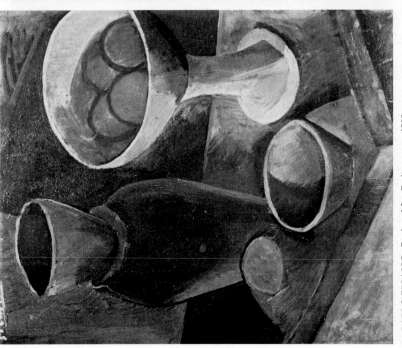

6 PABLO PICASSO, *Landscape*, La Rue des Bois August 1908

5 PABLO PICASSO, *Bowls and Jug*, Paris summer 1908

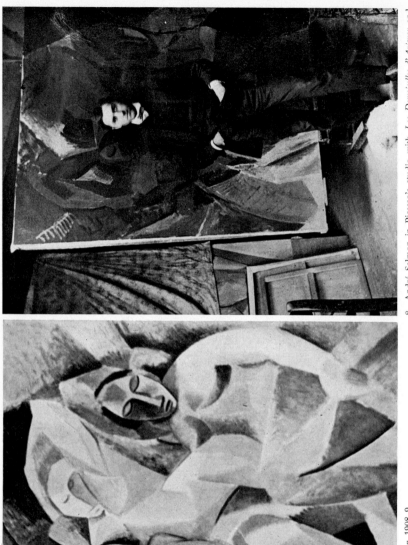

7 PABLO PICASSO, *Three Women*, 1908–9

must not have understood at all well at first. But Braque did in this painting use Cézannian *'passage'* to create a tightly interlocked spatial system in the background; and in the figure itself he followed Picasso's lead in combining several points of view into a single image.

During the summer of 1908, Picasso was painting Cézannian landscapes and still-lifes, first in Paris and later, during August, at La Rue-des-Bois, a small town in the Ile de France[9]. At the same time Braque was in southern France near Marseille, at L'Estaque, where Cézanne himself had frequently painted. Braque's landscapes of this summer reveal a much more literal study of Cézanne than does the contemporary work of Picasso. His *Houses at L'Estaque (Ills. 10, 11)* nevertheless demonstrates Braque's sensitive assimilation of the same aspects of Cézanne that interested Picasso; and a comparison with his *Grand Nu* of a few months earlier shows the progress he had made in this direction. At a much later date Braque said of this crucial moment in his development that at first he had been blinded by the brilliance of Provençal colour and light, but that gradually 'it was necessary to find something deeper and more lasting'[10].

Like Picasso, Braque was learning to stand on Cézanne's shoulders, extracting from his art its structural and non-illusionistic features while discarding Cézanne's lingering interest in observed visual detail. A series of these L'Estaque paintings, when rejected by the jury of the 1908 Salon d'Automne, formed the nucleus of a Braque exhibition in November 1908 at a small gallery in Paris that had been recently opened by a young German, Daniel-Henry Kahnweiler, who was later to become the dealer for all the leading cubists. In his review of this exhibition the critic Louis Vauxcelles used the word 'cubes' for the first time in relation to the new style that was emerging (text 4 and p. 51).

The rapidity with which Braque advanced along the path of a post-Cézannian art may be seen in a *Still-life with Fruit (Ill. 13)* of late 1908, in which a complex system of intersecting planes defines volumes in space in an already proto-cubist non-illusionistic manner; the debt to Cézanne is still considerable, as in the perspective distortion of the banana in the lower left hand corner, recalling Cézanne's similar treatment of curving roadways. But Braque had now begun to use *chiaroscuro* in the decidedly arbitrary way that became a characteristic of his and Picasso's paintings until 1912. Braque's choice of a single, three-dimensional solid as the subject of his painting also became the rule in his and Picasso's work of the following three years. For as the cubist painter Juan Gris said much later, this early period of cubism was

primarily a matter of the relation between the painter and the objects which he painted, rather than the relations between the objects themselves (text 46).

During the winter of 1908–9 Picasso completed his monumental *Three Women (Ill. 7)*, on which he had been working intermittently since the spring of 1908. This painting marks the end of a crucial phase in Picasso's early cubism that began with *Les Demoiselles* and during which the artist was seeking both new formal and new expressive values. *Three Women* is really a summation of the previous two years; and historically it bears a symmetrical relation to *Les Demoiselles*, by comparison with which it is more successful and unified, though less ambitious. In the succeeding five years Picasso devoted himself almost completely to formal problems, to the exclusion of the haunting new states of mind which he had created in *Les Demoiselles, Three Women,* and many other paintings of 1907–8.

During the summer of 1909 Picasso spent several months in the village of Horta de San Juan in his native Spain. In Paris during the spring of 1909 he had already begun to use large, shaded facets that reduced the human figure to a sculptural assemblage of geometrical solids. At Horta he continued in this direction with a series of landscapes and in a group of portraits of his mistress, Fernande Olivier. In *Houses on a Hill (Ill. 15)* Picasso returned with renewed intensity to a Cézannian style, including Cézanne's high eye-point. A photograph by Picasso[11] of the landscape at Horta *(Ill. 14)* shows, however, that he was applying his assimilated knowledge of Cézanne to a quite realistic portrayal of the motif; such paintings in fact were a retreat from the tense ambiguities of spatial structure in the *Three Women* of 1908–9. These geometrical simplifications recall Cézanne's famous remark about the cylinder, the sphere, and the cone; and for one of the few instances in its history one can speak of 'cubes' in a cubist painting. It is not difficult at this point to see why Picasso and his friends appreciated the works of the Douanier Rousseau, whose untrained but extraordinary sensibility also apprehended forms in a schematic, conceptual way, as may be seen in a landscape of 1909 *(Ill. 12)*.

In depicting the houses in his Horta landscapes, however, as well as in his portraits of Fernande Olivier, Picasso continued to combine separate points of view into a single image. But from the standpoint of the future development of cubism, it is evident from Braque's *Château at La Roche-Guyon* (Pl. II) painted in this same summer of 1909, that he had reached a more advanced position than Picasso in the application of the lessons to be learned from Cézanne.

Before Braque had met him at the end of 1907 Picasso had been alone in his search for a new art; and until 1909 the two of them were without followers. But by 1909 at least one other painter in Paris had begun to draw important conclusions from the study of Cézanne. Fernand Léger (1881–1955) had arrived, in such works as his little-known *The Bridge (Ill. 16)* of 1909, at a point comparable with that of Braque's L'Estaque paintings of the previous year. But where Braque had shown an instinctive painterly delicacy, Léger's robust personality revealed itself even at this early moment. *The Bridge* nevertheless shows an understanding of Cézannian '*passage*' and its potentialities for creating a new system of indicating space. During 1911, when cubism had become a widespread movement, this stage of Léger's art would be reflected in the paintings of such newcomers as Le Fauconnier and Gleizes. But in 1909 Léger, and to a lesser extent his friend Robert Delaunay, were the only painters besides Picasso and Braque who were exploring the heritage of Cézanne in a significant and creative way. Léger, who met Picasso towards the end of 1910[12], was shortly to embark on the development of his own version of cubism, which has qualities in common with the contemporary work of Picasso and Braque. His *Nudes in the Forest (Ill. 18)* of 1909–10[13] does not represent a major advance over *The Bridge* except that here, for almost the first time, Léger used the cylindrical forms which were by 1913 to become an essential feature of his pictorial vocabulary; as early as the autumn of 1911 Léger was being called not a cubist but a 'tubist'[14]. It should be noted that in the *Nudes in the Forest,* despite superficial appearances to the contrary, Léger created a traditional hollowed-out space, using as in *The Bridge* a perspectival diminution of scale and a Cézannian high eye-point. The same may be said of Picasso's *Houses on a Hill,* although to a much lesser extent. It is not at all accidental that, in order to avoid this traditional illusionistic effect, Picasso and Braque painted very few landscapes after 1910, limiting themselves almost completely to figures and still-lifes placed against a nearby flat background and as seen from a relatively close range.

By the end of 1909 Braque and Picasso had become close friends; and in their work they had arrived more or less independently at very similar, though not identical, styles. Braque in fact often originated startling new ideas of his own, as in the *Pitcher and Violin (Ill. 19),* painted during the winter of 1909–10. Here the facetting of forms has reached a point where the intersecting planes have begun to follow an artistic logic of their own, as much in accordance with the rhythmic structure of the painting as with

the necessity of describing the subject. Lighting, or rather the contrast of light and shadow, has now also been completely subordinated to the demands of pictorial structure. As an indication of this new balance between art and reality, Braque painted an illusionistic nail at the top of the painting, as though to indicate by means of the shadow it casts that his canvas is simply a flat, painted surface which is tacked to a wall. This device is an example of the idea, which was becoming current by 1911, of the *tableau-objet*, the painting as object (see texts 11, 15, and 23). By comparison, a still-life by Picasso, painted early in 1910 *(Ill. 17)*, seems to remain an extreme development of Cézannian ideas (see text 8); for example Picasso still respects the exterior contours of objects, whereas in the *Pitcher and Violin* Braque did not hesitate to violate the contour of the violin.

Picasso, however, was soon to take the same step, as in his magnificent *Portrait of Ambroise Vollard (Ill. 20)*, the Parisian dealer who had exhibited him as early as 1901. Begun probably by the end of 1909, this portrait was not finished until late in the spring of 1910[15]; not only is it an astonishing likeness (see *Ill. 22*), but when compared with Cézanne's portrait of Vollard *(Ill. 21)* Picasso's version reveals the distance the artist had traversed since his Cézannian paintings of 1908. Vollard is seated facing us; behind him is a table, on which are a bottle, on his right, and an upended book, on his left. Picasso has even included the handkerchief in Vollard's breast pocket. The whole surface of the painting is a series of small, intersecting planes, any one of which, because of *'passage'*, may be understood as being both behind *and* in front of other, adjoining planes. Picasso does not hesitate now to violate the contours of forms in the interest of his overall pictorial structure; but within this dense, yet flat structure he has placed clues which enable the viewer to recognize the subject.

The real subject, however, is not Vollard but the formal language used by the artist to create a highly structured aesthetic object. Obviously it would be incorrect to call this painting an abstraction, since it bears a specific relation to external, visual reality; indeed, the persisting fascination of this and other 'analytical' cubist paintings of the following two years is precisely the result of an almost unbearable tension experienced by the viewer. He is delighted by the intellectual and sensuous appeal of an internally consistent pictorial structure, yet he is also tantalized by the unavoidable challenge of interpreting this structure in terms of the known visual world. This exquisite tension between the world of art and the world of perceptual experience persists until the end of 1912. Then, with the invention of collage and *papier*

collé, cubism enters a stage in which the work of art, though at least as basically realistic as before, is nevertheless far more independent of the visual world than is the 'analytical' cubism of 1910.

Another portrait by Picasso, of Wilhelm Uhde, the German critic, connoisseur, and collector of cubism, is contemporaneous with the Vollard portrait, but it is not quite on the same high level of subtlety and richness of realization, (see *Ills. 23, 24*). But the Uhde portrait, like that of Vollard, foreshadows an important step taken by Picasso during the summer of 1910, which he spent at the coastal village of Cadaqués in the north-east corner of Spain. There, as Kahnweiler has rightly emphasized (see text 41), Picasso abandoned the use of facetted, closed forms in favour of planes with long, straight edges that disregarded the contours of objects; now, more than ever before, the subject was linked to the flattened structural continuum of the whole surface of the painting *(Ill. 25)*. As a result, the subject became yet more elusively difficult to comprehend than before; the term 'hermetic' has often been applied to the 1910–11 works of Picasso and Braque.

With Picasso at Cadaqués was his friend André Derain (1880–1954), who, like Braque, had previously been a fauvist. Derain has sometimes been mistakenly associated with cubism, but, as his view of *Cadaqués (Ill. 27)* reveals, Derain in 1910 was already the traditional painter he would remain for the rest of his life, strongly influenced by Cézanne yet unable to create a significant style of his own.

Although Picasso's Cadaqués paintings were an important step, they are not the single most crucial moment in the history of cubism. Rather, at Cadaqués, Picasso shifted the balance between pictorial structure and the description of the visual world further towards structure, as was already becoming apparent in his *Portrait of Vollard*. The new emphasis on formal elements is evident in the *Portrait of Kahnweiler* (Pl. III, *Ill. 28*), painted in the autumn of 1910. Compared with the Vollard portrait the subject is less recognizable, although the painting was certainly based on Kahnweiler's appearance (see *Ill. 29*). He is shown seated, wearing a watch chain, his hands clasped in his lap; to his right is a bottle and glass. Behind him is a table, and on the wall in the upper left-hand corner of the painting is a wooden sculpture from the French colony of New Caledonia in the Pacific. Picasso owned two pieces of New Caledonian sculpture as early as 1908; they are visible in a photograph of his studio at the Bateau-Lavoir *(Ill. 54)*. Indeed, in this portrait Picasso seems to have made a deliberate and witty juxtaposition between his sitter and the Oceanic sculpture, since he made

room for it in his composition by placing Kahnweiler's head off-centre. As at Cadaquès, the planes are no longer bounded by the closed form of the object, but instead they continue freely from one part of the composition to another, giving the effect of being alternately solid and transparent. *Chiaroscuro* contrast has become equally flexible, now totally divorced from any illusionistic function and used only to indicate the relations between planes. With this new emphasis on structure since Cadaquès, Picasso reduced his palette to browns, greys, and black; but even in 1909 he had largely restricted himself to ochres. By the end of 1910 Braque had similarly limited his palette.

Braque was to follow the same course as Picasso in finally abandoning closed form and concentrating on planar structure. His view of *Sacré-Cœur (Ill. 30)* of early summer, 1910, is still quite clearly relatable to the motif (see *Ill. 31*). By the end of 1910, however, Braque was painting works in which the original objects are hardly recognizable, as in his *Still-life with Decanter and Glass (Ill. 40)*, which was as close as Braque ever came to abstract painting. This still-life is also notable for being oval, as were many paintings by him and Picasso after 1910. The oval, or sometimes circular, shape solved the problem of what to do with the corners in a cubist composition, and it was also another indication that the artist considered his painting to be a real object in itself, more than simply an illusion of the visual world.

During 1910 Léger too had begun to emphasize the two-dimensional relations of formal elements in his paintings, but he followed a method different from that of Picasso and Braque. Léger's approach was to emphasize the contrast between the amorphous, translucent quality of clouds or smoke, and the hard, geometrical structure of houses or of his tubular figures, as in *The Wedding* of 1910–11 (Pl. IV; see also text 32), painted as a wedding present for the poet André Salmon. In works such as this Léger achieved a balance between subject and pictorial structure comparable to that in the works of Picasso and Braque of mid-1910; yet unlike them Léger devised his formal means by a literal adaptation of visual effects in nature, and he also respected the closed contours of objects.

The painter Jean Metzinger (1883–1956) followed Picasso and Braque more closely. His *Nude* of 1910 *(Ill. 35;* see also text 10) shows a knowledge of Picasso's attempts to abandon closed form (see text 9), but Metzinger did not apply the idea consistently or with sufficient understanding. The result is a chaotic mixture of cubism and traditional illusionistic painting.

Metzinger was nevertheless the only painter besides Léger whose work in 1910 approached the artistic aims of Braque and Picasso.

Until early 1912 the cubism of Picasso and Braque remained generally within the confines of their art at the end of 1910, for at that moment the possibilities of the style had suddenly become so rich that almost two years were necessary for their exploration before a further change could take place. Thus the *Still-life with Clarinet (Ill. 32)*, painted by Picasso during the summer of 1911 when he and Braque were at Céret in the French Pyrenees, represents a continuation of the stylistic innovations of his *Portrait of Kahnweiler,* but with one significant change. In this still-life are a clarinet[16], a pipe, a bottle, a musical score, and an opened fan, all on a table top and with each object indicated by means of at least one characteristic or recognizable detail. Such a still-life is more ambitious than most of his paintings since the *Three Women* of 1908–9, because here Picasso has used his by now fully developed 'analytical' cubist style to depict not one but many discrete objects, and he has sought furthermore to relate them all to each other, in a non-Cézannian way, as well as to an overall diamond-shaped compositional scheme (see text 13). The fact that this and other paintings of the same period are extremely difficult to read points to a problem inherent in this stage of cubism. For while it is suitable for paintings of a single figure or object, which are in the majority at this time, a complex system of interlocking, monochromatic planes becomes dangerously obscure when the artist seeks, in Gris' words, to reveal not merely the relation between the object and himself but between the objects themselves (see text 46). That the artists recognized this problem is evident in the rapid development of its solution with the invention of collage cubism in 1912. But before that moment they acknowledged the danger of reaching a point of complete abstraction which would have been the antithesis of the always realistic orientation of cubism (see text 12) by introducing not only realistic clues but also words, letters, and numbers into their compositions. Braque had begun to do so in the spring of 1911, and Picasso soon followed suit. The effect of this stratagem was to prevent their paintings from appearing to be absolutely flat abstractions, even while they remained objects. For the presence of typographical signs such as letters or numbers, which by nature are only two-dimensional, would by contrast force the composition on which they were superimposed to be understood as a three-dimensional image. These words and letters were never chosen arbitrarily but almost always referred to a specific aspect of the objects being portrayed, such as the name

of a newspaper. Later this device was to become an essential element in collage cubism, but a good example of Braque's use of it may be seen in the *Still-life with Harp and Violin* of early 1912 *(Ill. 34)*. In addition to a harp in the background there is a still-life with a bottle, glass, violin, musical score, and a newspaper (EMPS) of the period, the full name of which was *Le Temps*. Braque perhaps also intended to make a play on words, by which (T)EMPS would refer both to a newspaper and to a musical beat.

'Analytical' cubism reached its zenith in a dozen or more paintings of a single figure by Picasso and Braque, during 1911 and early 1912. Typical of these great paintings is Picasso's *Man with Violin (Ill. 33)* of late 1911. The subject is identifiable through realistic clues provided by the artist—an ear, his goatee, buttons on his coat, and the strings and sound holes of a violin. It has proved tempting with such works to speak of the dissection or analysis of masses, and of the combination of multiple points of view, with implications of a 'Fourth Dimension' or of non-Euclidean geometry; many critics have offered such explanations of these works. It is important to remember, however, that by the end of 1911 neither Picasso nor Braque was any longer painting directly from nature. One may legitimately speak of the combination of separate viewpoints in *Les Demoiselles d'Avignon*, Picasso's figure paintings done at Horta, and other examples of pre-1910, Cézannian cubism. But by 1911 cubism was as much an autonomous, internally consistent style with a new formal vocabulary of its own, as it was a means for describing the immediately visible world. The unresolvable tension between these two functions in 'analytical' cubism is the source both of its greatness as an art and of its misinterpretation by critics.

Therefore, in confronting a painting like the *Man with Violin*, one must not try to establish an equivalent in the known visible world for each of its components; the painting presents a man and a violin, it does not represent them (see text 37). The violinist's head is not simply a summation of different points of view, but the product of an intellectual process by which are superimposed separate planar schemes for the man's head, followed by a process of uniting the resultant forms in order to make a pictorially consistent structure. The *Man with Violin* in fact presents the viewer with an experience which has ultimately a relation to the visible world but which, like a Renaissance painting, is more directly based on stylistic conventions inherited or, as in Picasso's case, invented by the artist. Instead of experiencing the illusion of masses situated within a space by means of the convention of one-point perspective, the viewer is confronted by a different

set of conventions which in this case produce the effect of flatness but not of spacelessness; for the figure in Picasso's painting has a density and thickness far greater than its surroundings, and yet paradoxically and miraculously this figure projects neither forward nor backward into space. In any given area of this composition the planes may describe an aspect of the subject. But their primary function at the same time is, as in the *Still-life with Clarinet*, to take part in the non-illusionistic spatial structure of the painting and to contribute to the overall architecture, here pyramidal, of the composition. The problem for the cubist painter was thus simply a new version of that which faced a renaissance or baroque artist when with each brush-stroke he had to fulfil simultaneously the requirements of anatomical modelling (or landscape topography) and those of perspective, light, and composition. And, like the great artists of the past, Picasso and Braque worked by intuition, rather than by following rules as their lesser followers unfortunately did.

1911 saw the spread of cubism beyond the circle of Picasso and Braque. The cause of its spread is not easy to explain precisely, but undoubtedly it owed much to such figures as the omniscient and ubiquitous Apollinaire, who had been an intimate friend of Picasso since 1905, and who knew and frequented apparently every advanced artistic milieu in Paris. Metzinger, who knew Picasso by 1910 if not before (see text 9), must also have been instrumental in the spread of cubist ideas, particularly through his friendship with Gleizes and with other artists who met at the home of the writer Alexandre Mercereau (see the notes to text 31).

The result of this spread of cubism became publicly known in the Salon des Indépendants of the spring of 1911 and at the 1911 Salon d'Automne, in both of which the new adherents to cubism formed a distinct group; during 1911 also the term cubism came into general usage. (See text 48). None of these painters, however—Gleizes, Metzinger, Le Fauconnier, Lhote, and many others—contributed anything new or essential to the cubism of Picasso and Braque; and few, if any of them, really understood it. Furthermore it is difficult to believe that these newcomers to cubism arrived at their art independently of Picasso and Braque, who must in the end be considered the one source from which the new style spread (text 11). The art of Delaunay is an exception; although he knew Picasso by 1910, his intentions were never basically cubist, save in the broadest sense.

Léger's painting, however, was at this time a genuine alternative to the cubism of Picasso and Braque, as has been discussed above (see also text 12).

His *Study for 'The Woman in Blue' (Ill. 37)* of 1912 is a further development of the contrasts between curves and geometrical solids in *The Wedding* of the previous year. Now Léger has suppressed illusionistic space, and like Picasso and Braque he has dispensed with closed form in order to create a powerful composition of colour planes, related to the subject of the painting but not subordinated to it. But he did not follow Picasso and Braque in their use of arbitrary, grisaille planes, interlocked by *'passage'*. Instead he passed directly from the amorphous puffs of smoke or cloud in *The Wedding* to their formal descendants in the flattened geometrical patterns of *The Woman in Blue,* thus bypassing some of the problems of hermetic obscurity in 'analytical' cubism.

The influence of Léger's formal vocabulary may be seen in Albert Gleizes' (1881–1953) *Man on a Balcony (Ill. 36)* of 1912. But whereas Léger, like Braque and Picasso, had come to avoid motifs with deep space, Gleizes attempts to combine a foreground figure with distant landscape. The result is only superficially a cubist painting and in fact contains traditional deep space and perspective diminution of scale. In the foreground figure as well Gleizes used traditional *chiaroscuro* in the modelling of the face and elsewhere, a technique that he was to abandon when he arrived at a truly cubist style in 1914. The work of Gleizes is characteristic of the rapidly growing number of painters who during the years 1911 to 1914 adopted something of the external substance of cubism, but little if anything of its essential qualities.

In the spring and summer of 1912 the art of Picasso and Braque underwent a series of crucial changes, which brought to an end one phase of cubism and inaugurated a second that was to prove even richer in possibilities than the first. By the end of 1911 the two artists had found that the formal language of 'analytical' cubism, brilliant though its aesthetic results had been, was becoming increasingly inadequate to describe the visual world. In addition, the problem of colour, which had been almost completely neglected in the works of 1910 and 1911, had yet to be resolved (see text 12); for the colour of objects was as much a part of their visual qualities as was their form. Although a way had been found to depict reality without the use of traditional *chiaroscuro* and perspective, the artists' fascination with intricate spatial structures during 1910 and 1911 had all but overshadowed the question of colour. These very triumphs of form could perhaps have been achieved only at the expense of colour, which would have been still another variable in an already dangerously complex

artistic equation; now, however, in a few paintings of late 1911 and early 1912, both Picasso and Braque made tentative efforts to reintroduce it.

Also during early 1912 the objects in the paintings of these two artists became somewhat easier to recognize, and in order to make them yet more recognizable Picasso and Braque began to indicate their textures. In the spring of 1912 Braque started to imitate the graining of wood, first by means of conventional brushwork, then by using a housepainter's comb. Picasso soon copied this technique but he also applied it to other effects, notably to the simulation of hair, as in *The Poet (Ill. 39;* see also text 33).

The problem of describing visual reality without resort to illusionism was thus being attacked in various new ways; much the most important step in this direction however was Picasso's incorporation of a ready-made facsimile of an object into a still-life painting, in May 1912[17]. His *Still-life with Chair Caning (Ill. 41;* see also text 25, section on Picasso) is the first cubist collage; in a still-life scene at a café, with lemon, oyster, glass, pipe, and newspaper, Picasso glued a piece of oilcloth on which is printed the pattern of woven caning, thus indicating the presence of a chair without the slightest use of traditional methods. For just as the painted letters JOU signify JOURNAL, a section of facsimile caning signifies the whole chair. Later Picasso would go one step further and incorporate into his collages actual objects or fragments of objects, signifying literally themselves.

This strange idea was to transform cubism and to become the source for much of twentieth-century art[18]. But its immediate usefulness to cubism was not to emerge until a few months later, when in September 1912[19] Braque glued strips of artificially wood-grained wallpaper into a *Still-life with Fruit-dish and Glass (Ill. 38).* These strips, indicating the drawer and top of a wooden table, were the first example in cubism of the use of pasted paper, or *papier collé*[20]; and with this innovation most of the problems remaining in cubist art were to be resolved (see texts 24, 25).

In Braque's first *papier collé* the strips of paper *signify* both the colour and the texture of an object, while the forms and interrelations of objects are indicated by means of the vocabulary of lines and planes perfected during the previous two years. Since 1910 Braque and Picasso had dispensed with closed form; so now, with *papier collé*, the strips of pasted paper were not restricted to the contours of the objects they signified. The artist was now free to compose the strips of paper in a *papier collé* according to a scheme of pattern and colour aesthetically independent of all

realistic intent, even while these same coloured or patterned papers conveyed information about the objects depicted (see text 29).

These pieces of pasted paper also eliminated all vestiges of illusionistic space; the *papier collé* is concretely and absolutely flat. But these paper strips could also, when the artist so desired, express spatial relations directly, by overlapping each other or by their relation to lines drawn over or under them. And, as in 1910–11 cubism, a spatial ambiguity which itself denied illusionism could be created by means of mutually interlocking strips, overlapping each other in one sequence at a given point of juncture but in a different sequence at a second point. Lines and planes indicating the formal qualities of objects could be drawn across, or separate from, the paper strips, so that both the colour and the form of an object might be described. The previously existing dilemma of local colour versus *chiaroscuro* was thereby eliminated; and with the discovery of a technique involving neither brushwork nor oil pigment, the cubist break with previous artistic methods and attitudes was virtually complete.

Both Picasso and Braque had experimented during 1912 with cardboard relief constructions, of which only a few survive; and undoubtedly these constructions, which they continued to make in 1913 and 1914, contributed measurably to the invention of *papier collé*, as did also very possibly a renewed study of certain types of African sculpture. As soon as Braque had made the first *papier collé*, he and Picasso proceeded rapidly to develop its enormous potentialities with all the brilliance and subtlety that had gone into the cubist masterpieces of 1910 and 1911. But in contrast to Braque's generally more straightforward and often lyrically serene use of the new medium, Picasso discovered in *papier collé* a means of creating paradox, ambiguity, and wit, as in one of the greatest of all *papiers collés*, his *Still-life with Violin and Fruit* (Pl. V) of early 1913[21]. Here in one instance Picasso uses newsprint—(JOU)RNAL—in a collage-like way to signify literally a newspaper on a table. Elsewhere in the picture he gives a purely arbitrary significance to the newspaper fragments; in the upper left hand corner, to indicate fruit in a dish he has pasted printed illustrations of apples and pears above a segment of newsprint which in this instance signifies the bowl of the fruit-dish, while below it an absolutely blank white strip of paper indicates the stand of the fruit-dish. Paradoxically, the cut-outs of fruit seem to overlap each other, yet physically they do not. The wood-grained papers identify alternately the violin and the table on which it sits; there is also a second white strip, related compositionally to the first,

which signifies the unshadowed side of the fingerboard and neck of the violin. At the bottom, a large piece of newspaper functions both as an abstract compositional element and as a sign for the tablecloth; at the lower left a grid of horizontals and verticals adds stability to the otherwise unanchored diagonals above and also indicates the presence of a chair. Superimposed on the newspaper at the right, and at a cocked angle to it, is a second, smaller piece of newspaper, on which in turn is a drawing. The drawing and the small cut-out together signify a wineglass, in a highly condensed and conventionalized manner; many formal characteristics of the glass have here been fused, if only tentatively, into a single image. This type of condensed image, when fully perfected, was to play a highly important role in later cubism. Even the transparency of the wineglass has been indicated by the fact that its paper cut-out is at an angle to the larger newsprint fragment, here used literally, beneath it: thus the transparent, refractive quality of the empty glass is emphasized. Finally, as if aware of the extraordinary freedom and inventiveness of his achievement, Picasso has not neglected the witty implications of the newspaper captions: LA VIE SPORTIVE ('the sporting life') and (APP)ARITION! Such word-play soon became a deliberate component in cubist collages, especially in those of Gris.

Braque's generally more direct, but no less breathtaking, use of *papier collé* is well illustrated in his *Still-life with Mandolin, Violin and Newspaper (Le Petit Eclaireur)*, of mid-1913 *(Ill. 42)*. On the left, a segment of paper cut in a bulging curve stands for the characteristic silhouette of a mandolin; in the centre, a square cut from a paper strip indicates its round sound-hole, while the hole is repeated in line on the third, vertical strip. At the right, the violin is suggested by its characteristic outline and by a displaced hint of its own *f*-shaped sound-hole.

Papier collé inevitably had a powerful effect on the paintings of Picasso and Braque, as may be seen in the latter's *The Violoncello* (Pl. VI) of 1912, where despite the medium of oil-paint the appearance is that of superimposed strips of paper. Picasso did not hesitate to combine mediums; his *Still-life with Violin and Guitar (Ill. 43)* of early 1913 is executed in oil, cloth and plaster, as well as wood-grained *papier collé*.

At this point it is well to take a brief look at the course taken by Picasso and Braque since 1910. By early 1910, a temporary balance had been struck between the demands of reality and those of art; this balance was to tip sharply in favour of art after Picasso's Cadaqués paintings and during 1911. During 1912, numerous efforts were made by both Picasso and Braque

to redress this balance without sacrificing the innovations in formal vocabulary of the previous two years. This effort culminated in collage and *papier collé* at the end of 1912. Compared with the hermetic quality of Picasso's *Still-life with Clarinet (Ill. 32)* of 1911, his 1913 *Still-life with Violin and Guitar (Ill. 43)* is far more easily legible, once the viewer understands the new conventions established by collage and *papier collé*; yet the artist was not forced to make any concessions to the traditional means of illusionism. At the same time, the methods of *papier collé* gave the artist an almost limitless freedom in formal organization. Thus a new balance was struck in which, almost miraculously, the interests both of reality and of art could be served to the maximum degree, and by means which were completely independent of past artistic traditions.

Juan Gris (1887–1927), who had been living in Montmartre near his Spanish compatriot Picasso since 1906, was quick to understand the significance of collage; there were in fact few painters other than Picasso, Braque, and Gris who worked in the new medium, especially before 1914. (Exception must be made, however, for the Italian Carlo Carrà, who was ostensibly a futurist but whose collages at their best may be compared with those of the cubists.) Gris began to paint seriously in 1911; he passed rapidly through a Cézannian, 'analytical' period and by 1912 was creating an austere, though usually highly colouristic, cubist style of his own, as distinct from that of Picasso and Braque as was Léger's. His *The Washstand (Le Lavabo)* of 1912 *(Ill. 46)* is a collage, incorporating a fragment of a mirror in the upper centre of the composition. Since his subject called for a mirror at that point, Gris reasoned in his characteristically rigorous fashion that no technique of painting could give the equivalent of the reflecting qualities of the mirror itself. (See text 21.) This painting was shown at the *Section d'Or* exhibition of October 1912; and in this, as well as in many later works, Gris used the golden section, in combination with a modular system, in laying out his composition[22].

Also in the *Section d'Or* exhibition was Metzinger's *Portrait of Albert Gleizes (Ill. 44)* of 1912. While Metzinger rather naively combined separate eye points in this painting, he also adopted a brighter colour scheme than he had previously used, probably influenced by Gris and the return of colour in the *papiers collés of* Picasso and Braque. Metzinger also imitated the appearance, but not the mathematical precision, of Gris' system of composition by means of the golden section, an indication of the newcomer's early influence on other cubists[23].

By 1914 Gris had reached a point in his version of cubism that was without an exact counterpart in the work of Picasso and Braque; his *Teacups* of that year (Pl. VII) is especially interesting as an example of Gris' contribution to *papier collé*. Almost the entire surface of the canvas is covered with pasted paper, laid out according to a strict geometrical system. The pasted paper is in turn covered with a complex cubist composition drawn on top of it. The references to reality follow a method similar to that of Picasso and Braque, except that Gris maintained the integrity of objects far more than they did, and was more fond of making objects appear transparent (see text 29). The newspaper fragment inserted in this work is a highly amusing example of wit in Gris' collages, for the twin photographs on the front page are of the pedestal to a statue before and after the passage of a law forbidding the pasting of notices on public buildings; the ironic reference to collage is obvious.

Léger's art by 1913 was neither so complex nor so subtle as that of Picasso and Braque, but its plastic vigour was unexcelled. He made a large number of paintings in 1913–14 which he called *Contrasts of Forms* (*Ill. 47*; see also texts 27 and 32). The tubular forms and flat areas in these paintings are a culmination of his work since 1910. By 1914 Léger had developed a theory (text 32), based ultimately on his study of Cézanne, by which he thought he could achieve the maximum of pictorial contrast in the largest number of ways: contrasts of colour, based not on the scientific investigations of light by the neo-impressionists, but on strictly formal considerations; contrasts of straight and curved lines; contrasts of solids with each other and with flat planes. The result was at times completely abstract and had more to do with an almost animistic belief in visual dynamism for its own sake than with cubism, although usually these *Contrasts of Forms* had an ostensible subject and were devoid of illusionistic space. After World War I, however, Léger was to pursue his own version of a later cubist style.

During 1913 and 1914 so many artists in Paris had turned to cubism that it temporarily became the universal language of *avant-garde* painting. By means of printed reproductions and of works sent to exhibitions in England, Holland, Germany, Russia and the United States, cubism on the eve of World War I was exerting an overwhelming influence on young painters everywhere. In Paris, many artists of little intrinsic talent turned to painting cubist pictures, which reflected only the slightest understanding of the

style. Others, such as Marcoussis, Reth and even the young Diego Rivera, came closer to the essentials of cubism.

Another tendency which may be noted in passing was the application of the idea of simultaneity to both painting and literature (see text 30). Simultaneity was the rather naïve idea, derived from the writings of Apollinaire, Gleizes, Metzinger and others, and practised also in the early poetry of Mercereau, that was used in describing the simultaneous presence in a cubist painting of separate points of view. Since this simultaneity implied movement, and hence time, the 'Fourth Dimension' and non-Euclidean geometry were also frequently cited as justifications (texts 23, 25, 29, 31).

An interesting though rather literal-minded application of the idea of simultaneity may be seen in the works of Gleizes and Metzinger, and in some of the paintings of Delaunay: at the same time as the artist shows us an object seen from several sides at once, he also brings together objects distant in space and otherwise not visible simultaneously. This tendency, which has been called 'epic' cubism[24] because of the often wide-sweeping landscape views either implied or directly presented, is well exemplified by Metzinger's *The Blue Bird*[25] of early 1913 *(Ill. 50)*. Three female nudes are in various postures, and the blue bird is held by the uppermost figure; in other parts of the composition are numerous birds, grapes in a dish on a table, the striped canopy of a Paris café, the dome of Sacré-Cœur in Montmartre, and a ship at sea. So far as cubist style is concerned, however, Metzinger's painting has little in common with the art of Picasso and Braque: there is no coherent presentation of visual reality by means independent of the renaissance illusionistic tradition (see text 42). Metzinger's treatment of the figures and the spatial composition as a whole are what in fact could only be called sub-cubist.

With the outbreak of war in 1914 there inevitably came a sharp break in the artistic life not only of Paris but of all Europe. Of the principal cubists, only Picasso and Gris, being Spaniards, were not mobilized, and it is to the work of these two that one must turn for the final stage of the style. During the latter part of 1913 and in 1914, Picasso had turned temporarily toward expressionistic and decorative concerns in his painting, even while remaining within the limits of cubism; and during the next ten years he was also to alternate between cubism itself and a linear, realistic neo-classicism which nevertheless contained cubist elements. But during the year before war was declared, a new idea was emerging in his work and in that of Braque and Gris, which concerned the creation of signs that would

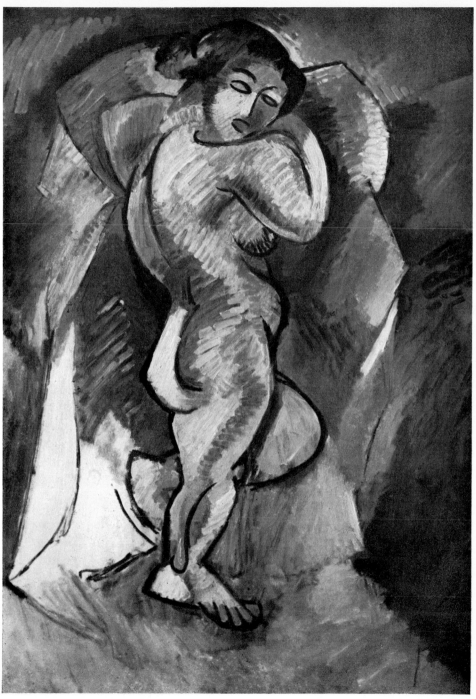

9 GEORGES BRAQUE, *Grand Nu*, Paris 1908

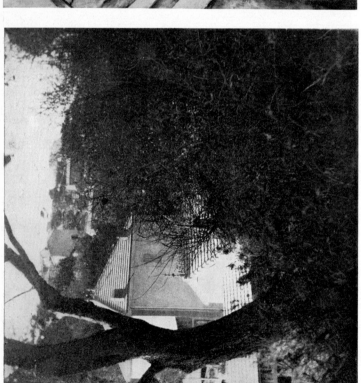

10 Houses at L'Estaque, photographed by D.-H. Kahnweiler, 1909

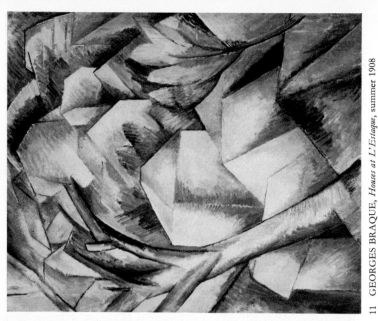

11 GEORGES BRAQUE, *Houses at L'Estaque*, summer 1908

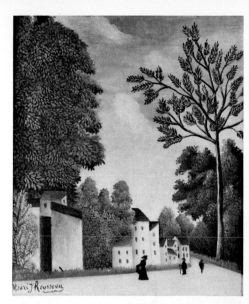

12 HENRI ('Le Douanier') ROUSSEAU,
Village Street-scene, 1909

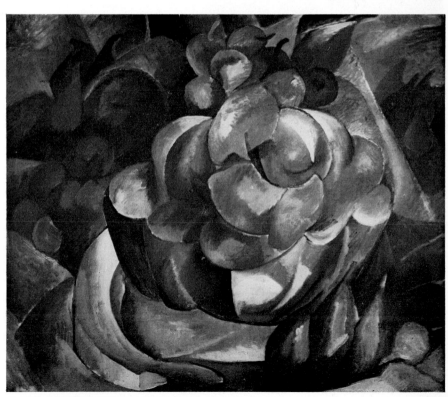

13 GEORGES BRAQUE, *Still-life with Fruit*, Paris late 1908

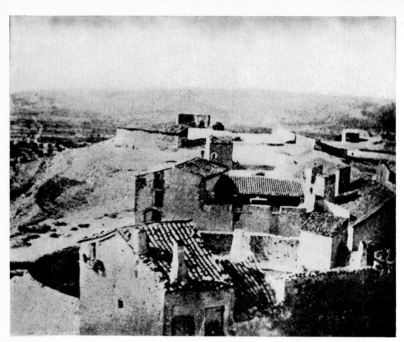

14 Houses at Horta de San Juan, photographed by Picasso, summer 1909

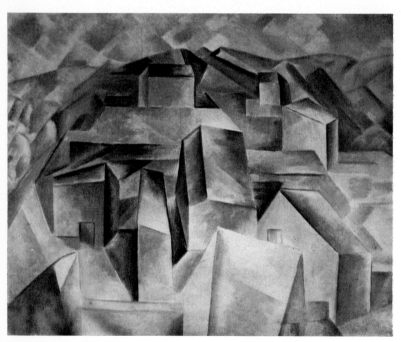

15 PABLO PICASSO, *Houses on a Hill*, Horta de San Juan summer 1909

summarize in one form many characteristics of a given object; the wineglass in Picasso's *Still-life with Violin and Fruit* collage (Pl. V) was an early example of this new idea.

It is probable that at this moment African sculpture played a renewed role in cubism, for, as Maillol later remarked, the Negro sculptors often had the gift of combining 'twenty forms into one'[26]. African sculpture also presents analogies to the way in which a given material in a Picasso collage may signify itself but elsewhere in the same collage is given arbitrarily a different signification; similarly, in African sculpture a solid may indicate a void, and vice versa, or a concave form may stand for something which in nature is convex (see *Ill. 3*).

Signs had played an important role earlier in cubism, ever since late 1910 or early 1911 when artists ceased to depend on the direct observation of nature. Realistic clues appeared in the 'hermetic' paintings of 1911 (see *Ill. 32*), and the words which Picasso and Braque put in their works were literally signs for newspapers or other printed material; Braque also used words for their associative meanings, as with the word BAR or the names of drinks in café still-lifes (see *Ill. 38*), or musical terms and even names of composers in pictures containing musical instruments. In collages, either an object literally signified itself, or a portion of an object, such as the fragment of a newspaper title, signified the whole (see Pl. V). Now the sign was to assume a more central role in cubism.

The *Man Leaning on a Table*, a masterpiece of 1915 *(Ill. 48)*, is a summation of Picasso's pre-war art, but it also contains the germ of later, or 'synthetic' cubism. The pointillist dots of his decorative, 1913–14 *détente* are still present; but so is his mastery in organizing spatially interlocked planes, accumulated with the experience of the previous five years. The large size of the planes is an outgrowth of *papier collé*, which in turn was itself the fulfilment of Picasso's and Braque's break with closed form in 1910. But the new element in this work is Picasso's use of condensed signs for the head, torso, and leg of the figure, and for the legs of the table: all the formal qualities of an object are 'synthesized' into a single characteristic, but highly conventionalized, new form (see text 26). As in *papier collé*, the colour of this synthesized form could be related to that of the original object, or, as became usual, it could quite arbitrarily play a part in the colour system of the whole painting. This colour system could be almost, but not completely, independent of the formal structure; there remained the necessity of indicating, where desired, the continuity of a given plane,

to which therefore would be assigned the same colour wherever it reappeared. Even this limitation could be dispensed with if the artist wished to heighten the ambiguities of spatial relations between planes, thus denying illusionistic space, or if the demands of the overall composition were paramount. Hence, the only limitation upon the artist was topological: he must not allow two areas of the same colour accidentally to adjoin each other when the spatial organization of the painting dictated otherwise.

All these aspects of form and colour are evident in the next, and final, stage of cubism, which might be called synthesized, synthetic cubism. In such works as Picasso's *Still-life with Pipe and Glass (Ill. 51)* or Gris' *The Man from Touraine (Ill. 52)*, both of 1918, the condensed signs for objects are themselves combined into a tightly structured composition. (See texts 35, 37, 38, 46.) In addition to the usual cubist interlocking colour planes, the individual synthesized signs are related to each other by a variety of other means, most prominent of which is visual rhyming, a device which first appeared in some of Picasso's *papiers collés* during 1912 and 1913: morphologically similar elements, such as circles, are emphasized in the separate signs to which they belong. The composition as a whole could also be forced into a unifying geometrical pattern, which could itself be the original point of departure of the painting, particularly in the work of Gris (see text 43); Gris was in fact primarily responsible for this final stage in cubism. The often crystalline appearance of these late cubist works appealed particularly to the 'purists' Ozenfant and Jeanneret (see text 47), who found in them inspiration and justification for their own non-cubist art.

Picasso's *Three Musicians* (Pl. VIII), of which there are two versions, is the crowning masterpiece of synthesized, synthetic cubism; in it is summed up all the long, complicated process of discovery and invention which began in 1907. We are now in a purely stylistic realm, at a long remove indeed from visual reality: each element in the *Three Musicians* is presented by means of a sign, which itself is the product of a long historical evolution; and all the signs are in turn related to each other by the greatest number of means possible, including visual rhymes, interlocking planes, and the colour scheme. As evidence of Picasso's joyous and absolute mastery of his art, one finds here and there visual puns, such as the profile silhouette of a human head just above the musical score in the centre of the painting.

After the War, Léger developed a version of synthetic cubism roughly comparable to that of Picasso, as in *The Discs* of 1918–19 *(Ill. 49);* but, as

before 1914, Léger's art had more to do with visual dynamism than with pure cubism. Léger's espousal of the city and the machine as subjects for his works of the 1920s was a direct reflection of his artistic temperament. His formal means, however, often paralleled those of Picasso's synthetic cubism. Braque, who was severely wounded in the War, made an effort in 1917 and 1918 to recapitulate his immediately pre-1914 style, and he also painted a few 'crystalline' synthetic works. By the 1920s, however, he was launched on a personal version of synthetic cubism which he was to practise until his death and which, with its rich colour and broad painterly qualities, heralded the re-emergence of an artistic sensibility that before 1908 had found its expression in fauvism. Juan Gris, progressively weakened by an illness to which he succumbed in 1927, continued until the end to work according to the methods of synthesized, synthetic cubism, although except for some still-lifes of 1926 and 1927 his paintings of the 1920s gradually became more realistic.

As had also been the case before 1914, later cubism was practised by numerous painters both in Paris and in other artistic centres; but by approximately 1925 all the potentialities of the style had been realized by its creators, while the lesser followers, by their very prolific and mediocre production, were only hastening its decay (see text 40). The most gifted artists of the period were beginning to respond to other, less rational and more emotionally expressive realms of human experience. Those who had participated in cubism must have come to feel much as did the sculptor Jacques Lipchitz when he exhorted Gris and his other cubist friends to escape the Golden Cage of their formal principles and to use the language they had learned for saying something[27]. Picasso, the greatest artist in the first half of the twentieth century and at almost all times the architect and leader of cubism, was himself in 1925 to turn away from his own superb creation. The expressive intensity of his blue period and of Les Demoiselles d'Avignon, which had for so long been suppressed or sublimated in a long series of brilliant formal inventions, emerged in his Three Dancers (Ill. 53) of 1925, never again completely to disappear. With this work, cubism as a living style came to an end, although both Picasso and virtually every other artist of the next four decades remained indebted in one way or another to what is still today the greatest single aesthetic achievement of the century.

Cubism as a stylistic and historical phenomenon

Cubism is a generic name that has been given to a varied range of art produced between 1907 and the middle or late 1920s. As has been shown, there is a great difference between the cubism of Picasso, Braque, and Gris, and that of other painters. This difference is based ultimately on the degree to which the artist in question succeeded in breaking with the European illusionistic tradition; and the formal means associated with this break also indirectly involved a choice of subject matter. It may be argued that those artists who did not break with illusionism in a stylistically coherent way were nevertheless the creators of another sort of cubism, different from that of Picasso, Braque and Gris, but equally valid as a style. In fact, however, the pre-1914 works of these artists—Gleizes, La Fresnaye, Le Fauconnier, Metzinger, Lhote, and many others—when examined closely reveal in almost every case a still illusionistic, or at best Cézannian, conception of painting, concealed beneath a half-understood adaptation of the formal means of Picasso or Braque. The same artists later usually followed one of two courses: either, like Villon by 1913 or Gleizes by 1914, they assimilated the style of the leaders and followed in their wake; or, like Lhote and Le Fauconnier, they reverted to the traditional style which had been the basis of their art even at its most cubistic moments.

All the critics of cubism, both during its life span and afterwards, agree that its intentions were basically realistic. It is certainly easy to recognize how much more dispassionately realistic it was than such other styles of the period as futurism or German expressionism. An indication of this ultimate reliance on the visual world is the fact that a true cubist painting contains as subject-matter only those objects which might plausibly be seen together in one place. The real problem, therefore, is the precise nature of cubist reality, compared with the treatment of reality in earlier art, and whether or not the character of this cubist reality changes with the evolution of the style.

Two of the standard explanations of cubism offered by its defenders were that it portrayed a reality of conception, not of vision (see texts 20, 27), and that nevertheless the cubists were seeking the truth in visual experience (see text 16). Paradoxically, both of these statements are true, but this seeming dilemma may be most clearly resolved with a review of the previous half-century of the artistic tradition to which cubism belongs.

Gleizes' and Metzinger's *Du Cubisme* and Apollinaire's *Les Peintres Cubistes* both refer to Courbet as a spiritual ancestor of cubism, and in one sense they are correct. Courbet wished, as had few painters before him, to exclude from his art those symbolic, literary, and historical dimensions which had preoccupied European art for a thousand years and more; out of the total spectrum of possible artistic functions he chose to concentrate on capturing what was strictly visible to his own eyes. While he often unwittingly included much more than the record of his visual experience, his successors, the impressionists, were more single-minded in their adherence to this goal, and they went beyond Courbet in choosing subjects that were as nearly emptied of symbolic content as possible. To these neutral subjects they were applying by the mid-1870s a technique which in retrospect may not appear scientific but which may certainly be termed an empirical realism of retinal perception.

From this newly achieved style emerged numerous sequels, but for the history of cubism the most important was the art of Cézanne. Maintaining the impressionists' restricted range of neutral subjects—landscape, still life, portraiture—Cézanne discarded fidelity to direct retinal experience in favour of an art which, although less directly and literally realistic, reflected more faithfully than did impressionism the complex psychological process of visual perception itself[28].

Objects in the paintings of Cézanne assume a 'distorted', non-perspectival form as a result of multiple perceptions from discrete points of view, accumulated and then expressed in a single composite shape. Such a process led inevitably to an emphasis on qualities of form rather than those of texture and colour, although where necessary Cézanne utilized colour contrasts to model the volumes resulting from this process of multiple perceptions. Similarly, in his compositional methods, Cézanne organized his forms into discrete areas corresponding to the limits of the human visual field; within these areas, he further 'distorted' objects for purposes of achieving contrasts of form, so that, for example, lines would meet each other at right angles. Within these smaller areas he also realigned and reshaped objects in the interest of an overall unifying two-dimensional structure; as, finally, he did for the composition in its entirety, where, using *'passage'*, he also created pictorial unity between near and distant objects, especially in his landscapes.

This complex style, which cost Cézanne immense pains in realizing each painting, was, as has been shown, one of the principal sources of early cubism. But what Cézanne accomplished in remaining faithful to his 'little

sensation', the careful recording of the process of perception and the aesthetic ordering of that process, was used by Picasso and Braque for very different purposes. Retaining the same restricted range of subject matter as their predecessors, Picasso and Braque at first (1908–9) assimilated Cézanne's art. They then intensified certain of its characteristics—'*passage*', multiple viewpoints—to such a degree that what, in Cézanne, had been the means of remaining faithful to the process of vision, became by 1912 the foundation of a new, completely non-illusionistic and non-imitative method of depicting the visual world. The peak of what was in fact a new convention of realism was reached in the *papiers collés* and paintings of 1913–14, after which the artists turned to exploiting the more strictly aesthetic properties of their inventions.

The change in the approach to the visual world between Cézanne and 1913–14 cubism has a parallel in the history of philosophy with the differences between the thought of Henri Bergson (1859–1941) and Edmund Husserl (1859–1938). In such works as his *Introduction à la Métaphysique* of 1903 or *L'Evolution Créatrice* of 1907 Bergson stressed the role of duration in experience: with the passage of time an observer accumulates in his memory a store of perceptual information about a given object in the external visible world, and this accumulated experience becomes the basis for the observer's conceptual knowledge of that object. This process is analogous to the methods of Cézanne[29] and of the cubists in 1908–10. After Picasso's Cadaqués paintings of mid-1910, pictorial structure became a more powerful guide than the accumulated experience of vision; what Cézanne had made into a composite image remained separate, in 1911–12 cubism, as superimposed, interwoven or adjoining planes.

After 1911 the cubists no longer worked directly from a model in nature; and in the *papiers collés* and paintings of 1913–14, which contain no illusionistic space, there was no prior Bergsonian accumulation of knowledge through multiple perceptions in time and space. Instead the cubists proceeded directly to an ideational notation (see text 39) of forms that were equivalent (see text 42) to objects in the visible world without being in any way illusionistic representations of those objects. With the invention of *papier collé* it became possible to indicate all the spatial, colouristic, and textural qualities of objects; and the development of the sign in synthetic cubism completed the repertoire of formal means by which the visible world might be described. However, this notation of the visible world in the cubism of 1913–14 included not all the qualities of a given object, but only those which charac-

terized it sufficiently well—its characteristic form, colour, texture, silhouette—to permit unequivocal recognition.

The relation of Picasso's and Braque's 1913–14 cubism to the experiential world very closely parallels the method of so-called eidetic reduction in the phenomenology of Husserl. This parallel was first noted by Ortega y Gasset in 1924[30] and has been discussed most fully by Guy Habasque[31]. Husserl sought in the years before 1914 to establish a method of apprehending existence which should be independent of psychological explanations, and which he set forth in his *Ideen* of 1913[32]. This method of eidetic reduction, concrete[33], purely descriptive[34], and based on intuition[35], can be used to arrive at the essence of an object, at those essentials which qualify it if secondary determinations are to qualify it also[36]; these essentials shall include its morphological essences as opposed to ideal, abstract, geometrical concepts[37], and shall include all but a specifically individual content[38]. Later, in his *Méditations Cartésiennes*[39], Husserl clarified his approach by means of concrete examples, such as that of the apprehension of the essential qualities of dice cubes[40].

The striking similarities between Husserl's method and the art of Picasso and Braque in 1913–14, although historically coincidental, provide an obvious contrast to the psychologically oriented methods of Cézanne and Bergson. Picasso and Braque also worked not by rule but by intuition; when describing the essential qualities of objects they never tied their forms to a specific object, save when in collage a real object stood for itself and for the class of all similar objects. In the *papiers collés* and, later, in the fused signs of synthetic cubism, the forms chosen were invented, not copied from nature; and this product of intuitive invention differed fundamentally from the Cézannian composite form, which was the result of a cumulative psychological process, closely tied to visual experience. And, also unlike Cézanne, the form chosen was only one of many possible choices (see text 23). As Apollinaire remarked, a chair will be understood as a chair from no matter what point of view it is seen if it has the essential components of a chair (see text 24); or as Picasso remarked to Leo Stein, the brother of Gertrude, before 1914: 'A head . . . was a matter of eyes, nose, mouth, which could be distributed in any way you like—the head remained a head'[41], a mode of thought analogous to the method of composition by tone-row in the music of Schoenberg and other twelve-tone composers.

The differences between Cézanne, or early cubism, and cubism after 1912 may be defined in another way as a shift from an art of induction that

d an ideal immanence, to an art of deduction (see text 43)
a transcendental essence[42]; this process of deduction in turn
certain pre-existing ideas[43], whether gained through Bergsonian
through pure creative imagination. A similar contrast can be
comparison between sculpture of the idealizing classical tradi-
tion . specific, signifying qualities in African sculpture, as Gris himself
recognized[44].

A further contrast between Cézanne, as well as the impressionists, and the
1913–14 cubism of Picasso and Braque is that while the nineteenth-century
artists used abstract stylistic means of depicting reality, those of the cubists
were concrete and literally tangible as in collage; a difference between the
nineteenth and twentieth centuries which has been noted in other areas of
culture, notably in technology[45]. A situation somewhat similar to that in
painting may be seen in literature also; for while Proust achieved what
would seem to be the ultimate possibilities of Bergsonian psychology, such
writers as Hemingway, and later Robbe-Grillet, have employed what can
well be termed a concrete, phenomenological method in the novel.

There is one interpretation of cubism which is perhaps worthy of special
comment, namely that it should be associated with mannerist art of the
sixteenth century. Undeniably there are spatial ambiguities in both cubism
and mannerism, often as a result of similar formal means[46]; and it is tempting
to assign similar roles to the intrusion of such alien artistic influences as that
of Dürer in sixteenth-century Italy and African art in twentieth-century
France. Gustav René Hocke[47] and others have cited the cubistic tendencies
of Dürer, Cambiaso, and Bracelli, and the mannerist quality of twentieth-
century cubism, as aspects of a larger general tendency which reappears at
various moments in European culture. The cubistic drawings of Dürer and
other artists of the sixteenth century have, however, almost nothing in
common with the art of the twentieth-century cubists. In addition, cubism is
as an art anything but mannerist, although its spread perhaps indirectly
encouraged the re-evaluation of sixteenth-century mannerism carried out
during the 1920s by Dvořák, Friedlaender and other pioneering historians.
But, in a historical context, a style is mannerist in relation to a previous
normative style; and in the twentieth century cubism has if anything played
the role of such a normative style[48]. It is indeed one sign of its greatness that
cubism was able to furnish artists of the stature of Schwitters, Duchamp,
and countless others after them with a norm from which to borrow, or
against which to react, in creating their own styles.

The heritage of cubism to later artists has in fact been primarily that of its formal principles, whereas the specifically phenomenological character of its realistic intentions has found few if any disciples. Thus the flatness of the picture plane, the idea of the *tableau-object,* the non-illusionistic inter-relations of pictorial planes, collage and other non-traditional technical means—all products of the cubist aesthetic—became fundamental if not dogmatic values in much subsequent twentieth-century art. The intensive elaborations and variations upon these principles by innumerable painters have often been justified in the name of artistic research, a justification which was repudiated originally by Picasso himself (see text 45). This reflexive[49] attitude, in which the subject of art is its own formal language, may well deserve the epithet 'mannerist' in the pejorative sense.

A more creative use of the cubist heritage was made by those who used its methods for expressive purposes, as Picasso has continued to do, most notably in *Guernica,* and as have numerous other artists, from Klee to de Kooning.

The historical paradox of cubism is, finally, that in providing the final break with an artistic tradition almost 500 years old, it nevertheless revi-talized and extended that tradition by redefining its realistic premisses. In place of an outworn illusionism and the discarded spiritual or symbolic values which it had served, the cubists united a new interpretation of the external world with formal inventions adequate for that interpretation. In so doing they founded a new tradition, the destiny of which still lies in the future.

Documentary Texts

The following selection of texts on cubism does not pretend to be exhaustive. The quantity of contemporary criticism of cubism was immense, particularly on the occasions of the large annual Parisian exhibitions, the Salon des Indépendants and the Salon d'Automne, from 1911 until the First World War. Almost every one of the dozen or more Paris newspapers of the period had its art critic, and by the autumn of 1912 cubism had become sufficiently notorious to provoke extensive journalistic comment. The great majority of this criticism is worthless from an intellectual or theoretical point of view and reflects little more than the ignorance or hostile conservatism of its author.

Therefore as much emphasis as possible has been given to the writings of the painters themselves. In the case of Picasso and Braque, who maintained an almost complete public silence on their art until well after 1914, it is necessary to turn to the small group of poets and writers who were their intimate friends, in order to discover what were the ideas and preoccupations of the two principal cubists. Of this group the oldest friends of Picasso were Max Jacob, who had known him since 1901, and Apollinaire, whom Picasso met in 1905. Unfortunately Jacob is one of the least reliable of eye witnesses, and invented as much as he remembered, while Apollinaire presents an entire problem in himself of interpretation and demystification, if one attempts to rely on his statements beyond the level of documentation and reportage. André Salmon, however, remains one of the most important eye-witnesses to the cubism of the Montmartre painters, particularly since from 1909 to 1914 he wrote an almost daily column on art under the pseudonym 'La Palette' in a succession of Paris newspapers. Maurice Raynal also frequented Picasso and Gris in Montmartre from about 1910, and his early writings are a very intelligent reaction to the ideas of the cubist milieu.

Beyond the immediate circle of the artists themselves and their closest literary friends, such young poets and critics as Allard, Mercereau, and Olivier-Hourcade wrote on cubism, generally on the occasion of a salon or exhibition; and their comments represent the small fraction of intelligent criticism published in the newspapers and reviews of the period. Their reaction to the public manifestations of cubism are also a valuable reflection of what was current *avant-garde* thinking.

Later attitudes to cubism, whether on the part of the poet Cendrars or the aesthetician-architect collaboration of Ozenfant and Jeanneret, have been included to demonstrate a change in opinion that corresponds to the drawing to a close of the cubist movement; and as such these post-War statements belong to the intellectual history of the style.

The order followed in presenting these texts has been, in general, that of their date of publication; where they were written considerably earlier an attempt has been made to establish the date of composition.

Mécislas Golberg

The Moral Philosophy of Lines

c. 1905

There is in his [Rouveyre's] work a mad onrush of lines, lines answering each other in accordance with the laws of plane surfaces; curves, upper lines and lower lines intersecting, receding or stopping in accordance with the abstract suggestions and unities whose functions they are.

Sometimes this becomes like the whirling of a luminous point, a vertigo of lines; the body turns into an ellipse, cylinder or circle. Some have seen in this method an attempt to pile on effects, but to us it is a rare, persuasive and real manifestation of certain immaterial qualities of things. Yes! There exist circle-men, and others—made in squares. In these works there are visions of heads, shoulders, arms and joints that seem to have escaped from Euclid's immortal book . . .

Precise definition of the planes by the minimum effort of line; a tendency towards polygons and towards curves closer to the ellipse than to the circle; suggestion by means of points or strokes; and, lastly, distribution of light by reference to the inclination of the planes and not in accordance with their convexity or concavity: this is modern design, the product of the modern soul.

From *La Morale des lignes,* Paris, 1908, pp. 32, 49–50

Mécislas Golberg (1868–1907), a figure whose very name is unknown to all but a few specialists in French literature deserves to be remembered as one who prophesied the cubist contribution to twentieth-century art[1]. Golberg had been an anarchist, for which he was imprisoned in both Poland and Germany; he spent his last years in Paris, in extreme poverty, dying of tuberculosis in 1907. But in the first few years of the century he apparently played a role in Parisian literary circles, was a friend of Jules Romains, and attended the gatherings of poets at the Closerie des Lilas presided over by Paul Fort, 'prince of poets'. Of the cubist milieu Apollinaire knew him, as did André Salmon (see Salmon's memoirs, *L'Air de la Butte,* Paris, 1945, pp. 189–95). Golberg had written art criticism, but his sympathies were, according to Salmon, for the generation of Gauguin. Shortly before he died, however, he had a presentiment of what Matisse would accomplish, and, as we see here, of cubism

itself. Golberg had also been associated briefly with the Abbaye de Créteil², an idealistic colony near Paris in which were involved the painter Gleizes, the poet Allard, and Alexandre Mercereau, who became one of the great impresarios of early twentieth-century art (see text 31).

La Morale des Lignes, published posthumously, was written *c.* 1905, when Golberg was already dying of tuberculosis; the drawings of Rouveyre, on which Golberg based the text of his book, show the influence of *Jugendstil* and have the flavour of fashion illustrations. A few show a coincidental similarity to Léger's drawings of 1905–6. But Golberg's thought, as we see in the passages quoted here, envisages an art which was not to develop until after his death; his words contain a curious foreshadowing of cubism.

2

Guillaume Apollinaire

Matisse

1907

Consequently the artistic 'handwriting' of all kinds of styles—those of the hieratic Egyptians, the refined Greeks and the voluptuous Cambodians, the works of the ancient Peruvians, the African statuettes proportioned according to the passions which have inspired them—can interest an artist and help him to develop his personality.

La Phalange, Paris, 15 December 1907, pp. 483–4

Guillaume Apollinaire (1880–1918) is almost as essential to the history of cubism as Picasso himself. Not only was he one of the greatest lyric poets of the twentieth century, but also one of its most extraordinary human beings. Born an illegitimate child in Rome in 1880, son of a young Polish woman in exile and an Italian father, he was educated in Monaco and Nice, spent his youth in intermittent travels across Europe, and in 1902 settled in Paris. He rapidly gained entrance to the literary world of ephemeral reviews, and by 1905 had met Picasso and the poet Max Jacob, both of whom were to be his life-long friends. In addition to his poetry and prose, Apollinaire early showed a gift for writing on art, and from 1905 until the War he was constantly involved in publicizing and defending his artist friends, whether in

newspaper articles or in public lectures. Apollinaire was not an infallible critic, but he had an uncanny instinct for detecting genius and for sensing the revolutionary quality of a new idea or work or art. Thus, although much of what he wrote as a critic cannot be accepted today as true, he was frequently accurate and perceptive to an astounding degree; and in his choice of who or what was significant he seems in retrospect to have been nearly always right. Apollinaire did not by any means limit himself to defending the cubists, as one tends to think today, thanks to the influence of his *Les Peintres Cubistes*. He never lost sight of the genius of Picasso, overtopping all of his contemporaries; yet Apollinaire immediately recognized the importance of Rousseau, of Italian futurism (which he was later to reject), and of Delaunay, as well as most of the other important movements and individuals of his age. He was incredibly learned in an erratic, self-taught fashion; and as a personality his genius for living made him unforgettable. He enlisted when War was declared, was seriously wounded in 1916 and was removed to Paris, where after a partial recovery and a resumption of his literary activities he succumbed to influenza in the epidemic of 1918.

This brief excerpt from Apollinaire's article on Matisse's aesthetic ideas is of historic importance as the first published reference to the new possibilities which African Negro sculpture suggested to occidental artists. Apollinaire here in fact cites African sculpture as only one of several sources from which artists might profitably borrow; his mention of Egyptian and also Cambodian art recalls Gauguin's eclecticism.

Apollinaire interestingly explains the special qualities of negro sculpture as the result of the artist's passions. More significant is his recognition that Negro sculpture incorporates figure proportions which depart widely from the Western classical canon; it was precisely this aspect of African art that interested Picasso, as was noted by André Salmon (see text 20).

A Note on the Discovery of African Sculpture
The discovery of African sculpture by the cubists, as well as their use of it as a guide in the early days of cubism, remains a difficult and unresolved question. Apollinaire noted in 1911 that Picasso had both African and Oceanic sculpture in his studio[1], and Salmon in 1920 mentioned that by 1906 Picasso was an enthusiastic collector of Negro masks[2]. Picasso himself, somewhat unconvincingly, has denied knowing about African sculpture until after he completed *Les Demoiselles d'Avignon*[3]. But by 1907, according to Kahnweiler, Picasso was collecting Oceanic art and owned a figure from the Marquesas Islands[4]. Braque also discovered African sculpture at an early date; as early as 1905 he had bought a Congolese mask near Le Havre in his native Normandy[5]. There were in addition a few collectors of African art, such as André Level[6], even at this early date. But the first real aesthetic interest in African art was among the fauve painters, of whom Braque has already been mentioned. Matisse by

1908 had a collection of 20 Negro sculptures[7], and according to Max Jacob it was through Matisse that Picasso discovered primitive art[8], a story that Gertrude Stein recounts also[9]. Both Stein and Roger Allard[10] mention a second-hand dealer in the Rue de Rennes as one of the places where artists bought African art, a fact later confirmed by Matisse himself[11].

The fauve painter André Derain was also an early collector of African art; Salmon calls him the 'third collector of Negro statues'[12]. Derain knew Picasso by 1906 (see text 22 of this volume), and it is through Derain, according to a somewhat unreliable tradition, that Picasso discovered Negro sculpture. Apollinaire (see text 22) tells of the fauvist Vlaminck's enthusiasm for collecting primitive art and of his showing it to his friend Derain. Vlaminck himself described, but without giving the date, his purchase of two African masks[13]. Goldwater places the Vlaminck-Derain discovery in 1904, on Kahnweiler's verbal authority[14]. One might note that Derain was in military service until the end of 1903[15]. But Vlaminck in a later book places the event in 1905, speaks of three African pieces instead of two as before, and mentions that he sold one of them to Derain; he further asserts that it was in Derain's studio in Montmartre that Picasso and Matisse were first confronted with Negro sculpture[16]. Roland Dorgelès repeats the story of the Derain studio encounter, in a version based on nothing more than his own imagination[17]. Goldwater, whose book is a fundamental and pioneering study in this field, is nevertheless contradictory on the Derain-Picasso question; at one point he states that it was in fact Derain who introduced Picasso to Negro art, in 1906, but elsewhere he says that Picasso 'made an independent discovery of Negro art'[18]. It is quite possible that Picasso did discover African art through friends who had collected it, but it is also very possible that he saw it in the collections of the Trocadéro (now in the Musée de l'Homme)[19]. Salmon in his memoirs says of the Trocadéro that it was there that he, Picasso, Apollinaire, and Max Jacob discovered Negro art[20]. Vlaminck also speaks of visiting the Trocadéro, with Derain, before 1905[21]. Michel Georges-Michel states that Picasso, in the company of Apollinaire, visited an exhibition of Negro sculpture and was overwhelmed by his discovery; but the author does not say when this exhibition took place, or whether it was at the Trocadéro or elsewhere[22]. The first exhibition of African sculpture in a Parisian gallery was not until 1916[23]. So far as the history of cubism is concerned, one may safely say that by 1907 the fauves Vlaminck, Derain, and Matisse knew and appreciated African sculpture, and that Braque and Picasso did also; and that this discovery was often an individual affair on the part of the artist, reinforced by a similar enthusiasm among his painter friends. In Picasso's case, his introduction to African art must have happened no later than early in 1907, and probably some time in 1906. Of the entire cubist movement in painting it was the group in Montmartre around Picasso who showed the greatest interest in African art, and only Picasso was able to make effective and significant use of it in his painting[24].

Guillaume Apollinä

Georges Braque

1908

This is Georges Braque. He leads an admirable life. He strives with passion towards beauty—and he attains it, apparently, without effort.

His compositions have the harmony and fullness we have waited for. His decorative touches show a taste and culture which issue from a sure instinct.

By taking from within himself the elements of the synthesized motifs which he paints, he has become a creator.

He no longer owes anything to his surroundings. His spirit has deliberately challenged the twilight of reality, and here, working itself out in plastic terms, within him and outside him, is a universal rebirth.

He expresses a beauty that is full of tenderness, and the mother-of-pearl of his pictures gives iridescence to our understanding.

A lyricism full of colour, too rarely to be found in this world, fills him with a harmonious enthusiasm, and on his musical instruments St Cecilia herself is the player.

In his valleys the bees of youth hum and plunder, and the happiness of innocence reposes on his civilized terraces.

This painter is angelic. Purer than other men, he pays no attention to anything that, being alien to his art, might cause him suddenly to fall from the paradise he inhabits.

Let no one expect to find here the mysticism of the church-goers, the psychology of the men of letters or the demonstrative logic of the scientists. This painter composes his pictures in absolute devotion to complete newness, complete truth. And if he falls back on human means, on earthly methods, this is to guarantee the reality of his lyricism. His canvases have a unity which renders them inevitable.

To the painter, to the poet, to all artists—and this is what distinguishes them from other men, especially from scientists—each work becomes a new universe with its own laws.

Georges Braque is untiring, and each one of his pictures is a monument to an effort which no one before him had yet attempted.

Braque exhibition catalogue, Galerie Kahnweiler, Paris, 9–28 November 1908

r 1908 the young German art dealer, Daniel-Henry Kahnweiler,
ibit of paintings by Georges Braque in his tiny gallery at 28 Rue
the Madeleine in Paris; it was the first public manifestation of cubist

ract from Apollinaire's introduction to the catalogue is characteristic of
indirect, yet lyrically evocative art criticism. Apollinaire later used parts
of this introduction in *Les Peintres Cubistes*.
The exhibition did not go unnoticed. Texts 4 and 5 of this volume reproduce the
two most interesting critical responses to it.

Galerie Kahnweiler
28, Rue Vignon, 28

Exposition ≋ Georges Braque ≋

Du 9 au 28 Novembre 1908

4

Louis Vauxcelles

Braque at the Galerie Kahnweiler

1908

Monsieur Braque is a very daring young man. The bewildering example of
Picasso and Derain has emboldened him. Perhaps, too, the style of Cézanne
and reminiscences of the static art of the Egyptians have obsessed him dis-
proportionately. He constructs deformed metallic men, terribly simplified.
He despises form, reduces everything, places and figures and houses, to geo-
metrical schemas, to cubes. Let us not make fun of him, since he is honest.
And let us wait.

'Exposition Braque. Chez Kahnweiler, 28 rue Vignon',
Gil Blas, Paris, 14 November 1908

This famous paragraph contains the first published use of the word 'cube' in regard to the new style that would soon bear the name; the term cubism came into general use by 1911. Vauxcelles' review is also noteworthy for its fairness and accuracy on the part of a critic who was by 1912 to become a ferocious adversary of cubism. Louis Vauxcelles (born 1870) was art critic on the highly respected newspaper *Gil Blas* from the 1809s until its dissolution at the outbreak of World War I.

There is a tradition according to which it was Matisse who, as a member of the jury of the 1908 Salon d'Automne, first spoke of 'cubes' on seeing Braque's paintings submitted for inclusion in the Salon; this story is told by Apollinaire in the *Mercure de France* of 16 October 1911, and he repeats it in *Les Peintres Cubistes*. By 1912 this was the accepted version of the origin of the term cubism (see texts 18, 22). However, the 1908 Salon d'Automne opened on 1 October, six weeks before this article on Braque, and Vauxcelles made no mention of the Matisse incident, nor of 'cubes', in his review of the Salon, from which Braque had withdrawn his paintings. It seems therefore plausible to give credit for the name of cubism to Vauxcelles, who also coined the term fauvism.

dessinateur méticuleux, de Renefer, un jeune d'avenir, de Deneram, Zoir, Hochard, Lequeux, de Latenay, Hillekamp, Larsson Suikens, Schwab, Oudart, Lunoir, Montalban, Jonas, Le Meileur, Dallemagne, de Pardieu, Bremond, Bruyer, Brunet-Debaynes, de Beaupré et Beleys.

Ce groupe de xilographes, d'aquafortistes, de lithographes, est vivant, varié, progressera et se complètera. Nous faisons confiance à ses dévoués organisateurs, MM. Edouard André et Peters-Desteract.

EXPOSITION BRAQUE

Chez Kahn Weiler, 28, rue Vignon. — M. Braque est un jeune homme fort audacieux. L'exemple déroutant de Picasso et de Derain l'a enhardi. Peut-être aussi le style de Cézanne et les ressouvenirs de l'art statique des Egyptiens l'obsèdent-ils outre mesure. Il construit des bonshommes métalliques et déformés et qui sont d'une simplification terrible. Il méprise la forme, réduit tout, sites et figures et maisons, à des schémas géométriques à des cubes. Ne le raillons point, puisqu'il est de bonne foi. Et attendons.

Louis Vauxcelles

La Conquête de l'air

AU MANS

Wilbur Wright gagne le prix de la hauteur

Le Mans, 13 novembre. — M. Wilbur Wright a ... a 4 heures pour le prix de hauteur de

But the boldnesses of M. Van Dongen would seem *excessively* 'reasonable' if we compared them with those of M. Georges Braque. But here there is more—not worse or better—than a difference in the degree of boldness; there is something else. M. Van Dongen retains taste, having regard to the accepted belief that forms should in general be 'plausible'; from this last 'trammel' M. Braque has shaken free. Visibly, he proceeds from an *a priori* geometry to which he subjects all his field of vision, and he aims at rendering the whole of nature by the combinations of a small number of absolute forms. Cries of horror have been uttered in front of his figures of women: 'Hideous! monstrous!' This is hasty judgement. Where we think we are justified in looking for a feminine figure, because we have read in the catalogue: *Nude Woman,* the artist has seen simply the geometrical harmonies which convey to him everything in nature; to him, that feminine figure was only a pretext for enclosing them within certain lines, for bringing them into relation according to certain tonalities. In the three rules he also seeks these harmonies and nothing else; nobody is less concerned with psychology than he is, and I think a stone moves him as much as a face. He has created an alphabet of which each letter has a universal acceptance. Before declaring his book of spells hideous, tell me whether you have managed to decipher it, whether you have understood its decorative intentions. These strange signs, which I am unable either to praise or to condemn, remind me of an admirable and useful saying of Carrière's: 'Think of what it would be like as a statue.'

Mercure de France, Paris, 16 December 1908, pp. 736–7

The writer Charles Morice (1861–1919) was an important figure in the post-impressionist movement, serving as a friend and mentor to Gauguin and later publishing a monograph on him, as well as studies on Cézanne, Pissarro, and Carrière. His reactions to Braque's exhibition are thus necessarily somewhat biassed, but he clearly perceived the impersonal intensity with which Braque was proceeding in his analysis of visual form. Furthermore, in calling Braque's art

'*a priori*', Morice recognized that his approach to nature was far more conceptual than that of Cézanne.

6

<div align="right">

Georges Braque

Personal Statement

1908–9

</div>

I couldn't portray a woman in all her natural loveliness ... I haven't the skill. No one has. I must, therefore, create a new sort of beauty, the beauty that appears to me in terms of volume, of line, of mass, of weight, and through that beauty interpret my subjective impression. Nature is a mere pretext for a decorative composition, plus sentiment. It suggests emotion, and I translate that emotion into art. I want to expose the Absolute, and not merely the factitious woman.

<div align="right">

The Architectural Record, New York, May 1910, p. 405

</div>

This short statement is taken from an interview with Braque (1882–1963) by the American Gelett Burgess, which was published in an article called 'The Wild Men of Paris', in the *Architectural Record* of May 1910. From internal evidence the interview can be dated during the autumn or winter of 1908, and as such it is probably the earliest published eye-witness account of cubism, and the earliest recorded statement by a cubist on his art.

In this text Braque refers to his painting the *Grand Nu (Ill. 9)* of early 1908, and to a previous drawing study which he gave to Burgess (p. 54). Braque emphasizes the difference between nature and art, and the necessity for art not to imitate nature but to be a formal equivalent to the artist's visual and emotional experience of nature. The result, says Braque, shall have a new kind of beauty, different from that of nature, and will be closer to the reality of nature than the immediate experience of the senses. Braque is here formulating a Kantian view of reality, which he arrived at by way of Cézanne and the Cézannesque paintings he did during the past summer at L'Estaque. But in speaking of the decorative quality of art and its formal elements of line and mass he is already envisioning the autonomous work of art, and the *tableau-objet* suggested in his paintings of 1909–10 that contain an illusionistic nail *(Ill. 19)*.

The drawing which Burgess reproduced in his article (above) is of great interest in what it tells of Braque's beginnings as a cubist. It represents what was probably Braque's first artistic reaction to Picasso's *Les Demoiselles d'Avignon*, in late 1907; the central female nude in it is a fairly close copy of the lower right hand figure in Picasso's painting. The left hand nude in the drawing is closely related to Braque's subsequent *Grand Nu;* and the composition as a whole shows Braque's attempt to follow Picasso in the interlocking of surface and depth. Elsewhere in Burgess' interview Braque says of this drawing that it was necessary to draw three figures to portray every physical aspect of a woman, just as a house must be drawn in plan, elevation and section. Burgess' article also contains photographs of Braque and Picasso (*Ills. 54 and 57*) and the first published reproduction of *Les Demoiselles d'Avignon.*

Gertrude Stein

Picasso

1909

One whom some were certainly following was one who was completely charming. One whom some were certainly following was one who was charming. One whom some were following was one who was completely charming. One whom some were following was one who was certainly completely charming.

Some were certainly following and were certain that the one they were then following was one working and was one bringing out of himself then something. Some were certainly following and were certain that the one they were then following was one bringing out of himself then something that was coming to be a heavy thing, a solid thing and a complete thing.

One whom some were certainly following was one working and certainly was one bringing something out of himself then and was one who had been all his living had been one having something coming out of him.

Something had been coming out of him, certainly it had been coming out of him, certainly it was something, certainly it had been coming out of him and it had meaning, a charming meaning, a solid meaning, a struggling meaning, a clear meaning.

One whom some were certainly following and some were certainly following him, one whom some were certainly following was one certainly working.

One whom some were certainly following was one having something coming out of him something having meaning and this one was certainly working then.

This one was working and something was coming then, something was coming out of this one then. This one was one and always there was something coming out of this one and always there had been something coming out of this one. This one had never been one not having something coming out of this one. This one had been one whom some were following. This one was one whom some were following. This one was being one whom some were following. This one was one who was working.

This one was one who was working. This one was one being one having something being coming out of him. This one was one going on having something come out of him. This one was one going on working. This one was one whom some were following. This one was one who was working.

Camera Work, New York, August 1912, pp. 29–30

Gertrude Stein (1874–1946) and her brother Leo were among the earliest defenders and collectors of cubism. Leo, himself a painter, soon lost faith in the new art but remained devoted to the work of Matisse, as he relates in his memoirs, *Appreciation. Painting, Poetry and Prose,* New York, 1947. Gertrude stayed on intimate terms with Picasso for most her life; she also championed Juan Gris. Born in Pennsylvania and raised in San Francisco, Gertrude Stein came to Paris in 1903 after having studied with William James and attended Johns Hopkins Medical School. Having independent means, she installed herself in comfortable quarters on the Left Bank, began to collect contemporary art, and devoted herself to writing. She met Picasso in 1906 and soon afterwards sat for his celebrated portrait of her (now in the Metropolitan Museum of Art, New York). Her collection included many of Picasso's finest cubist paintings.

The present extract from her prose portrait of Picasso is one of a large group she did of her friends. Written in 1909, it was published in 1912 in Stieglitz's *Camera Work,* together with her prose portrait of Matisse.

Gertrude's Stein's prose has been termed cubist; in this characteristic early example she uses repetition of a phrase with progressive variations, keeping the syntax as simple as possible yet forcing the reader to follow closely the shifts in the grammatical relationship of one word to another. Both words and phrases become in this way very much like physical objects, and the progressive development of her thought seems to circle, and little by little define, an unapprehended subject behind the opaque surface of the prose. The parallel with 'analytical' cubism is in fact rather striking, if one bears in mind the inherent differences between the two media; as a literary stylist Stein undoubtedly profited and was influenced to a considerable degree by her familiarity with cubist painting.

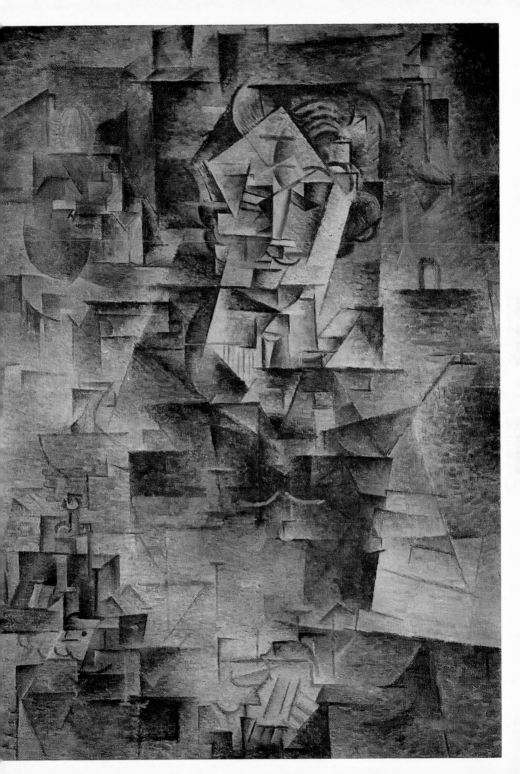

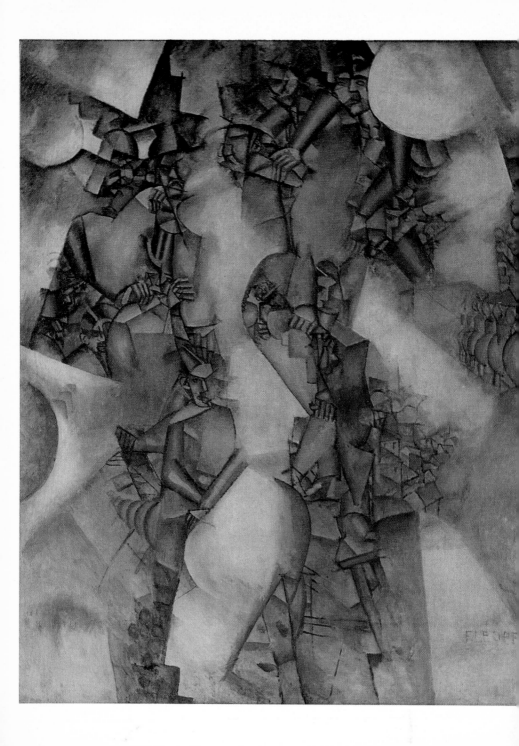

I too could invent a few definitive phrases on the art that must give the structure of things and must not confine itself to catching in a vague tremor the appearance and emotion of the moment, the eye's whim. I could say, too, that true decorative nobility is a necessary consequence of the search for structures made manifest on the canvas by the essential planes discovered by the painter's mind. I could add that, instead of reproducing in their photographic or tactile appearances the movement of the masses in a landscape or the play of the muscles in a body, what matters is to perceive their laws, and that only the figures of geometry can yield this without lying. I could say that the forms created by M. Picasso are not abstract schemas, except for those whose interest is in anecdotes, and that these forms alone have the power and the right to transfer on to the plane of a picture the sensations and reflections which we experience with the passage of time. I could say that, while it innovates, the painting of M. Picasso is essentially traditional, that it is linked both with the great traditions of instinct and the great traditions of the mind. I could invoke the example of the savages of Oceania—not more than is appropriate—and that of Cézanne, for whom nature was sphere, cone and cylinder, and who said so . . .

The relationship between the geometrical forms created by the mind and the forms of nature has preoccupied the philosophers. And if geometry owes its certainty to the suggestions of our senses, why not reverse the process and go from geometry to nature? Or again, why not, starting from nature, arrive at a mathematics accessible to the senses, a mathematics that would be art?

These pictures borrow nothing from geometry, and if their sources of inspiration are diverse M. Picasso should not be reproached for that. Like all artists at their beginnings, he has sometimes, in seeking for himself, found others. These pleasing and ingenious works lead M. Picasso finally to this

fruit-dish and glass, which display their structure, substructure and super-structure, and whose harmony, simplified as it is, is made up of the yellows and greens of certain Cézannes; and to this landscape of cubic roofs, cubic chimneys and trees that are like the chimneys but decorated at the top with palms.

'Exposition Picasso', *La Phalange*, Paris, June 1910, pp. 728-30

Léon Werth (born 1879), writer and art critic, published a monograph on Bonnard, and also a collection of essays entitled *Quelques Peintres* (Paris 1923), containing a chapter on cubism. The article quoted here is a review of a Picasso exhibition in Paris, cited by Werth as at the Galerie Notre-Dame des Champs, in May 1910. Picasso exhibited rarely in Paris, and by 1910 almost exclusively at Kahnweiler's. Hardly any documentation on this exhibition is known save Werth's article, although there was a Galerie Notre-Dame des Champs at number 73 of the street of the same name.

Werth's essay is remarkable for its concise and accurate summary of many of the principal aesthetic problems in cubism, particularly in view of its very early date, which makes it probably the first serious effort to deal with the subject in a reasoned manner. Werth contrasts the impressionists' interest in fugitive light effects with the search for an intellectual structure of reality in the art of Picasso, thus amplifying Braque's earlier statement (see text 6); while admitting, as did Braque, the decorative effect of this art, he denies that it is abstract and insists, on the contrary, that it is the only way to depict sensory perceptions accumulated over a passage of time—one of the most discussed points in subsequent criticism of cubism. He is furthermore one of the first to see Picasso's debt not only to Cézanne but to primitive art as well. Werth finally raises the question of induction versus deduction in the relation of cubism to nature, a problem which was later to be given its final resolution by Juan Gris (see text 43).

Jean Metzinger

Note on Painting

1910

Is there any of the most modern works in painting and sculpture that does not secretly obey the Greek rhythm?

Nothing, from the Primitives to Cézanne, breaks decisively with the chain of variations contained in the Hellenic theme. I see today the rebels of yesterday mechanically prostrating themselves before the bas-relief at Eleusis. Gothics, Romantics, Impressionists, the old measure has triumphed over your praiseworthy departures from rhythm; and yet your labours have not been in vain—they have established in us the foreknowledge of a new and different rhythm.

For us the Greeks invented the human form; we must reinvent it for others.

We are not concerned, here, with a partial 'movement' dealing in accepted freedoms (those of interpretation, transposition, etc: half-measures!), but with a fundamental liberation.

Already there are arising men of courage who know what they are doing— here are painters: Picasso, Braque, Delaunay, Le Fauconnier. Wholly and only painters, they do not illuminate concepts in the manner of the 'neo-primitives'; they are too enlightened to believe in the stability of any system, even one called classical art, and at the same time they recognize in the most novel of their own creations the triumph of desires that are centuries old. Their reason holds the balance between the pursuit of the transient and the mania for the eternal. While condemning the absurdity of the theoreticians of 'emotion', they take good care not to drag painting towards purely decorative speculation. When, in order to defeat the deceptiveness of vision, they momentarily impose their domination on the external world, their understanding remains untouched by Hegelian superstition.

It is useless to paint where it is possible to describe.

Fortified with this thought, Picasso unveils to us the very face of painting.

Rejecting every ornamental, anecdotal or symbolic intention, he achieves a painterly purity hitherto unknown. I am aware of no paintings from the past, even the finest, that belong to painting as clearly as his.

Picasso does not deny the object, he illuminates it with his intelligence and feeling. With visual perceptions he combines tactile perceptions. He tests, understands, organizes: the picture is not to be a transposition or a diagram, in it we are to contemplate the sensible and living equivalent of an idea, the total image. Thesis, antithesis, synthesis—the old formula undergoes an energetic inter-inversion of its first two terms: Picasso confesses himself a realist. Cézanne showed us forms living in the reality of light, Picasso brings us a material account of their real life in the mind—he lays out a free, mobile perspective, from which that ingenious mathematician Maurice Princet has deduced a whole geometry.

The fine shades neutralize one another round ardent constructions. Picasso disdains the often brutal technique of the so-called colourists, and brings the seven colours back to the primordial unity of white.

The abandonment of the burdensome inheritance of dogma; the displacing, again and again, of the poles of habit; the lyrical negation of axioms; the clever mixing, again and again, of the successive and the simultaneous: Georges Braque knows thoroughly the great natural laws that warrant these liberties.

Whether it be a face or a fruit he is painting, the total image radiates in time; the picture is no longer a dead portion of space. A main volume is physiologically born of concurrent masses. And this miraculous dynamic process has a fluid counterpoint in a colour-scheme dependent on the ineluctable two-fold principle of warm and cold tones.

Braque, joyfully fashioning new plastic signs, commits not a single fault of taste. Let us not be misled by the word 'new'; without detracting from this painter's boldness in innovation, I can compare him to Chardin and Lancret: I can link the daring grace of his art with the genius of our race . . .

'Note sur la peinture', *Pan*, Paris, October–November 1910, pp. 649–51

Jean Metzinger (1883–1956) is remembered today for having written, in collaboration with Albert Gleizes, the first book on cubism, *Du Cubisme* (Paris 1912; see text 27). In fact he played a very important role in winning public recognition for the new art. Metzinger was one of the principal organizers of the first large public manifestation of cubism, Room 41, of the Salon des Indépendants in the spring of 1911 (see text 48). And, since Picasso and Braque rarely took part in Parisian exhibitions, Metzinger, exhibiting prominently in all the pre-War salons, became in the eyes of the public the chief of the new school[1].

He began his career as much a writer as a painter and published poetry in small Parisian reviews before 1910. As a painter he passed through a symbolist period, as did so many artists of his generation, before turning to cubism in 1910. He was one of the very first followers of Picasso and Braque; already in 1911 Salmon names him third among cubists after the two leaders[2]. Metzinger lived in Montmartre only a few streets away from Picasso from 1908 to 1912; as this article reveals, the two knew each other surely by 1910, and very probably by 1909. When Picasso moved to Montparnasse in the autumn of 1912, Metzinger also left Montmartre and settled on the Left Bank, in a section which was significantly half way between Montparnasse and Passy. For there was by 1912 an artistic group in Passy and nearby Puteaux which included Gleizes and the Duchamp brothers and which was to develop its own version of cubism; by 1912 Metzinger was already closely associated with this group[3].

Metzinger's early acquaintance with the leaders of cubism, and the fact that he was a painter as well as a writer, give his articles of 1910 and 1911 the special value of being an intelligent reflection of the ideas circulating in the group around Picasso. Here he emphasizes the non-literary yet anti-decorative, basically realistic intentions of the cubists, speaks of a new kind of perspective, and mentions tentatively the role of duration in time already discussed by Werth (see text 8).

Metzinger also mentions in passing Maurice Princet, a figure who appears here for the first, but not the last, time in the literature of cubism. Princet was an actuary employed by an insurance company, who lived in Montmartre at 90 Rue Lepic (Picasso-Stein correspondence, collection Yale University). His wife left him to marry André Derain[4]. Princet frequented Picasso's atelier in the Bateau-Lavoir[5] and was a friend of many other painters in Montmartre, and of Marcel Duchamp in Puteaux. By 1925 André Warnod was ready to name him as among the creators of cubism[6], as do Alice Halicka[7] and many other writers in their memoirs. But in Princet's introduction to an exhibition of Delaunay's paintings[8] no such profound theoretical gifts emerge, and one must agree with Kahnweiler that he had no real influence on the thinking of the cubists[9].

At the Paris Salon d'Automne

1910

Metzinger's nude and his landscape are governed by one and the same striving for fragmentary synthesis. None of the clichés of the aesthetic vocabulary fits the art of this disconcerting painter. Let us consider the elements of his nude: a woman, a clock, an arm-chair, a pedestal table, a vase with flowers... such at least is the extent of my own list. The head, whose expression is very noble, is treated formally, and the artist seems to be aiming at an integral application of his law. The truth is that a picture by Metzinger sets out to sum up the whole plastic matter of one aspect and nothing else. Thus is born, at the antithesis of impressionism, an art which, with little concern for copying some incidental cosmic episode, offers to the viewer's intelligence, in their full painterly quality, the elements of a synthesis situated in the passage of time. The analytical relationships of the objects and the details of their subordination one to another are henceforward of little importance, since they are left out of the picture as painted. They appear later, subjectively, in the picture as *thought* by each individual who sees it.

'Au Salon d'Automne de Paris', *L'Art Libre*, Lyons, November 1910, p. 442

Roger Allard (1885–1961), poet, essayist and critic, was among the most energetic early supporters of cubism. Born in Paris, he spent part of his youth in Lille, where he published his first volume of poetry in 1902. Allard was briefly associated with the Abbaye de Créteil in 1907–8, where he probably met Alexandre Mercereau and Albert Gleizes; Gleizes illustrated a volume of Allard's poetry published in 1911. Allard continued to defend the cubists until the War; in 1919 he edited the review *Nouveau Spectateur,* and in the 1920s he wrote monographs on several contemporary painters, notably Roger de la Fresnaye.

The present text is taken from Allard's first article dealing with cubism. The painting by Metzinger which he discusses is illustrated in this volume *(Ill. 35);* so far as cubism is concerned, Metzinger's was the most advanced work exhibited at this salon. Allard does not seem to have heard of Picasso or Braque at this time, although by the following spring he had become aware of their importance[1]. He

repeats and amplifies the idea that cubism derives from a synthesis of experience over a period of time; but he adds a suggestion that the viewer can reconstitute the fragmented elements in the painting and thus arrive at a full comprehension of the original object.

Allard here is the first writer to use the term 'analytical' in a sense similar to that in which critics today apply it to the cubism of 1909–12. Allard also curiously speaks of 'synthesis', but in reference to a Bergsonian assimilation of sequential experience. It was not until 1913 that the word 'synthesis' was used to describe the morphological processes underlying 1913–25 cubism (see text 26). Both terms came into general use following Kahnweiler's example in his *Weg zum Kubismus*, Munich 1920 (written 1915–18, see text 41).

11 Roger Allard

On Certain Painters

1911

No interested and impartial observer could doubt that, of all arts, painting now occupies the most advanced point on the ideal curve of evolution. Indeed, if we grant—as we must—that the noblest achievements of the visual arts are the product of logic and conscious thought, it follows that almost everywhere masters whose artistic canons are short-lived but who are destined to live on by virtue of their genius, have forestalled, by the glamour of a few patches of colour, the meditations of the philosophers and the Word of the poets ...

At the 1910 Salon d'Automne a landscape by Le Fauconnier, another by Albert Gleizes and one by Metzinger expressed, in their different ways, something like a postulation for an artistic renaissance—an idea that could certainly never be suggested by the tendencies of those contemporary painters who, in a childishly bellicose metaphor, are given the title *avant-garde*.

On these three artists, and on others to be mentioned below, the influence of Cézanne is manifest. But this fact once noted, it is important to guard against misunderstanding. Cézanne rediscovered a certain number of painterly truths—or, better, a single truth with many aspects ... The artists

in question . . . have managed, unlike so many others, . . . to find in the work of Cézanne a lesson and an encouragement.

I could without injustice omit to mention Picasso and Braque in discussing influences; and I would have done so, had not Metzinger, with his delicately literary and highly impressionable nature, confessed not long ago to having looked at the pictures of these artists (who indeed are estimable) with other eyes than those of objective criticism. Picasso's violent personality is resolutely outside the French tradition, and the painters with whom I am concerned have instinctively felt this.

The lingering adherents of individualism will be greatly shocked—no bad thing—to see a *group* firmly constituting itself, under the domination of a shared ideal, which is this: *To react with violence against the notation of the instant, the insidious anecdotalism and all the other surrogates that pass under the name of impressionism. Not to content themselves with making clever variations on fashionable externals, but to overhaul the arsenal of painting in order to exclude from it the bric-à-brac of false literature and pseudoclassicism.*

The ambition of these artists is to express themselves with the means proper to painters. Between their sensibility and that of the viewer they claim to allow no intermediaries but paint and canvas. Courageously they set out to destroy the contrived screens that are indispensable to all the adepts of the *direct appeal* . . .

. . . But of course this effort is above all an exploration of possibilities. And so I am led to a natural conclusion. The tendencies of which I have just given an all too summary indication are signs, in short, of a unanimous determination: to paint *pictures*. And by pictures I mean composed, constructed, ordered works, not notes and dashed-off sketches whose false spontaneity serves as a bluff to mask their basic nullity.

'Sur quelques peintres', *Les Marches du Sud-Ouest,* Paris, June 1911, pp. 57–64

In this, his third article concerning the cubists, and his second on the 1911 Salon des Indépendants, Allard is more insistent than ever on the debt of the young *avant-garde* to Cézanne, as indeed the work of La Fresnaye, Gleizes, and Le Fauconnier at this Salon revealed.

Now aware of Picasso and Braque, Allard senses the expressive power in Picasso and the distance which separates him from the young French painters in this Salon, who, consciously or not, were following him. The most striking idea Allard puts forth here is in his conclusion, where he comes close to announcing the doctrine of

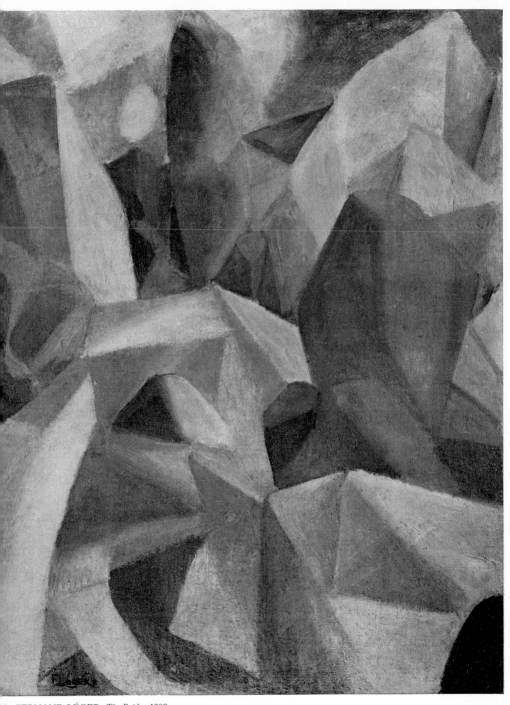

6 FERNAND LÉGER, *The Bridge*, 1909

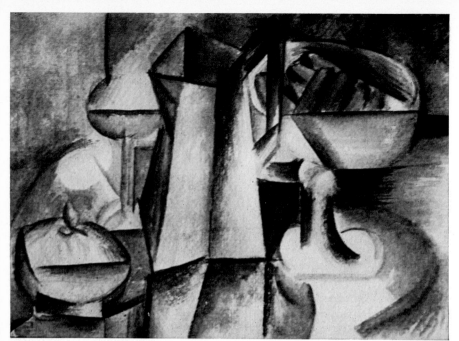

17 PABLO PICASSO, *Still-life*, spring 1910

18 FERNAND LÉGER, *Nudes in the Forest*, 1909–10

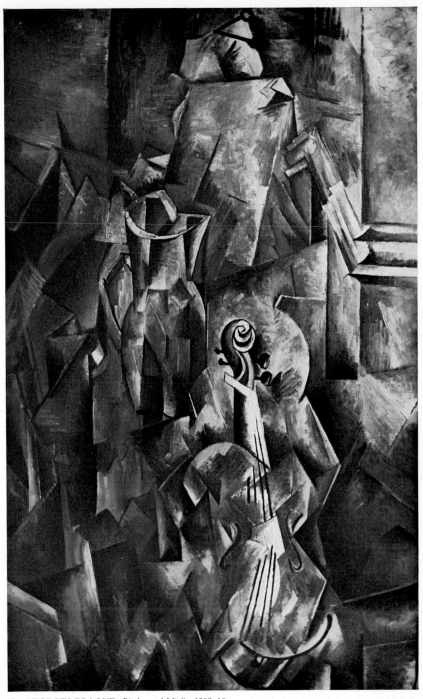

19 GEORGES BRAQUE, *Pitcher and Violin*, 1909–10

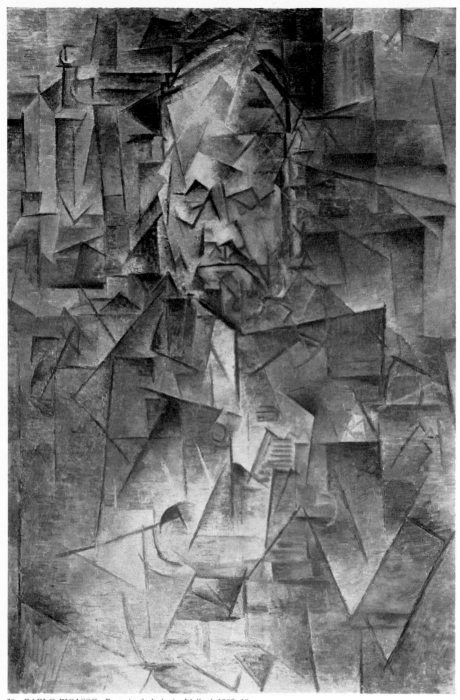

20 PABLO PICASSO, *Portrait of Ambroise Vollard*, 1909–10

21 PAUL CÉZANNE, *Portrait of Ambroise Vollard*, 1899

22 Ambroise Vollard

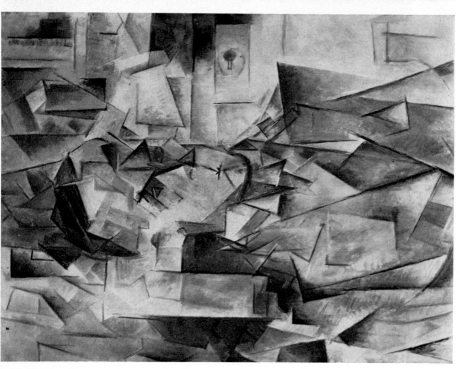

23 PABLO PICASSO, *Portrait of Wilhelm Uhde*, spring 1910

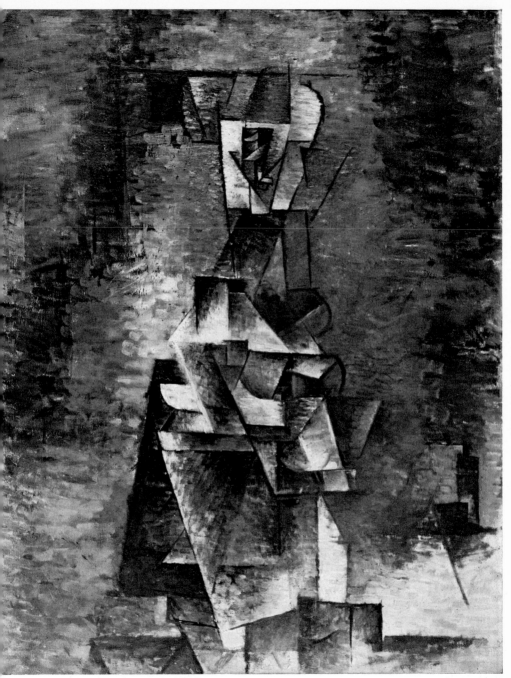

PABLO PICASSO, *Female Nude*, Cadaqués summer 1910

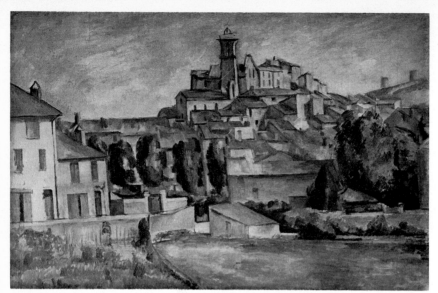

26 PAUL CÉZANNE, *Gardanne*, 1885–6

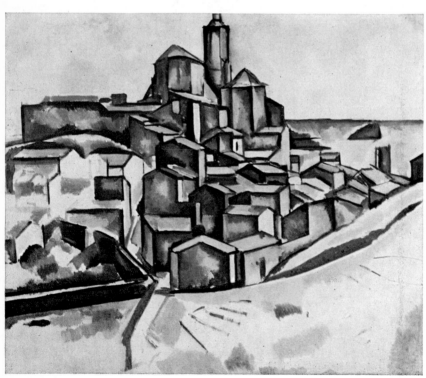

27 ANDRÉ DERAIN, *Cadaquès*, summer 1910

the painting as autonomous object; an idea which was to be stated most explicitly in Gleizes' and Metzinger's *Du Cubisme* of 1912 (see text 23).

(see text 23)

12 Michel Puy

 The Salon des Indépendants

 1911

Cubism is, as it were, the culmination of the work of simplification undertaken by Cézanne and continued by Matisse, then by Derain ... It is said to have begun with the work of M. Picasso, but as this painter rarely exhibits his work, its evolution has been observed chiefly in M. Braque. Cubism seems to be a system with a scientific foundation, which enables the artist to support his effort on reliable data. In it the theoretical basis of design is the regular parallelepiped known as a cube; in practice all bodies are reduced to polyhedra, whose edges and surfaces the artist strives to bring out and place rightly.

They are hungry for objective truth ...

The cubists have exiled from their domain all those figures usually borrowed by painters from fable, mythology or history: they have nothing but disdain for the delight which their colleagues attempt to enclose in a nude body; they aspire to the essence, to the pure idea ... Their wish has been to reduce the universe to a conjunction of plane-faceted solids.

By reducing the beauty of a landscape or the grace of a woman to precise geometrical bodies, one is led to give more vigorous definition to the planes, to establish the structure better, and to penetrate more deeply into the relations between form and colour.

Revolutionary as cubism may seem, people have already gone a stage further. M. Léger and Mlle Gerebtzoff no longer even attempt to connect the various geometrical elements of which they compose a body,—fragments of spheres, arcs of circles, prisms ...

'Les Indépendants', *Les Marges,* Paris, July 1911, pp. 27–30

Michel Puy (born 1878) was the regular art critic for *Les Marges,* an established and respected review to which Apollinaire contributed from time to time. In 1910 Puy had written a long essay, 'Le dernier état de la peinture française', for the *Mercure de France*[1], in which he singled out Braque and Metzinger for special discussion. In this review of the 1911 Indépendants he voices the attitude of the informed and sympathetic general public of the time, for whom cubism meant above all Metzinger, Gleizes, and Le Fauconnier; Braque had last exhibited in Paris at the Indépendants of 1909. For this general public cubism[2] was primarily a mysterious and arbitrary geometry which the artists imposed on nature; yet Puy sees, as so many of his contemporaries did not, that cubism was basically a realistic art. He is also one of the first to notice, if only in passing, the problem which colour presented to the cubists. And he rightly senses that Léger's art is a distinct tendency within the movement. In this Salon Léger exhibited his *Nudes in the Forest (Ill. 18)*[3].

13

<div style="text-align:right">

Jean Metzinger

Cubism and Tradition

1911

</div>

Today, thanks to a few painters, painting is emerging naked and pure.

United by an exemplary discipline, these painters obey no slogan, are slaves to no formula. Their discipline consists in their common determination never to infringe the fundamental laws of Art.

Because they use the simplest, most complete and most logical forms, they have been dubbed 'cubists'. Because they labour to elicit new plastic signs from these forms, they are accused of betraying tradition.

... The men known as cubists are trying to imitate the masters, endeavouring to fashion new types (to the word *new* I attach the idea of *difference,* and exclude from it the idea of superiority or progress). Already they have uprooted the prejudice that commanded the painter to remain motionless in front of the object, at a fixed distance from it, and to catch on the canvas no more than a retinal photograph more or less modified by 'personal feeling'. They have allowed themselves to move round the object, in order to give, under the control of intelligence, a concrete representation of it, made up of

several successive aspects. Formerly a picture took possession of space, now it reigns also in time. In painting, any daring is legitimate that tends to augment the picture's power as painting. To draw, in a portrait, the eyes full face, the nose in semi-profile, and to select the mouth so as to reveal its profile, might very well—provided the craftsman had some tact—prodigiously heighten the likeness and at the same time, at a crossroads in the history of art, show us the right road.

The technique of the 'cubists' is clear and rational: it excludes school tricks, facile graces and the stylizations so much in favour nowadays. These are painters aware of the miracle that is achieved when the surface of a picture produces Space, and as soon as line threatens to take on a descriptive or decorative importance they break it. Elements of light and shade, so distributed that the one engenders the others, justify these breaks in plastic terms; the arrangement of the breaks creates the Rhythm.

'Cubisme et Tradition', *Paris-Journal*, 16 August 1911

In this important but little-known article Metzinger expounds what was soon to become critical dogma: the idea that a cubist painting contains the implication of movement and that in addition to space it expresses time. He also sees the need to reconcile the conflict between the new way of representing reality and the necessity to create an aesthetic order, to 'create the Rhythm', as he says, within the painting.

This article played an interesting role in the history of cubism. At the end of 1911 Alexandre Mercereau was only one of the first among many defenders of cubism to declare that Henri Bergson had given his approval to cubism[1]. André Salmon, in announcing the exhibition of the '*Section d'Or*', intimated that Bergson would write the preface to the catalogue, which Bergson in fact did not do[2]. Bergson would have been a powerful ally indeed, for by 1911 he had become a national sage in the eyes of his fellow Frenchmen. But if one examines the source of these rumours, an interview with Bergson published in *L'Intransigeant*[3], one finds that Bergson admits never to have seen the works of the cubists; on being shown a copy of this article by Metzinger, Bergson replied that he did not understand a single word of it[4]! Yet the legend persisted for years that Bergson approved of the cubists, even after a second interview, in 1913, in which he denied either knowledge or approbation of cubism[5].

He has left his trapper's cabin, perched on the Butte, for a more academic studio not far from the Cirque Médrano. The setting is picturesque and surprising. On every side strange wooden grimaces are to be seen: a superb selection of African and Polynesian sculpture. Firmly, before showing you his own works, Picasso presents these primitive marvels for your admiration. Welcoming and quizzical, dressed like an aviator, indifferent to praise as he is to criticism, at length Picasso shows the much sought-after canvases which he has the coquetry not to exhibit at any *salon*. Here, dating back twelve years now, are vagabonds in striped clothes—the influence of Toulouse-Lautrec is evident in these; here are the beggars, the cripples and the suppliant women, all painted in blue and white, harrowing, tragic and reminding one of the Greeks; here are the harlequins, the acrobats, the mystical mountebanks, which revealed the true personality of Picasso. And now at length come the latest works, which some people seem to find less directly moving. The astonishment of some art-lovers gives Picasso great pleasure, and he does not contradict them. The most he does is to deny being the father of cubism, which he merely suggested. To a younger man, who asks him whether one should draw feet round or square, Picasso replies with much authority: 'There are no feet in nature!' The young man fled, and is still running, to the great joy of his mystifier.

Paris-Journal, 21 September 1911

André Salmon (1881–1969), poet and critic, is one of the most valuable eye witnesses of the cubist era. He frequented Montmartre from 1903, met Picasso in 1904 and soon became an intimate of the circle which included Apollinaire, Picasso, and Max Jacob. Salmon stayed in Montmartre, living in the Bateau-Lavoir, 'the trapper's cabin' (a strange old wooden structure where Picasso had his studio) until

1909 when he married and moved to Montparnasse. However he remained a close friend of those in the Montmartre group around Picasso even after his move to the Left Bank.

A prolific writer, Salmon has since 1945 published three volumes of memoirs, which though not always reliable contain an enormous amount of detailed information on art and artists in Paris before 1914. He has also published four books dealing specifically with the art of this period: *La Jeune Peinture Française*, Paris, 1912 (see text 18); *La Jeune Sculpture Française*, Paris, 1919 (see text 33); *L'Art Vivant*, Paris, 1920 and *Propos d'Atelier*, Paris, 1922; as well as monographs on Cézanne, Derain, and the Douanier Rousseau, and a novel, *La Négresse du Sacré-Cœur* (Paris, 1920), which is a fictionalized account of life in the circle around Picasso in Montmartre. Salmon also wrote daily critical articles on literature and art, often under the pseudonym 'La Palette', for Paris newspapers from 1909 to 1914[1], thus furnishing an invaluable record of the cultural life of this period from the point of view of a leading member of the young *avant-garde*.

This article on Picasso is one of a series Salmon wrote in late 1911 on the cubist painters; Picasso had already moved from the Bateau-Lavoir to a new studio on the Boulevard de Clichy (see *Ill. 55*) in the autumn of 1909. The remark which Salmon quotes is typical of Picasso's ironic humour, and is only one of the first of many cryptic aphorisms which have since then become attached to his name.

The Médrano circus in Montmartre played a large part in the lives of the cubists; they would go in convivial groups, preferring it to the theatre. Picasso made numerous paintings during his blue and pink periods of clowns, harlequins, and other circus subjects, and the harlequin recurs frequently in the cubist painting and sculpture of Picasso, Gris, and Lipchitz as late as the 1920s. This interest may have been, as is often said, a sign of sympathy for the alienated and marginal lives of the circus performers, so similar to the artist's own plight. But the wit, make-believe, and kaleidoscopic artifice of the circus world had a special fascination for the cubists; for as Salmon himself said, speaking of his old friends in Montmartre, 'We invented an artificial world with countless jokes, rites, and expressions that were quite unintelligible to others.'[2]

The Signs of Renewal in Painting

1912

To live with the unfolding of a style in painting, right to its disintegration and death (survived, then, by the pseudo-style of its decadents) provides the mind with the best possible school in which to study the laws that govern evolution in the arts.

Now that impressionism belongs to the past, we are able to lay bare its historical relation not only—as has already been done so often—to the period that immediately preceded it, but also to the period following it: the art of our own day.

The indisputable analogies between impressionism, especially in its later period, and naturalism, surely constitute the deeper reason why impressionism failed to lead to the formation of a great style. In other ages great periods of art produced schools, and the forms of major innovators created firm styles. But the narrow limits of the impressionist principle gave scope for only three or four great artists to unfold their personality to the full.

Surprising reactions followed, such as neo-impressionism, essentially a concealed reactionary movement, which finally declined into preciosity. Even the legacy of Cezanne was picked to pieces, and his hard-won discoveries made light of; although in fact Cezanne's art is the arsenal from which modern painting drew weapons for the primary struggle to drive naturalism, false literature and pseudo-classicism from the field. Now the battle concerns other things.

To present this prehistory of cubism, down to the moment when it was actually formulated in works of art, seems to us important as a means of countering the trivial and misleading accounts current in the pages of periodicals and newspapers, which help to give cubism a bad name.

What is cubism? First and foremost the conscious determination to re-establish in painting the knowledge of mass, volume and weight.

In place of the impressionist illusion of space, which is founded on aerial perspective and naturalistic colour, cubism gives us plain, abstract forms in precise relation and proportion to each other. Thus the first postulate of cubism is the ordering of things—and this means not naturalistic things but

abstract forms. Cubism feels space as a complex of lines, units of space, quadratic and cubic equations and ratios.

The artist's problem is to bring some order into this mathematical chaos by bringing out its latent rhythm.

In this way of looking at things, every image of the world is the point of convergence of many conflicting forces. The subject of the picture, the external object, is merely a pretext: the *subject* of the equation. This has always been true; but for many centuries this basic truth lay in a deep obscurity from which today modern art is seeking to rescue it.

Is it not remarkable how hard it is for our present-day critics and art-lovers to admit that painters and sculptors are justified in transmuting the vision of nature into an exact and abstract world of forms, when in other domains—in music and poetry—they already take a similar abstraction for granted? Camille Mauclair, for instance, sees in cubism nothing but a Scholastic sophistry, leading to the sterilization of creative thought. He forgets that the pleasure of a work of art involves two creative beings: one is the artist who makes it, the main animator and inventor, and the other is the viewer, whose mind finds the way back to the natural object. The further both of them travel, to meet at one and the same goal, the more creatively both are working.

Everyone who carefully analyses his own experiences of aesthetic pleasure will feel the truth of this.

If some deny *a priori* the possibility of any scientific study of aesthetic experiences, one may reply by asking them whether order is the same thing as disorder. Surely the human mind may—and must—seek definitions, distinctions and theories in this field as in any other? This is not to deny that all values in the world, and not least aesthetic ones, are relative and variable.

It remains to say a few words about the expressive forms and means which have so far come into use within the wide system of cubism at this early stage in its development.

Some artists have dematerialized their image of the world by setting out to divide it into its various parts; others have sought a system for trans-forming the objects in a picture into abstract cubist forms and formulae, into weights and masses.

Then appeared the ideas of the futurists (cinematism), which set up in place of the old European laws of perspective a new, and as it were *centrifugal,* perspective which no longer assigns to the spectator one fixed position

but, so to speak, leads him round the object; some artists experimented with interpenetrating objects, to intensify the expression of movement.

Of course none of these ideas, whether separate or combined, establishes a canon for artistic creation: on the contrary, their alarming fertility is a danger-sign of decadence. On such a foundation no sound aesthetic edifice can be constructed. We have the same movement in literature: a fervent urge towards synthesis leads to arbitrary theoretical arrangements which drive poetry to the picturesque, the threshold, precisely, of the anecdotalism which the new artist shuns: a vicious circle. Thus futurism seems to us a tumour on the healthy stem of art.

While we proclaim the rights of the new, constructive movement in art, let us turn to the defence of the good cause against that romantic view which would forbid the creative artist all thought and speculation and would see him simply as an inspired dreamer whose left hand knoweth not what his right hand doeth.

The first and greatest privilege of an artist is to be a conscious builder of his own ideas.

How many highly gifted artists of our day have squandered their resources through disrespect for their own right to work consciously. Those with the greatest integrity have recognised the iron necessity of new aesthetic laws and of knowledge concerning these laws.

Cubism is not some new phantasmagoria of the so-called 'wild men', not a scalp dance about the altars of 'official art', but the honourable cry for a new discipline.

This makes nonsense of the old quarrel over who discovered it first. Without question Derain, Braque and Picasso made the first formal experiments in the direction of cubism, and these were later followed by more systematic work by other artists. We owe it to the intelligence and energy of those three to place their names at the head of this objective account, which is concerned not so much to evaluate talents as simply to exhibit the curve of the development. This curve has taken on a very precise direction since the 1910 Salon d'Automne. Then the 1911 Salon des Indépendants and Salon d'Automne brought the whole movement into focus and made it possible to speak of a 'renewal' in painting. The established critics, who had hitherto reserved judgement, now condemned cubism in violent and offensive terms. They had found it possible to tolerate the gambolling of a few cubs; but a serious movement, which constituted a threat to the very existence of traditional art, was something else entirely. Nor did the new

painters attempt to brush the sand from their tired old eyes so that they could see these athletic works more clearly; and this infuriated them all the more. Utterly perplexed by the incalculable, pulsing life of the new movement, the critics tried to dismiss it as an attempt to pull the wool over the eyes of the public. In this they were unsuccessful. The new painters numbered within their ranks talents too remarkable to be thus easily dismissed. I am thinking of Le Fauconnier, whose finely structured spatial compositions express all the noble reserve of his northern temperament; Metzinger; Albert Gleizes, who compels his rich world of imagination into logical structures; Fernand Léger, who is always seeking new ways of relating masses to each other; and lastly Robert Delaunay, a true painter who has gone further than anyone else in transcending the surface arabesque and revealing the rhythm of the limitless depths.

<div style="text-align:right">

'Die Kennzeichen der Erneuerung in der Malerei',
Der Blaue Reiter, Munich, 1912 (2nd ed. 1914), pp. 35–40

</div>

In this article Allard goes to considerable lengths to provide a historical background for his discussion of cubism. He resorts to surprising mathematical metaphors to explain what had become by 1912 the very complex appearance of cubist paintings. Yet he recognizes that cubism is not mathematics, and he feels, as did Metzinger (see text 13), that the artist must give an aesthetic order to his complex method.

Such an aesthetic ordering Allard finds to have been always true of art, concealed perhaps during the recent history of painting, but reappearing now as it had already in music and poetry. This he voices in a novel way the spreading idea of the *tableau-objet*, the autonomous work of art.

The Tendency of Contemporary Painting

1912

The ruling preoccupation of the [new] artists is with cutting into the essential TRUTH of the thing they wish to represent, and not merely *the external and passing aspect* of this truth . . .

All their works should carry, as their motto, a phrase of Rémy de Gourmont's: 'Everything that I think is real. The only reality is thought. The outside is relative. Everything is transitory except thought.'

This is the common factor in all the dreams of these impassioned creators; this is their ruling preoccupation.

The external appearance of things is transitory, fugitive and RELATIVE. Therefore one must search out THE TRUTH, and cease to make sacrifices to the pretty effects of perspective or of half-light, effects gradated in the manner of Carrière. One must seek the *truth* and stop making sacrifices to the banal illusions of optics.

So art is free! Provided that it renders the truth more plastically . . .

You all doubtless know Schopenhauer's phrase summing up the idealism of Kant:

'The greatest service Kant ever rendered is the distinction between the phenomenon and the thing in itself, between that which appears and that which is; and he has shown that between the thing and us there is always the intelligence.'

The painter, when he has to draw a round cup, knows very well that the opening of the cup is a circle. When he draws an ellipse, therefore, he is not sincere, he is making a concession to the lies of optics and perspective, he is telling a deliberate lie. Gleizes, on the contrary, will try to show things in their sensible truth.

. . . If Gleizes—and I could say the same of Lhote—had to render a book presented horizontally, he would show also one face of its cover and one of its sides. He would represent it to us in its three dimensions: length, height and breadth, as the Bibles are represented on the pediments of Protestant churches . . .

'La Tendance de la peinture contemporaine (notes pour une causerie sur l'art contemporain)', *Revue de France et des Pays français*, Paris, February 1912, pp. 35–41.

Olivier-Hourcade (1892–1914), a fervent defender of cubism, is a figure about whom little is known; he suddenly emerged as an active critic in 1912 and then soon disappeared from the artistic world. He was a poet, born in Bordeaux, where he organised an art theatre in which experimental poetry and drama were presented. In addition to contributing to several newspapers and small Parisian reviews, he founded *Les Marches du Sud-Ouest* and continued as editor when it became *La Revue de France et des Pays Français*[1]. He also gave at least two public lectures on cubism, one of which was the basis of this article. He gave the second as a substitute for Apollinaire on 19 October 1912[2]. He was killed early in World War I.

Although Hourcade shows more enthusiasm than understanding in this text, he is nevertheless the first critic to mention Kantian idealism in discussing cubism; Raynal and especially Kahnweiler were later to draw heavily on Kant in their critical essays[3]. Hourcade's description of Gleizes' method is ironically a rather accurate reflection of this artist's generally pedestrian and uninspired version of 'analytical' cubism.

17 Jacques Rivière

 Present Tendencies in Painting

 1912

One must, I think guard against misinterpreting the uneasiness and the hesitant conviction shown by the cubists. I do not see it as a sign that their vocation is arbitrary, nor do I conclude from it that their inner torments are all in vain. On the contrary, their perplexity makes me believe that there is in their enterprise something greater than themselves, an overwhelmingly powerful necessity in the evolution of painting, a truth greater than they can see at first sight. They are the precursors—clumsy, like all precursors—of a new art which is henceforth inevitable . . .

My intention is to give the cubists a little more freedom and assurance by supplying them with the deep reasons for what they are doing. True,

this will not be possible without showing them how badly they have done it so far.

I. THE PRESENT NEEDS OF PAINTING

... The true purpose of painting is to represent objects as they really are; that is to say, differently from the way we see them. It tends always to give us their sensible *essence*, their presence; this is why the image it forms does not resemble their *appearance* ...

Let us now try to determine more precisely what sorts of transformation the painter must impose on objects as he sees them in order to express them as they are. These transformations are both negative and positive: he must eliminate lighting and perspective, and he must replace them with other and more truly plastic values.

Why lighting must be eliminated
... It is the sign of a particular instant ... If, therefore, the plastic image is to reveal the essence and permanence of beings, it must be free of lighting effects ...

Lighting is not only a superficial mark; it has the effect of profoundly altering the forms themselves ... It can therefore be said that lighting prevents things from *appearing as they are* ... Contrary to what is usually thought, sight is a successive sense; we have to combine many of its perceptions before we can know a single object well. But the painted image is fixed ...

What must be put in place of lighting
He [the cubist] has renounced lighting—that is to say, the direction of the light—but not light itself ... It is enough for him to replace a crude and unjust distribution of light and shade with a more subtle and more equal distribution; it is enough for him to divide up between all the surfaces the shade that formerly accumulated on some; he will use the small portion of shading allotted to each one by placing it against the nearest edge of some other lit surface, in order to mark the respective inclination and divergence of the parts of the object.

In this way he will be able to model the object without having recourse to contrasts, simply by means of summits and declivities. This procedure will have the advantage of marking not only the separation but also the join of the planes; instead of a succession of bright salients and black cavities,

we shall see slopes supported on one another in a gentle solidarity. As they will be both separate and united, the exigencies of multiplicity and those of unity will be satisfied at one and the same time.

In short the painter, instead of showing the object *as he sees it*—that is to say, dismembered into bright and dark surfaces—will construct it *as it is*—that is to say, in the form of a geometrical volume, set free from lighting effects. In place of its relief he will put its volume.

Why perspective must be eliminated

... Perspective is as accidental a thing as lighting. It is the sign, not of a particular moment in time, but of a particular position in space. It indicates not the situation of the objects, but the situation of a spectator ... Hence, in the final analysis, perspective is also the sign of an instant, of the instant when a certain man is at a certain point.

What is more, like lighting, it alters them—it dissimulates their true form. In fact, it is a law of optics—that is, a physical law ...

Certainly reality shows us these objects mutilated in this way. But in reality we can change position: a step to the right and a step to the left complete our vision. The knowledge we have of an object is, as I said before, a complex sum of perceptions. The plastic image does not move: it must be complete at first sight; therefore it must renounce perspective.

What must be put in place of perspective

... The elimination of perspective leads quite naturally to this simple rule: the object must always be presented from the most revealing angle ...

It may even sometimes involve more than one viewpoint: sometimes it will display itself as it is impossible for us to see it, with one side more than we would ever discover in it if we stayed still ...

An object can be represented in a profound and perfect way by one only of its parts, *provided this part is the node of all the others* ... A house, if one looks at the point where two roof-planes and two walls meet, is more completely known than if one saw the whole façade and nothing else ...

Perspective is not the only way of expressing depth; nor, perhaps, is it the best way. It does not express depth in itself, directly and explicitly; it can only suggest it by outlining profiles ...

Fortunately depth is not pure emptiness; one can attribute a certain consistency to it, since it too is occupied—by air. The painter will therefore be able to express it otherwise than by perspective—by giving it a body; not by suggesting it, but by painting it as if it were a material thing. To this

end he will make all the edges of the object into starting-points for gentle planes of shadow that will recede towards the more distant objects. Where one object is in front of others, this fact will be shown by the fringes of shadow with which its contour will be edged; its form will detach itself from the others not as a simple profile on a screen, but because the strokes delimiting it will be flanges, and because from them shadows will flow towards the background, as the waters of a river fall regularly from a dam. The depth will make its appearance as a subtle but visible recession accompanying the objects; they will hardly appear to lie on the same plane, for between them there will insinuate itself a positive distancing and separation produced by these small dark slopes. They will be distinguished from each other without needing to alter their real appearance, simply and solely by the sensible presence, between their images, of the intervals which separate them in nature. By embodying itself in shadows, space, which maintains their discreteness in nature, will continue to do so in the picture as well.

This procedure will have the advantage over perspective of marking the connection as well as the distinction between objects; for the planes which keep them apart will also form a transition between them. These planes will at one and the same time repel and bring closer the more distant objects.

II. THE MISTAKES OF THE CUBISTS

In spite of appearances, painting has not yet emerged from impressionism. All art is impressionist that aims at representing, instead of the things themselves, the sensation we have of them; instead of reality, the image by which we become aware of it; instead of the object, the intermediary that brings us into relation with it . . .

The cubists are destined to take up the greater part of the lesson of Cézanne; they are going to give back to painting its true aim, which is to reproduce, with asperity and with respect, objects as they are . . .

First mistake of the cubists
From the truth that the painter must always show enough faces of an object to suggest its volume, they conclude that he must show all its faces. From the truth that sometimes it is necessary to add to the visible faces another, which could not be seen except by changing one's position a little, they conclude that it is necessary to add all the faces one could see by moving right round the object and looking at it from above and below.

The absurdity of such an inference does not need any long demonstration. Let us simply remark that the procedure, as understood by the cubists, arrives at a result that is the direct opposite of its purpose. If the painter sometimes shows more faces of an object than one can really see at once, this is in order to give its volume. But every volume is closed and implies the joining of the planes to each other; it consists in a certain relationship of all the faces to a centre. By putting all its faces side by side, the cubists give the object the appearance of an unfolded map and destroy its volume...

Second mistake of the cubists
From the truth that lighting and perspective, which act to subordinate the parts to the object and the objects to the picture, have to be eliminated, they conclude that all subordination must be renounced ... They understand *eliminating perspective and lighting* to mean *sacrificing nothing as secondary;* they take these two ideas as equivalent, as interchangeable. They thus condemn themselves never again to select anything from reality; and since there can be no subordination without selection, the elements in their pictures relapse into anarchy and form a mad cacophony which makes us laugh ...

Third and perhaps last mistake of the cubists
From the truth that depth must be expressed in genuinely plastic terms—by supposing it to have its own consistency—they conclude that it must be represented with as much solidity as the objects themselves and by the same means.

To each object they add the distance which separates it from neighbouring objects, in the form of planes as resistant as its own; and in this way they show it prolonged in all directions and armed with incomprehensible fins. The intervals between forms—all the empty parts of the picture, all the places in it occupied by nothing but air, find themselves filled up by a system of walls and fortifications. These are new, entirely imaginary objects, thrusting in between the first ones as though to wedge them tight.

Here again the procedure renders itself useless and automatically does away with the effects it aims at producing. The purpose of the painter's efforts to express depth is only to distinguish objects one from another, only to mark their independence in the third dimension. But if he gives to what separates them the same appearance as he gives to each of them, he ceases to represent their separation and tends, on the contrary, to confuse them, to weld them into an inexplicable continuum.

In short, the cubists behave as if they were parodying themselves. By carrying their newly-found principles to the point of absurdity, they deprive them of meaning. They do away with the volume of the object by their unwillingness to leave out any of its elements. They do away with the individual integrity of the objects in the picture by trying keep them intact. They do away with depth (whose function it is to distinguish one object from another) by trying to represent it solidly . . .

It is, indeed, impossible not to discern already in the work of some young artists a more intelligent and penetrating understanding of cubism. I have directed my criticisms here principally at Picasso, at Braque and at the group formed by Metzinger, Gleizes, Delaunay, Léger, Herbin, Marcel Duchamp. Le Fauconnier, who was a member of it, seems to be freeing himself from it. He may become a fine painter. But it is chiefly towards Derain and Dufy on the one hand, and on the other towards La Fresnaye, de Segonzac and Fontenay, that my best hopes have tended, ever since Picasso, who for a moment seemed near to possessing genius, strayed into occult researches where it is impossible to follow him. Lastly, I shall set apart André Lhote, whose recent works appear to me to announce, with admirable simplicity, the decisive arrival of the new painting.

'Sur les tendances actuelles de la peinture', *Revue d'Europe et d'Amérique*, Paris, 1 March 1912, pp. 384–406

In November 1911 the *Revue d'Europe et d'Amérique* published a fervent defence of cubism by Joseph Granié. This article by the distinguished essayist and critic Jacques Rivière (1886–1925), who became editor of the *Nouvelle Revue Française* in 1919 was intended by the editors of the review to be a reply to Granié. It is one of the most intelligent and profound of all the contemporary criticisms of cubism. Rivière immediately recognized the problem of light, which was so difficult for the cubist painters to resolve. Similarly, Rivière's discussion of the problem of space and perspective is remarkable, and his description of the cubists' solution is accurate. He was almost alone in seeing the connection between light and space in this solution.

But it is Rivière's objections to cubism which are extraordinary. In rejecting the way in which the cubists wove together objects and the space in which those objects exist, he unwittingly put his finger on a cardinal feature of the style after 1910; and what Rivière most disliked, this interweaving of forms and spatial relation-

ships, is that deliberate ambiguity and duality which the cubists had made a central principle of their art.

Rivière was one of the very few men of his time who looked at cubism and really understood it, and he was almost alone in putting this clarity of observation into words. Therefore it is all the more ironic that as the most promising of the new painters he should have picked André Lhote, who was later to become one of the most academic of the cubists.

18 André Salmon

Anecdotal History of Cubism

1912

I

Picasso at that time was leading a wonderful life. Never had the blossoming of his free genius been so radiant.

He had put his question to the masters best fitted to hold sway over troubled and fervent souls, from El Greco to Toulouse-Lautrec. Now, truly himself, sure of himself, he consented to be led by an imagination quivering with excitement, an imagination that was both Shakespearian and Neo-Platonic.

Picasso, at this period, was guided by the spirit only. An example will throw a light on his methods.

After a fine series of acrobats that were also metaphysicians, of ballerinas that were attendants of Diana, of sorcerer clowns and figures like Apollinaire's *'arlequin trismégiste'*, Picasso had painted, without a model, the extremely pure, simple image of a young Parisian workman, beardless and dressed in blue. Very much as the artist himself looked when he was at work.

One night Picasso deserted the group of friends deep in intellectual discussion: he went back to his studio and, taking up this picture, which he had left untouched for a month, gave the young artisan in it a crown of roses. By a sublime stroke of caprice he had turned his picture into a masterpiece.

Picasso was able to live and work in this way, happy, justifiably satisfied with himself. He had no ground for hoping that some different effort would bring him more praise or make his fortune sooner, for his canvases were beginning to be competed for.

And yet Picasso felt uneasy. He turned his pictures to the wall and threw down his brushes.

Through long days—and the nights as well—he drew, concretizing the abstract and reducing the concrete to its essentials. Never was labour less paid with joys, and it was with none of his former juvenile enthusiasm that Picasso set to work on a major picture which was intended to be the first application of his researches.

Already the artist had taken ardently to the sculpture of the Negroes, whom he placed well above the Egyptians. His enthusiasm was not based on any trivial appetite for the picturesque. The images from Polynesia or Dahomey appeared to him as 'reasonable'. Renewing his work, Picasso inevitably presented us with an appearance of the world that did not conform to the way in which we had learned to see it.

The familiars of the strange studio in the Rue Ravignan, who put their trust in the young master, were for the most part disappointed when he gave them the chance of judging his 'new' work in its first form.

This canvas has never been exhibited to the public. It contains six huge female nudes; the drawing of them has a rugged accent. For the first time in Picasso's work, the expression of the faces is neither tragic nor passionate. These are masks almost entirely freed from humanity. Yet these people are not gods, nor are they Titans or heroes; not even allegorical or symbolic figures. They are naked problems, white numbers on the blackboard.

Thus Picasso has laid down the principle of the picture-as-equation.

One of Picasso's friends spontaneously christened the new canvas 'the philosophical brothel'. This was, I think, the last studio joke to cheer the world of the young innovating painters. Painting, from now on, was becoming a science, and not one of the less austere.

II

The large picture, with its severe figures and its absence of lighting effects, did not long remain in its original state.

Soon Picasso attacked the faces, whose noses were for the most part placed full-face, in the form of isosceles triangles. The apprentice sorcerer was still seeking answers to his questions among the enchantments of Oceania and Africa.

After no great while, these noses became white and yellow; touches of blue and yellow added relief to some of the bodies. Picasso was composing for

himself a limited palette of succinct tones corresponding rigorously to his schematic design.

At length, dissatisfied with his first researches, this Neronian attacked other nudes—which he had so far spared, kept in reserve—seeking a new statics, and composing his palette of pinks, whites and grisaille tones.

For a rather short time Picasso seemed satisfied with this gain; the 'philosophical brothel' was turned face to the wall, and it was at this moment that he painted those pictures with their fine harmony of tones and very supple drawing—nudes for the most part—which made up Picasso's last exhibition in 1910.

This painter, who had been the first to find a way of restoring a certain nobility to the discredited subject, here returns to the 'study'—and to the studies of his first manner; *Woman dressing, Woman combing her hair.* He seemed content for the moment to draw no further upon the researches for which he had voluntarily sacrificed his original gift of immediate attractiveness.

It is necessary to follow, step by step, the man whose tragic curiosity was to produce cubism. A holiday interrupted his painful experiments. On his return, Picasso took up again the big experimental picture, which, as I have said, lived only by its figures.

He created its atmosphere by a dynamic decomposition of light values; an effort which left the attempts of neo-impressionism and 'divisionism' far behind. Geometrical signs—belonging to a geometry that was both infinitesimal and cinematic—came on the scene as the principal element in a kind of painting whose development, from now on, nothing could stop.

Never was Picasso to become again—for inevitably he could not—the fertile, ingenious, skilful creator of works filled with human poetry.

III

Let those who have been inclined to consider the cubists as daring practical jokers or as canny business-men deign to take a look at the very real drama that hangs over the birth of this art.

Like many others, Picasso had 'meditated on geometry', and when he chose savage artists as his mentors he was not unaware of their barbarity. Only, his logic led him to think that their aim had been the genuine representation of a being, and not the realization of the idea we have of it, which is, more often than not, a sentimental idea.

Those who see in Picasso's work the marks of the occult, of symbolism or mysticism, are in great danger of never understanding it.

He is trying, then, to give us a total representation of man and things. This was the aim of the barbarian sculptors. But here we have to do with painting, with art on a surface, and therefore Picasso is obliged, in his turn, to create something new, by placing these balanced human figures, outside the laws of academicism and the anatomical system, in a space strictly conforming to the unforeseen liberty of their movements.

The will to such a creative act suffices to make the man who possesses it— even if he be doomed to experience only the bitter joys of research without gathering its fruits—the foremost artist of his age.

The results of the initial researches were disconcerting. No concern for grace; taste repudiated as an inadequate standard!

Nudes came into being, whose deformation caused little surprise—we had been prepared for it by Picasso himself, by Matisse, Derain, Braque, Van Dongen, and even earlier by Cézanne and Gauguin. It was the ugliness of the faces that froze with horror the half-converted.

Deprived of the Smile, we could only recognise the Grimace.

For too long, perhaps, the smile of the Gioconda was the Sun of Art.

Its worship corresponds to a particularly depressing, supremely demoralising kind of decadent Christianity. One might paraphrase Rimbaud and say that the Gioconda, like Christ, was an 'eternal thief of energies'.

It is hard not to reflect to the innovator's advantage if one puts face to face one of the nudes and one of the still-lifes that belong to this moment of Picassism (cubism was not yet invented).

While the human effigy appears to us so inhuman and inspires in us a sort of terror, we are more ready to submit our sensibility to the evident—and quite new—beauties of the representation of this piece of bread, this violin, this cup, in a way they had never been painted before.

This is because the accepted appearance of these objects is less dear to us than is our own representation, our reflection distorted in the mirror of the intelligence.

And so one would gladly be led to search, with a confidence born of desperation, for what underlies the work of Picasso or some other painter of his kin.

Would it be a great waste of time? Here we have a problem.

Who will demonstrate the necessity, the overriding aesthetic reason, for painting human beings as they are, and not as our eye has recognized them ever since men meditated on our image? Is this not the very essence of art?

When these artist-researchers inflict on us all the edges of a prism at once, and blend touch and light—which are the sources of such different delights—into one, is not science their only guide?

To this question nobody has yet been able to give a decisive answer.

At the same time, the concern to make us experience an object in its complete existence is not in itself absurd. The world changes its appearance, we no longer have the mask our fathers had, and our sons will not resemble us. Nietzsche has written: 'We have made the earth quite small, say the last men, and wink.' A terrible prophecy! Does not the salvation of the soul on earth lie in a quite new art?

I do not intend to answer that question today, my aim being simply to prove that certain artists, unjustly abused, were obeying ineluctable laws, for which anonymous genius bears the responsibility.

This chapter is nothing but an anecdotal history of cubism.

There is nothing very daring in what I am advancing here. Already in 1910 M. Jean Metzinger was telling a reporter: 'We had never had the curiosity to touch the objects we were painting.'

IV

But again Picasso took up that testing-ground picture. He had to try out the effect of a new range of colours. The artist found himself in a really tragic situation. He had as yet no disciples (and when he did later acquire disciples some of them were hostile ones); some of his painter friends were now giving him a wide berth (another man than I might not scruple to mention names), aware of their own weakness and afraid of his example, hating the fine snares of Intelligence. The studio in the Rue Ravignan was no longer 'the poets' rendezvous'. The new ideal was dividing the men who were beginning to look at each other—and perhaps at themselves—'from all sides at once' and so were learning to be sceptical of appearances.

Picasso, somewhat deserted, found his true self in the company of the African soothsayers. He composed for himself a palette rich in the colours dear to the old academic painters: ochre, bitumen, sepia—and painted several formidable grimacing nudes, worthy objects of execration.

But with what a singular nobility Picasso invests everything he touches!

The monsters of his mind drive us to despair; but never will they shake the philistines out of the democratic laughter which causes the invasion of the Indépendants by the Sunday populace.

Already the Prince Alchemist, the Picasso who brings to mind Goethe, Rimbaud, Claudel, was not alone.

Jean Metzinger, Robert Delaunay, Georges Braque were taking an especial interest in his work.

André Derain . . . was to join him by paths that were his own, only to draw away from him later; but he never went beyond him. Picasso taught him at least the necessity of deserting the conversational *salon* which adjoined the studio of Henri Matisse.

Vlaminck, that giant whose thoughts were as honest and categorical as the straight left of a good boxer, was losing—not without amazement—his conviction that he was a typical fauve. It had never occurred to him that the violences of agonized Vincent van Gogh could be surpassed in boldness. He returned to Chatou, pensive but not converted.

Jean Metzinger and Robert Delaunay painted some landscapes planted with small houses that were reduced to the strict appearance of parallelepipeds. These young artists, who lived a less inward life than Picasso and had remained painters in a more external sense than their fore-runner, were in far more of a hurry to get results—even if in a less thorough way.

It was their great haste that decided the success of the enterprise.

Their works were exhibited, and passed almost unnoticed by the public and by the art critics, who—green cap or blue cap, Guelph or Ghibelline, Montague or Capulet—recognized no one, whether for praise or for curses, but the fauves.

And the king of the fauves (was it imprudence or political astuteness?), Henri Matisse, who had just been crowned at Berlin, curtly rejected Jean Metzinger and Robert Delaunay from the family.

With that feminine sense of the fitting, of which his taste is formed, he christened the little houses in the two painters' landscapes 'cubist'. An ingenuous or ingenious art critic was with him at the time. He rushed to his newspaper, tossed off the article-gospel, and next morning the public learned of the birth of cubism.

Schools disappear for want of convenient labels. This is annoying for the public, for it likes schools—they enable it to see clearly without effort. The public accepted cubism very docilely, even going so far as to recognize Picasso as head of the school and refusing to go back on it.

Since then, misunderstanding has merely deepened.

Georges Braque, who a few months earlier had been painting violent landscapes in the manner of Vlaminck, and who was also troubled by Seurat's

discoveries, contributed not a little to the strengthening of the double misunderstanding.

He joined Jean Metzinger and Robert Delaunay. But, concerned with the human figure before they were, he borrowed directly from Picasso, although there is still sometimes room in his pictures for a modest expression of his sensibility.

Later he was to follow Picasso respectfully step by step, enabling one (frequently judicious) writer to record this judgement, which goes too far: 'It is said that the inspirer of the movement is M. Picasso; but since he never exhibits, we must consider M. Georges Braque as the real representative of the new school.' [But cf. Michel Puy, text 12.]

Being much more intellectual, M. Jean Metzinger—poet as well as painter, the author of fine esoteric verses—tried to justify this cubism, created by Henri Matisse who had no share in the enterprise, and gave thought to bringing together the confused elements of the doctrine.

In consequence, while cubism, named by Henri Matisse, stems in fact from Picasso who did not practise it, Jean Metzinger has grounds for claiming to be its leader. Nonetheless, it was not long before he conceded that 'cubism is the means, not the end'. Ergo: cubism is admirable because it does not exist, although it has been invented by four persons.

Today we see the cubists separating more and more; they are gradually abandoning the little tricks of the trade which they had in common; what they called discipline was, in short, only gymnastics, something like plastic 'physical culture'.

People thought they were at an Academy: they are emerging from the Gymnasium.

V

While Jean Metzinger and Robert Delaunay, for a while quite close together, and Georges Braque, in isolation, were offering the critics works that were considered as complete achievements, Picasso and André Derain (who were not exhibiting) were at work, each separately; the former going straight on with his researches, the latter moving further and further from dogmatism.

Picasso composed a new palette of greys, blacks, whites and greens which, adopted at once by Georges Braque, became the palette of all the cubists.

The school was then augmented by Le Fauconnier, an individualist who transformed everything he had received, authoritarian in his likings and in this very much akin to Matisse, whom he rejected; and by Albert Gleizes,

who joined the chorus of speculative thinkers without meaning to give up altogether the terrestrial fleshpots. Fernand Léger, ensconced in a calm academicism, was awakening, with great astonishment, to a prouder kind of art.

The résumé I have just given of the short but abundant history of cubism is totally unknown to the public and to most of the best informed art-lovers.

I have guessed at nothing. Fate has simply assigned me a part as eye-witness, and I am now trying to give my evidence faithfully.

The general ignorance of the circumstances which fostered the flowering of cubism is a sufficient explanation of the confusion of ideas that prevailed until the 1911 Salon d'Automne.

M. Desvallières, a convert to cubism who does not practise it (M. Charles Maurras defends the Roman Church in much the same way), encouraged by M. Granié, honorary counsel for the new cause, was the first to think of gathering into one room pictures united in diversity by the common interests shared by MM. Jean Metzinger, Le Fauconnier, Albert Gleizes, Fernand Léger, La Fresnaye, Duchamp, Dunoyer de Segonzac, André Lhote, Albert Moreau, Fontenay, etc. These artists were soon to be followed by Herbin and the sensitive Juan Gris.

The critics pronounced on this mosaic of works. The lack of unity is explained by the defection of Georges Braque and Robert Delaunay, who were expected to submit some characteristic paintings but passed up their place on the line to artists of an outside family—while Marchand was obscured by the proximity of Maurice Denis.

Never mind. This error counted for little. The great blow was struck. It was no longer possible to ignore cubism. *[See text 48.]*

Some admired, others mocked; air was in short supply in Room VIII. Some writers spoke of a renaissance, of the salvation of art; others adjured their colleagues not to countenance a national danger. Very few chose to adopt an attitude of disdain, or contented themselves with witticisms.

I limited my task to recognizing, within the cubist family, the artists really gifted with painterly virtues.

But it was the scoffers, the strangers to art, who made certain of the success of this exhibition.

In a similar way neo-impressionism, popularly called pointillism, became famous ten years after its first revelation, when Willette, a charming artist but singularly unreceptive to the things of the mind (he is all sentiment), drew a Pierrot as a painter exclaiming: 'Damnation! I'm doing paintings in confetti!'

Some people's anger far exceeded the fury of the anti-Wagnerians. As in the bad old days of the Dreyfus Affair, whole families were divided into opposing camps; long-standing friendships were broken up.

And now, just when cubism was commanding attention so loudly that for some people it raised a new social question, the school—still quite new—began to disintegrate, each artist going his own way.

The last-comer, Fernand Léger, seemed to have rallied the main body of the troop only to proclaim a schism. For him the name 'tubism' was found. Fernand Léger was to waste little time before returning to more profound researches.

All renounced unity of colouring, all began to break up the Picasso palette.

Albert Gleizes no longer made any bones about anecdotalism, and Jean Metzinger expended a great deal of talent on rehabilitating 'grace' among his own followers. In opposition to the grimacing idols, lately worshipped, he set up a kind of Gioconda of cubism.

VI

Since then, each one has been sticking to his positions and consolidating them. Though accepted, cubism has not triumphed, since the efforts of individuals are tending towards many different developments. It will last, but it will be ceaselessly modified; it is more susceptible of development than neo-impressionism, and for that very reason it will quite soon cease to be what it is now imagined to be.

Painters far removed from the cubists—their enemies even—will adopt some of the means of expression of Le Fauconnier and his friends, for Degas's saying is still true, and for everyone: 'They shoot us, but they go through our pockets.'

Henri Matisse is alone. This famous man grown rich on art, this painter crowned with honours, has acquired pupils in the fashionable quarters only: those of Paris (and more particularly in the Russo-American alleys of Montparnasse) and those of Munich, Berlin, Moscow.

The other intransigent fauves are in my view as disunited as the cubists. And yet it is from a close and inevitable union that the great painting of tomorrow must be born.

Despite all the struggles and all the sincere and laborious withdrawals that have taken place, the movements are as inextricably confounded—although they do not fully realise it—as they were in 1904.

Already the pupils of the fauves, without abandoning them, are allying themselves with the cubists for important public occasions.

Could cubism, therefore, be merely a sub-school, a province of the fauve kingdom—that kingdom made up of peoples agitated by conflicting needs and repudiating the authority of the foreign prince whom chance imposes on them?

Cubism will at least have restored the cult of method.

From now on our task is simplified. Without counting the absentees, the deserters and the defaulters, we have now to concentrate on examining the work of the young painters who set out to break with academicism.

from *La Jeune Peinture française*, Paris, 1912, pp. 41–61

Salmon's *La Jeune Peinture française* was written by April 1912 and was published in the autumn of that year[1] in a single edition of 530 copies. The chapter reprinted here is one of the essential documents of cubism, and in particular of its beginnings in *Les Demoiselles d'Avignon*. Salmon emphasizes unequivocally the role played by African and Oceanic sculpture in Picasso's thoughts before he began *Les Demoiselles*, and he also asserts that Picasso worked on this painting in two separate stages. It should be noted, however, that Salmon is in error in saying that *Les Demoiselles* contains six figures; the number varied from five to seven in the known preparatory sketches, but the final painting has only five.

Elsewhere in this same chapter Salmon makes the familiar distinction between optical and conceptual realism, the latter of which he ascribes to cubism; but curiously he also insists on a scientific basis for the new art.

Maurice Raynal

Preface to a Catalogue

1912

Along with a large number of intrepid scientists, who have devoted them-
selves to extraordinary scientific researches the mere starting-points of
which have made nonsense of accepted views and vulgar sensibility, the
twentieth century has seen the rise of a generation of artists who, possessing
an exceptionally wide culture, have tried to renew the pictorial conceptions
and styles of the past through their own knowledge in various fields and
their affinities with the modern movement.

A man's superiority is measured by the delicacy of his sensibility, and
this delicacy can only be acquired by the help of knowledge. It is in this
way that modern painting has transformed itself. Indecisive periods, when
the imperfect diffusion of scientific methods left room for the products—
often. charming, but insufficiently thought out—of imagination, chance,
inspiration, superficial observation and dreams, have been succeeded by a
more positive period, in which men have decided to study the essence of
things before trying to expound them.

The élite of today rightly considers that the artist, at the same time as he
sees, must conceive the object he proposes to represent. In fact, the aim
of art is not the servile imitation of nature; what interest would it have if it
were merely that? It must be a translation, an interpretation of nature
according to the artist's intellectual powers. Imitation by itself may, if one
likes, be an art, but one that photography may easily bring to perfection.

Painters ancient and modern have indeed claimed that they too have
interpreted nature according to their sensibility, and this is true. But un-
fortunately artists, being reactionary in the main, have never been anxious
to modify their ways of thinking in accordance with the modifications to
which life has been subjected by time and progress. They have never been
willing to understand their art except in the way they had learned at school;
hence the torpor in which it has so long been embedded.

The painters and sculptors of our group have tried to free Painting and
Sculpture from the stagnation into which they had been plunged by the

obstinacy of artists, including some eminent ones. Although it is obviously risky to set out such theories in so few lines, we shall try to give an outline of their ideas.

The 'cubists'—since they have to be given this label, misleading though it is—have sought, first and foremost, to learn by their own efforts what the School had failed to teach them. This is why they have called to their aid that law of synthesis which—though they have been so much reproached on its account—today governs all conscientious speculation. They have endeavoured, in the reflection preceding their works and in the works themselves, to proceed judiciously from principles to consequences and from causes to effects, with a view to reducing the two arts to their common essential principle and to their ideal simplification—that is, line.

Before all else, they separate out—according to their own analytical methods and to the characteristics of the object—the principal elements of the bodies they propose to translate. Then they study these elements in accordance with the most elementary laws of painting, and reconstruct the objects by means of their elements, now known and strictly determined.

In this way the cubist painters will soon have created the algebra of Painting. They know that all bodies have a certain particular form only because this is the resultant of the mathematical conception of the object formed, more or less knowingly, by its maker. Thus objects must no longer be considered solely as haphazard representations, but as agglomerations of forces and as aggregates of distinct parts governed by mathematical laws. These objects will henceforward be volumes—volumes, in the strict sense of the word, *i.e.* spaces filled and occupied by aggregates of bodies.

At the same time, objects can be considered from two other points of view: in their natural equilibrium and in their various movements—that is to say, from the *static* point of view and the *dynamic*. The cubist painters and sculptors began by taking into account the fact that movement amplified forms and repose diminished them. Then, following the principles of statics and dynamics, the bodies can undergo sensible modifications—the dynamics of one body may influence the statics of another, or *vice versa*. In spite of what has sometimes been said, objects cannot be independent; they have inter-relations similar to the attractions and repulsions which exist between certain chemical elements. And as both static and dynamic elements may meet within one object, even an inanimate one, these objects will be expressed on the canvas by divergent lines occasioned either by their inner forces or by some external influence.

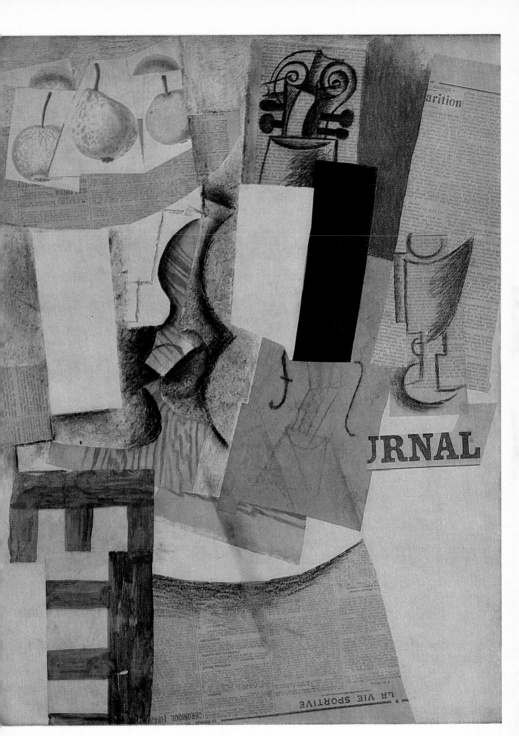

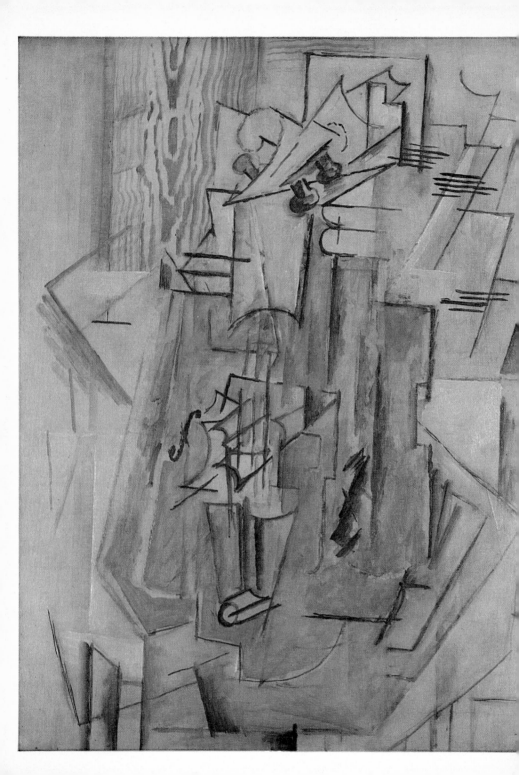

It is here that sensibility intervenes. Each artist, according to his temperament and his individual ideas of painting, will give the lines the directions that he, in his independent judgment, considers necessary. It is in this part of the work that the artist's personality will be affirmed most clearly; it is there that he will most allow himself to be ruled by the arbitrary; in a word, it is at this point that we should look for and expect to meet the full manifestation of the arts of Sculpture and Painting.

> Salon de juin: Troisième exposition de la Société normande de Peinture Moderne, catalogue, Rouen, 15 June–15 July 1912, pp. 9–11

In this and the following two texts the young critic Maurice Raynal (1884–1954) put his talents to the service of cubism for the first time. Raynal knew Picasso and his friends in Montmartre by 1910, and he was soon familiar also with the group of artists in Puteaux. His austere mentality was quickly attracted to the work of Juan Gris; Gris did Raynal's portrait in 1911 and painted Mme Raynal in 1912.

Raynal's criticism appears at times to be almost scientific, at a far remove from the lyrical prose of Salmon and Apollinaire. He became interested in seeking philosophical precedents for cubism, as in his pamphlet *Quelques Intentions du Cubisme* of 1919 (see text 39); but his clearsighted articles provided a much needed counterbalance to the vague enthusiasm or condemnation of many contemporary critics.

The Rouen exhibition of 1912 was organized in large part by the Duchamp brothers, whose family had its origins there; among the artists exhibited were Lhote, Léger, Gleizes, Laurencin, Gris, Villon, Picabia, La Fresnaye, and Marcel Duchamp. Thus it was a preliminary version of the October 1912 exhibition of *La Section d'Or*.

Raynal's text is notable for its succinct description of the intellectual process underlying 'analytical' cubism. The recent spread of futurist ideas after the Paris futurist exhibition of February 1912 is evident here in Raynal's discussion of movement and of the artists' interest in recording the dynamic qualities of an object. So far as cubism is concerned, Raynal was misled on this point, and he did not pursue it in his subsequent writings.

Conception and Vision

1912

The need to depict what one sees is an instinct and, in consequence, the antithesis of the higher aspirations of the mind. Indeed, in the animal kingdom one encounters many creatures that have this need in a highly developed form, and the ape offers some very curious examples of it.

The cave-man carved, on the walls of his home, figures of animals he had seen. The child, as soon as he is old enough to do so, executes portraits, 'just like daddy', or gives a lethal imitation (as his father and mother have done) of some rich old maid. Simple people make much of the need to depict what one sees—their 'picturesque' speech is flowery with hackneyed images, and it is not only the poets who sprinkle their works with metaphors and with imitative harmonies.

The need to imitate what one sees can still sometimes have unfortunate consequences in scientific research. There are many examples, but here is one that is topical. Icarus, when he wished to fly, tried to imitate the birds; this was a mistake, but he had the excuse of not being a scientist. And yet many researchers intent on the problem of the air have tried to solve it methodically by this same procedure, and in our modern age Ader has carried on the error, advocating in his turn the flapping-wing system. The fact that what was needed, in order to fly like a bird, was not wings like a bird's but a simple piece of spinning wood, shows that, in trying to reach the truth, one should not simply attempt to imitate nature, but look elsewhere.

The quest for truth has to be undertaken not merely with the aid of what we see, but of what we conceive. But since the time of the primitives, painters have chosen to render what they see in preference to what they conceive, and they have done so forgetting that nothing was less legitimate than external perception, nothing was [more] in contradiction with the laws of reason than visual sensation . . .

We shall not go so far as to accept Berkeley's idealism without reserve, but it will not be denied that judgements and reasonings based on perception only are for the most part erroneous.

The futurist painters provide a convenient example. Many of them have tried, in their pictures, to render the real movement of various objects; however, the perception of a real movement presupposes that we know some fixed point in space which will serve as a point of reference for all other movements. But this point does not exist. The movement which the futurists have perceived is therefore only relative to our senses and is in no way absolute. Here, then, is one error of reasoning due to our senses.

Painting based solely on external perception is, therefore clearly inadequate. If art is required to be not merely a means of flattering the mind and senses but more the means of augmenting knowledge, its function will only be served by painting forms as they are conceived in the mind; the primitives understood this very well.

When Giotto painted that picture in which, behind the men seen in the foreground, there is a fortified town, he showed the town in bird's-eye view. He thus described it as he had conceived it,—that is to say, complete, all of its parts at once. In this picture he respected neither perspective nor visual perception; he painted the town as he *thought* it and not as the people in the foreground might have *seen* it.

We never, in fact, see an object in all its dimensions at once. Therefore what has to be done is to fill in a gap in our seeing. Conception gives us the means. Conception makes us aware of the object in all its forms, and even makes us aware of objects we would not be able to see. 'I cannot *see* a chiliagon [a thousand-sided figure],' said Bossuet, 'but I can conceive it perfectly well.' When I think of a book, I do not perceive it in any particular dimension but in all of them at once. And so, if the painter succeeds in rendering the object in all its dimensions, he achieves a work of method which is of a higher order than one painted according to the visual dimensions only.

At the same time the primitives conceived not only the forms of the objects but also their qualities of form. When a primitive had to paint armed men crossing a bridge, the first thing that struck him was the idea 'armed man', which was indeed more important than the idea 'bridge', so the painter made the armed men much bigger than the bridge; which may be contrary to the laws of visual perception but is not contrary to those of reason.

Hence it is altogether regrettable that the artists who came after the primitives should have thought it right to abolish the principle of conception and substitute that of vision. This latter is incontestably of a far lower

intellectual and even practical value. It has replaced the idea of art for art's sake, which the principle of conception involved, by an idea of practical efficiency which has led painting into many errors, and resulted in the narrowness of outlook which is responsible for the rise of commercial painting.

If, on the other hand, it be admitted that the aim of the artist is to come as near as possible to the truth, the conceptualist method will bring him there. The mathematical sciences are exact—that is, they possess absolute certainty—because they deal with abstract notions. In painting, if one wishes to approach truth, one must concentrate only on the conceptions of the objects, for these alone are created without the aid of the those inexhaustible sources of error, the senses.

The beautiful must be, in Kant's excellent phrase, a 'finality apart from any end'—meaning that it requires an inner harmony with no purpose outside it. It must therefore be distinguished from expediency, mere arrangement with an ulterior purpose; for a beautiful form to give pleasure, there is no need to have a definition of it.

'Conception et vision', *Gil Blas,* Paris, 29 August 1912

In this little-known article Raynal sets forth his ideas on cubism in general terms. His use of the Icarus myth is particularly interesting, because his point is repeated later by Apollinaire and by Braque, who in his aphorisms said that 'One must not imitate what one wants to create' (see text 36). Raynal's explanation of the arbitrariness of one-point perspective goes beyond that of Rivière (text 17) by insisting on the importance of relativity in human experience. His example of the Italian primitives as conceptual painters became a favorite theme in post-World War I cubist theory, especially in the voluminous later writings of Albert Gleizes.

Raynal conspicuously avoids using the word 'cubism'. Nor does he as yet speak of the 'Fourth Dimension', preferring to remind us of the cumulative nature of knowledge in human experience. He follows a thoroughly Kantian aesthetic, and at one point he almost considers painting as a colleague of science in the search for an absolute truth; but in his conclusion he also accepts the sensuous pleasures which art offers.

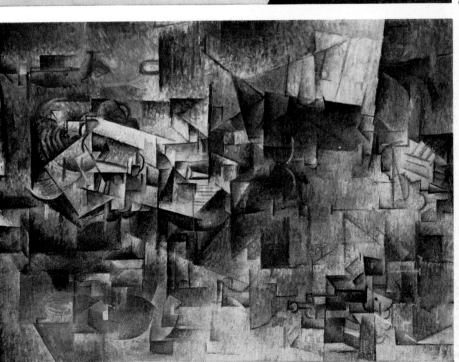

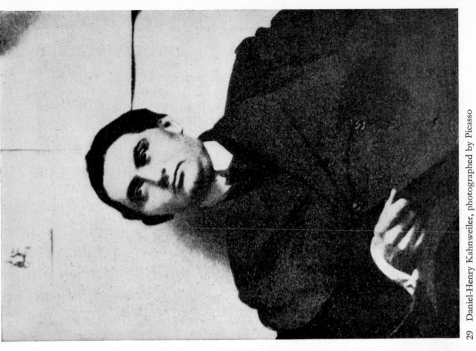

28 PABLO PICASSO, *Portrait of Daniel-Henry Kahnweiler*, autumn 1910

29 Daniel-Henry Kahnweiler, photographed by Picasso

31 Sacré-Coeur, Paris

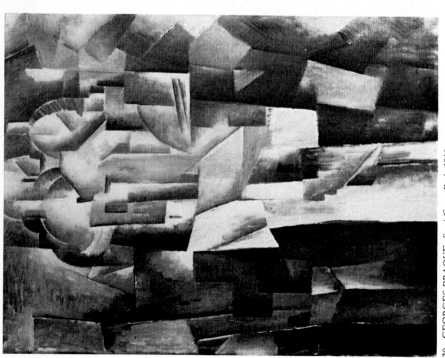

30 GEORGES BRAQUE, *Sacré-Coeur*, Paris 1910

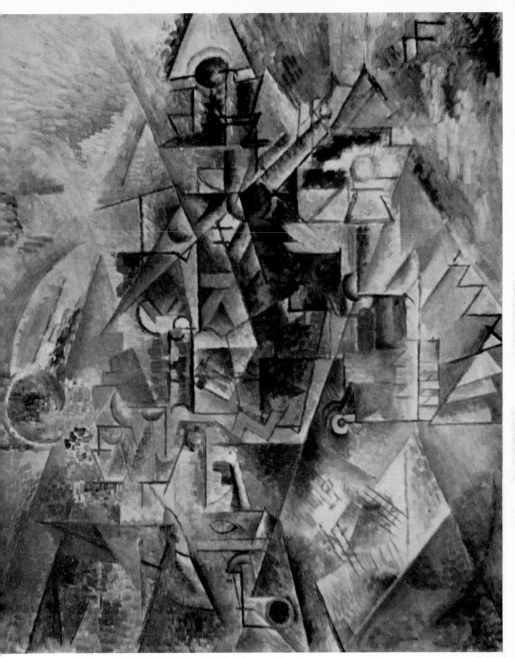

PABLO PICASSO, *Still-life with Clarinet*, Céret summer 1911

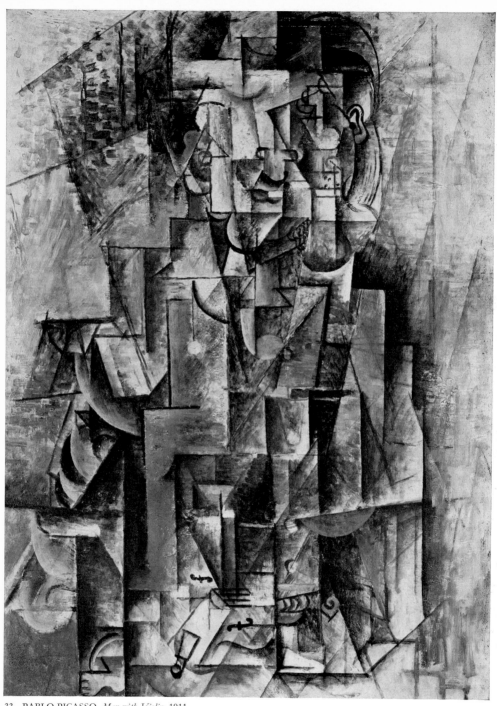

33 PABLO PICASSO, *Man with Violin*, 1911

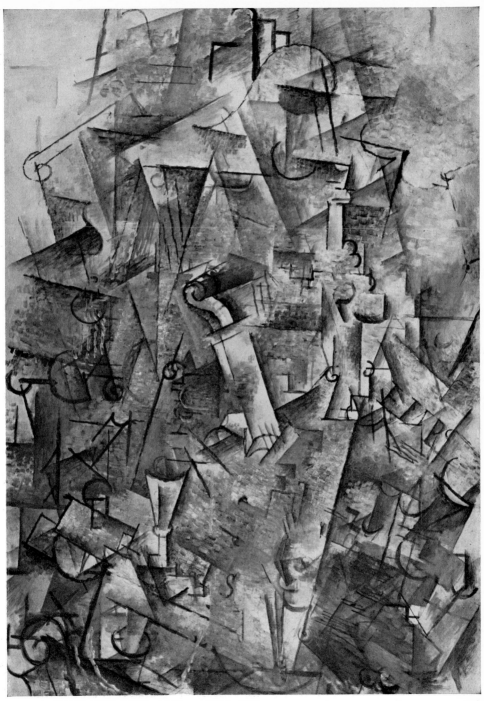

34 GEORGES BRAQUE, *Still-life with Harp and Violin*, 1912

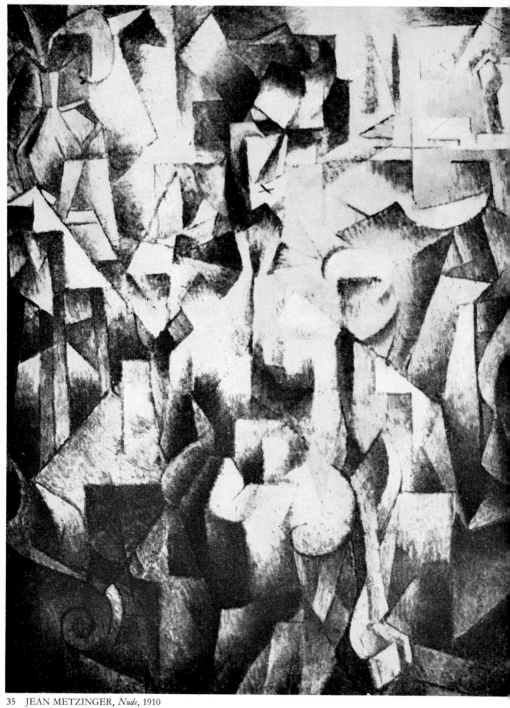

35 JEAN METZINGER, *Nude*, 1910

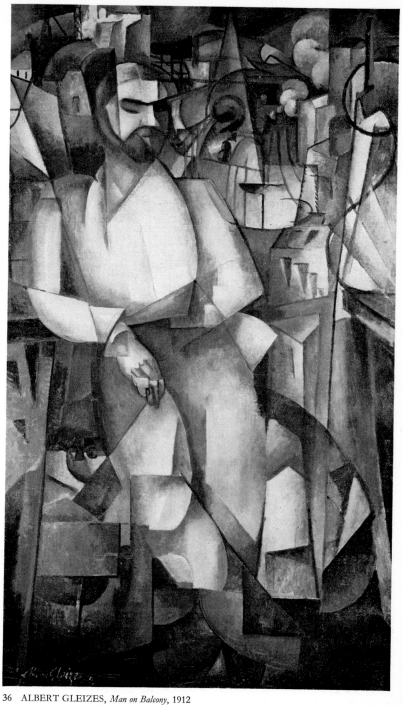

36 ALBERT GLEIZES, *Man on Balcony*, 1912

37 FERNAND LÉGER, *Study for 'The Woman in Blue'*, 1912

The *Section d'Or* Exhibition

1912

What will prove to have been the main point about the *Section d'Or*
Exhibition is that it has grouped together, for the first time with such
completeness, all those artists who have ushered in the twentieth century
with works clearly representative of the tastes, tendencies and ideas that
will be more characteristic of it than any others. Up to 1910, only those
who initiated the movement, in different ways which we shall discuss
elsewhere, P. Picasso, J. Metzinger and G. Braque, had given life to the
term 'cubism'. But since then the growing number of artists who have
followed them and have brought such fresh contributions to the quest for
truth, who have displayed so much courage in face of the inevitable attacks
of the critics, and who have recently caused so complete a disarray among
those judges who would now gladly refer to the superannuated pronounce-
ments of their predecessors as drivel (when really the poor devils think
exactly as they did)—this growing number has become so considerable and
confident as to make it today appear very difficult to group all its repre-
sentatives under one special label. The difference between Metzinger and
Picasso is as clear-cut as that which separates Renoir from Cézanne—to
whom indeed they are comparable in their temperaments and some of their
gifts. And again, there is such a difference between men like Fernand Léger
and Marcel Duchamp, between Picabia and La Fresnaye, or A. Gleizes and
Juan Gris, that, just as no one would think of treating Renoir and Cézanne
as impressionists, the term 'cubism' is day by day losing its significance, if
it ever had any very definite one. 'There were ten of them a year ago, there
are fifty this year', is the phrase used the other day, in one of the big
dailies, by a champagne broker who, with impeccable salesmanship, cushions
his venerable bottles of wine (far more praiseworthy than himself, of
course) with little diatribes against every artistic effort that he thinks (or
at least has been told) is determined to keep clear of grubby commercialism.
Well! for once the fellow was right. So much so, that the development
achieved by this movement in a short time has been considerable enough

Numéro Spécial consacré à l'Exposition de la " Section d'Or "

Première Année — N° 1 vendu exceptionnellement 0.50 9 Octobre 1912

LA SECTION D'OR

RÉDACTION - ADMINISTRATION	ABONNEMENTS		Secrétaire de la Rédaction
13 Place Emile Goudeau, Paris 18e	France et Algérie Etranger		PIERRE REVERDY
Adresser toute la Correspondance à	1 an...........5 fr. 1 an...........10 fr.		Les manuscrits non insérés ne sont
M. PIERRE DUMONT	6 mois........3 fr.		pas rendus.

COLLABORATEURS

Guillaume Apoilinaire

Roger Allard

Gabriele Buffet

René Blum

Adolphe Bassler

Marc Brésil

Max Goth

Ollivier Hourcade

Max Jacob

Pierre Muller

Jacques Nayral

Maurice Princet

Maurice Raynal

P. N. Roinard

Pierre Reverdy

André Salmon

Paul Villes

André Warnod

Francis Yard

Jeunes Peintres ne vous frappez pas !

Quelques jeunes gens, écrivains d'art, peintres, poètes, se réunissent pour défendre leur idéal plastique, c'est l'idéal même.

Le titre qu'ils donnent à leur publication : la Section d'Or, indique assez qu'ils ne se croient pas isolés dans l'art et qu'ils se rattachent à la grande tradition. Il se trouve qu'elle n'est pas celle de la plupart des écrivains d'art populaires de notre temps. C'est tant pis pour ces écrivains d'art.

Quelques-uns d'entre eux, pour donner du poids à leur légèreté, n'ont pas hésité à demander que leurs opinions entraînassent des sanctions pénales contre les artistes dont ils n'aiment point les œuvres.

La passion aveugle ces pauvres gens. Pardonnons-leur car ils ne savent pas ce qu'ils disent. C'est au nom de la nature que l'on tente d'accabler les peintres nouveaux.

On se demande ce que la nature peut avoir de commun avec les productions de cet art dégénéré que défend la citadelle de la rue Bonaparte ou avec les peintures des piètres héritiers des maîtres impressionnistes.

Bien plutôt renoueraient à l'étude de la nature les sévères investigations des jeunes maîtres qui, avec un courage admirable ont relevé le nom burlesque sous lequel on avait voulu les ridiculiser.

Les cubistes, à quelque tendance qu'ils appartiennent, apparaissent à tous ceux qui ont souci de l'avenir de l'art comme les artistes les plus sérieux et les plus intéressants de notre époque.

Et à ceux qui voudraient nier une vérité aussi évidente on répond que si ces peintres n'ont point de talent, que si leur art est indigne d'être admiré, ceux qui font métier

SALON

DE

" LA SECTION D'OR "

du 10 au 30 Octobre 1912

CATALOGUE

AVEC UNE

Préface de René BLUM

Prix : 0 fr. 60

PARIS

GALERIE LA BOËTIE

64 bis, Rue La Boëtie

to persuade its adepts that they should unite their efforts in this exhibition, in spite of the brokers, whatever side they are on, in spite of the persons who love novelty only on condition that it resembles the old, and in spite of those fools of whom La Rochefoucauld says that, even though they may be endowed with wit, they are incapable of honest judgement.

Again, this exhibition seems to me complete in that it offers an infinitely varied range of temperaments. It contains realistic and sensuous painters; idealists and intellectuals; impulsive ones and thoughtful ones, wise men who, according to the Greek philosopher's prescription, season their wisdom with a grain of madness, along with madmen who temper their madness with a little wisdom.

In a word, one encounters there a rich flowering of diverse personalities such as is to be found in every artistic period of any importance.

I shall not recapitulate here the principles of the only kind of painting worthy of the name, principles which these brilliant minds have codified. What finer idea can there be than this conception of a *pure* painting, which shall in consequences be neither descriptive, nor anecdotal, nor psychological, nor moral, nor sentimental, nor educational, nor (lastly) decorative? I am not saying that these latter ways of understanding painting are negligible, but it is incontestable that they are hopelessly inferior. Painting, in fact, must be nothing but an art derived from a disinterested study of forms: that is, free from any of the ulterior purposes I have just mentioned.

Can there be a more noble elevation of thought, or a more frank refusal to please the ignorant strollers round those great fairs of painting which are harboured yearly in market halls on baleful Avenues (whether Alexandre III or d'Antin)?

What is there to say of this rich flowering of new ideas, always very firmly based on the best and purest precepts of the ancients; this love of science, which is a criterion of our modern sensibility in all its refinement; this urge to weigh and measure everything properly, and to leave nothing to vague and absurd inspiration; this absolute desire to paint a picture otherwise than while holding the little naked model with one hand and thinking how much one can sell the picture for with the other (this must actually be quite difficult)? What, in short, is there to say about these noble efforts, except to express the enthusiasm they inspire?

Who will fail to be astonished by this marvellous idea, taken up afresh from the Primitives after the stuffed shirts of the Renaissance had forgotten it, the idea of painting conception instead of painting vision? One needs only have to have been very casually loved by the Gods (and cared for by one's mother) in order to get some inkling of the brilliant results that can be occasioned by this very strange and pure principle of painting things as one thinks them, not as the short-sighted eye of the above-mentioned broker (in I now forget what commodity) supposes it sees them!

How can one fail to praise this categorical rejection of such oldmaidish child's-play as horizontal composition, observance of perspective, *trompe-l'œil*, foreshortening and other petty tricks of the trade, worthy of some Rue Lépine competition or of a show at the Châtelet?

And, above all, this incorruptible love of stubborn research. Almost never satisfied with themselves, discontented with their works as soon as these are

done, one can feel that the authors of these pictures do not wait to finish a painting before setting themselves fresh problems, and that they only relax from a solved question in seeking to elucidate a new one.

To them every novelty immediately becomes an occasion for finding out about it, for discussing it, for drawing profitable lessons from it, with the purpose of refining their sensibility still further. They certainly are not of those who think that no art is possible in our age; on the contrary they are living in intimate contact with the age and acting as its sentinels . . .

Juan Gris has here made a considerable effort. He is certainly the fiercest of the purists in the group. To establish firmly that the sheer study of forms is his only concern, he numbers his pictures instead of giving them titles. The canvas representing a dressing-table complete with its accessories will attract attention (see *Ill. 46*). To show clearly that in his conception of pure painting there exist objects that are absolutely antipictorial, he has not hesitated to stick several real objects on to the canvas. Plane surfaces cannot, in fact, be painted, since they are not bodies; if one does so, one falls back into imitation or into the preoccupation with skill which is the preserve of the painters of shop signs. If I think of a bottle and wish to render it as it is, the label on it appears to me simply as an unimportant accessory which I might leave out, for it is only an image. If I feel I must show it, I could copy it exactly, but that is a useless labour; so I place the actual label on the picture—but not until I have cut it out to fit the form I have given to the bottle; this is the nicety which will determine the charm of the idea. Juan Gris has applied the same principle to the mirror he has placed on his canvas. This has caused much discussion, but it can be said that it does no harm to the picture and that it pinpoints the strange originality of Juan Gris's imagination.

'L'Exposition de *La Section d'Or*',
La Section d'Or, Paris, 9 October 1912, pp. 2–5

The *Section d'Or* exhibition, held in Paris at the Galerie de la Boëtie during October of 1912, was the most important of all cubist manifestations in France; coming after the *succès de scandale* at the 1911 and 1912 salons, it marked the

public consecration of the movement. The title probably originated with Jacques Villon, and he and his brothers, with Gleizes, Metzinger, Picabia, and Apollinaire, were its principal organizers. Other painters in the exhibition included Lhote, La Fresnaye, Léger, Marcoussis and Gris. Only the last two of these artists lived in Montmartre; and conspicuous by their absence were Picasso and Braque. But these two creators of the style had long before ceased to exhibit in France except at Kahnweiler's little gallery, and so the *Section d'Or* represented what the public thought of as cubism.

During the exhibition several lectures were given: Apollinaire's on 11 October, which he later published as part VII of his *Les Peintres Cubistes* (see text 25); Raynal's, *Essai de définition de la peinture cubiste,* was given on 18 October[1]; a third was given on 25 October by René Blum, who also wrote the vague introduction to the catalogue.

A review, *La Section d'Or,* was published at the time of the exhibition, in its first and only number; only one or two copies still survive. The first page is reproduced on page 98 of this volume. The list of collaborators is deceptive, although representative of the leading defenders of cubism. In its eight pages, in addition to the article quoted here and Apollinaire's front page exhortation, there is little touching directly on painting. Gabrielle Buffet, who married Picabia, contributed a short essay, 'Impressionisme musical'; Reverdy, the editor of the issue and future great poet, added what is probably his first published essay, entitled 'A un pauvre écœuré', a retort to the French minister Lampué who had attacked cubism; and Brésil reviewed the criticism of cubism in Parisian newspapers and magazines. Raynal's article however was sufficiently noteworthy to be reprinted in part by Louis Vauxcelles[2], and Raynal quoted from it in his own review of the exhibition[3].

Raynal introduces the idea of a 'pure' painting, autonomous yet not decorative. The term 'pure' was first used by Apollinaire in his essay 'Du sujet dans la peinture moderne' of early 1912[4], but Raynal is more explicit than Apollinaire in qualifying it and in applying it to cubism. In the context of late 1912, 'pure' painting has indeed a real meaning, for by then Delaunay, and before him Kupka, had arrived at an autonomous art of pure colour; while outside Paris, Kandinsky had already painted his first non-objective work by 1910. Also by late 1912, Picasso and Braque had begun to make *papiers collés,* thus turning away in their cubism from the pursuit of complexities in the visual world to the creation of flat, autonomous realities of their own making.

Raynal is the first to discuss this all-important innovation. The occasion is a painting by Gris in the exhibition, one of Gris' first collages *(Ill. 46)*; seeking to create the exact equivalent of a mirror over a dressing table, and finding that no pigment could give a satisfactory result, Gris was led by his own rigorous logic to use a fragment of a real mirror[5]. Thus, as Raynal explains, painting escapes the danger of falling back into its old imitative, illusionistic ways.

The Beginnings of Cubism

1912

In 1902, at the beginning of the autumn, a young painter, de Vlaminck, then living on the Ile de la Grenouillère, was painting the bridge at Chatou. He was painting quickly, using pure colours, and his picture was nearly finished when he heard a cough behind him. It was another painter, André Derain, who was examining his work with interest. The newcomer excused his curiosity on the ground that he too was a painter, and gave his name. The ice was broken. They talked about painting. Maurice de Vlaminck knew the works of the impressionists—Manet, Monet, Sisley, Degas, Renoir, Cézanne—which Derain did not yet know. They also talked of Van Gogh and Gauguin. Night came, and in the rising mist the two young artists went on talking until midnight.

This first meeting was the start of a serious and friendly relationship.

In his wanderings through the villages by the Seine, Vlaminck, always on the alert for unusual works of art, had bought from second-hand shops a number of sculptures—masks and fetishes—carved in wood by Negro artists in French Africa and brought back by sailors or explorers. In these grotesque and crudely mystical works he probably found analogies with the paintings, engravings and sculptures in which Gauguin drew inspiration either from Breton crosses or from the savage sculptures of the South Sea islands where he had withdrawn to escape from European civilisation.

However that may be, these strange African images made a profound impression on Derain, who studied them sympathetically, marvelling at the art with which the image-makers of Guinea or the Congo managed to reproduce the human figure without using any element taken from direct vision. Coming at a time when the impressionists had at last set painting free from the fetters of academicism, Maurice de Vlaminck's fondness for barbaric sculptures and André Derain's meditations on these same curious objects were to have a great influence on the destinies of French art.

At about the same time there lived in Montmartre an adolescent with restless eyes, whose face recalled those of both Raphael and Forain. Pablo Picasso, who from the age of sixteen had acquired a kind of fame by can-

vases in which people detected a certain affinity with the cruel paintings of Forain, had abruptly renounced this manner and begun to paint mysterious works in a deep blue. He had quarters in that odd wooden building in the Rue Ravignan where so many artists now famous, or on the way to becoming so, lived. I met him there in 1905. His renown did not yet extend beyond the limits of the Butte. His blue electrician's overall, his sometimes cruel wit and the strangeness of his art were well known throughout Montmartre. His studio, cluttered with canvases representing mystical harlequins and with drawings on which one walked and was always treading, and which anyone was allowed to take away, was the rendezvous of all the young artists and poets.

That year André Derain met Henri Matisse, and from this meeting was born the famous school of the fauves, which included a great number of young artists destined to become cubists.

I note this meeting because it is worth while to make clear the part played by André Derain, an artist who came from Picardy, in the evolution of French art.

In the following year he made friends with Picasso, and this friendship had as its almost immediate effect the birth of cubism, which was the art of painting new wholes with elements taken, not from the reality of vision, but from the reality of conception. Everyone has the feeling of this inner reality. There is, in fact, no need to be a cultivated man to conceive, for instance, that a chair, however you place it, does not cease to have four legs, a seat and a back.

The cubist canvases of Picasso, Braque, Metzinger, Gleizes, Léger, Juan Gris, etc., provoked the wit of Henri Matisse, who, struck by the geometrical look of these paintings in which the artists had tried to render essential reality with great purity, coined the burlesque nickname 'cubism' which was so quickly to make its way in the world. The young painters adopted it at once, because in representing *conceived* reality the artist can give the appearance of three dimensions. He could not do so by simply rendering *seen* reality unless he were to practise *trompe-l'œil* illusionism, through foreshortening or perspective, which would deform the quality of the conceived form.

Soon new tendencies manifested themselves within cubism. Picabia and Marcel Duchamp, breaking with the conceptualist formula, turned to an art completely free of rules. Delaunay for his part began inventing in silence an art of pure colour. And so we are moving towards an entirely new art

which will be to painting, as hitherto envisaged, what music is to poetry. It will be pure painting. Whatever may be thought of so hazardous an attempt, one cannot deny that these artists are sincere in their convictions and worthy of our respect.

'Les Commencements du cubisme', *Le Temps*, Paris, 14 October 1912

During the exhibition of *La Section d'Or*, Apollinaire published this history of cubism, based in large part on his own experience. It is thus authoritative, if allowance is made for Apollinaire's occasional errors of memory and his limitations as a judge of visual art. Vlaminck, for example, knew Derain by 1900[1], and not in 1902. Apollinaire also overestimates Derain's art and Derain's influence on Picasso. The two were close friends for many years and were often together until the First World War. But it is hard to see what influence Derain's art could have had on Picasso, except for the fact that by 1906 Derain was responding in his paintings both to Cézanne and to African sculpture. Picasso soon far outdistanced Derain in his use of these two sources, and by 1910 Derain's art was already conservative in relation to that of his contemporaries (see *Ill. 27*).

Collection " Tous les Arts

ALBERT GLEIZES & JEAN METZINGER

DU

"CUBISME"

NEUVIÈME ÉDITION

PARIS
EUGÈNE FIGUIÈRE ET C.º, ÉDITEURS
RUE CORNEILLE, 7

Tous droits réservés pour tous pays y compris la Russie.

Cubism

1912

To understand Cézanne is to foresee cubism. Henceforth we are justified in saying that between this school and previous manifestations there is only a difference of intensity, and that in order to assure ourselves of this we have only to study the methods of this realism, which, departing from the superficial reality of Courbet, plunges with Cézanne into profound reality, growing luminous as it forces the unknowable to retreat.

Some maintain that such a tendency distorts the curve of tradition. Do they derive their arguments from the future or the past? The future does not belong to them, as far as we are aware, and one must needs be singularly ingenuous to seek to measure that which exists by that which exists no longer.

Unless we are to condemn all modern painting, we must regard cubism as legitimate, for it continues modern methods, and we should see in it the only conception of pictorial art now possible. In other words, at this moment cubism *is* painting.

Here we should like to demolish a very general misunderstanding to which we have already made allusion. Many consider that decorative considerations should govern the spirit of the new painters. They cannot see that a decorative work is the antithesis of the picture.

A decorative work exists only by virtue of its destination; it is animated only by the relationship existing between it and the given objects. Essentially dependent, necessarily incomplete, it must in the first place satisfy the mind so as not to distract it from the spectacle which justifies and completes it. It is an organ.

The true picture, on the other hand, bears its *raison d'être* within itself. It can be moved from a church to a drawing-room, from a museum to a study. Essentially independent, necessarily complete, it need not immediately satisfy the mind: on the contrary, it should lead it, little by little, towards the fictitious depths in which the co-ordinative light resides. It does not harmonize with this or that ensemble; it harmonizes with things in general, with the universe: it is an organism . . .

Dissociating, for convenience, things that we know to be indissolubly united, let us study, by means of form and colour, the integration of plastic consciousness.

To discern a form implies, besides the power to see and to be moved, a certain development of the mind; in the eyes of most people the external world is amorphous.

To discern a form is to verify against a pre-existing idea; this is an act that no one, save the man we call an artist, can accomplish without external assistance.

In the presence of some natural spectacle, a child, in order to co-ordinate his sensations and to subject them to mental control, compares them with his picture-book; a man, culture intervening, makes reference to works of art.

The artist, having discerned a form which presents a certain intensity of analogy with his pre-existing idea, prefers it to other forms, and consequently—for we like to force our preferences on others—he endeavours to enclose the quality of this form (the unmeasurable sum of the affinities perceived between the visible manifestation and the tendency of his mind) in a symbol likely to affect others . . .

Let the picture imitate nothing; let it nakedly present its *raison d'être*. We should indeed be ungrateful were we to deplore the absence of all those things—flowers, or landscape, or faces—whose mere reflection it might have been. Nevertheless, let us admit that the reminiscence of natural forms cannot be absolutely banished; not yet, at all events. An art cannot be raised to the level of a pure effusion at the first step.

This is understood by the cubist painters, who indefatigably study pictorial form and the space which it engenders.

This space we have negligently confounded with pure visual space or with Euclidian space.

Euclid, in one of his postulates, speaks of the indeformability of figures in movement, so we need not insist upon this point.

If we wished to relate the space of the painters to geometry, we should have to refer it to the non-Euclidian mathematicians; we should have to study, at some length, certain of Riemann's theorems.

As for visual space, we know that it results from the agreement of the sensations of convergence and 'accommodation' in the eye.

For the picture, a plane surface, the 'accomodation' is useless. The convergence which perspective teaches us to represent cannot evoke the idea of

depth. Moreover, we know that even the most serious infractions of the rules of perspective by no means detract from the spatiality of a painting. The Chinese painters evoke space, although they exhibit a strong partiality for *divergence*.

To establish pictorial space, we must have recourse to tactile and motor sensations, indeed to all our faculties. It is our whole personality, contracting or dilating, that transforms the plane of the picture. Since in reaction this plane reflects the viewer's personality back upon his understanding, pictorial space may be defined as a sensible passage between two subjective spaces.

The forms which are situated within this space spring from a dynamism which we profess to command. In order that our intelligence may possess it, let us first exercise our sensibility. There are only *nuances;* form appears endowed with properties identical with those of colour. It can be tempered or augmented by contact with another form; it can be destroyed or emphasized; it is multiplied or it disappears. An ellipse may change its circumference because it is inscribed in a polygon. A form which is more emphatic than the surrounding forms may govern the whole picture, may imprint its own effigy upon everything. Those picture-makers who minutely imitate one or two leaves in order that all the leaves of a tree may seem to be painted, show in a clumsy fashion that they suspect this truth. An illusion, perhaps, but we must take it into account. The eye quickly interests the mind in its errors. These analogies and contrasts are capable of all good and all evil; the masters felt this when they tried to compose with pyramids, crosses, circles, semicircles, etc.

To compose, to construct, to design, reduces itself to this: to determine by our own activity the dynamism of form.

Some, and they are not the least intelligent, see the aim of our technique in the exclusive study of volumes. If they were to add that it suffices, surfaces being the limits of volumes and lines those of surfaces, to imitate a contour in order to represent a volume, we might agree with them; but they are thinking only of the sensation of *relief,* which we hold to be insufficient. We are neither geometers nor sculptors: for us lines, surfaces, and volumes are only modifications of the notion of fullness. To imitate volumes only would be to deny these modifications for the benefit of a monotonous intensity. As well renounce at once our desire for variety.

Between reliefs indicated sculpturally we must contrive to hint at those lesser features which are suggested but not defined. Certain forms should remain implicit, so that the mind of the spectator may be the chosen place of their concrete birth.

We must also contrive to break up, by large restful surfaces, all regions in which activity is exaggerated by excessive contiguities.

In short, the science of design consists in instituting relations between straight lines and curves. A picture which contained only straight lines or curves would not express existence.

It would be the same with a picture in which curves and straight lines exactly compensated one another, for exact equivalence is equal to zero.

The diversity of the relations of line to line must be indefinite; on this condition it incorporates the quality, the unmeasurable sum, of the affinities perceived between what we discern and what pre-exists within us: on this condition a work of art moves us.

What the curve is to the straight line the cold tone is to the warm tone in the domain of colour . . .

The law of contrast, old as the human eye, and on which Seurat judiciously insisted, was promulgated with much clamour, and none of those who flattered themselves the most on their sensitivity had enough of it to perceive that to apply the law of complementaries without tact is to deny it. It is only of value by the fact of automatic application, and only demands a delicate handling of values.

It was then that the cubists taught a new manner of regarding light.

According to them, to illuminate is to reveal; to colour is to specify the mode of revelation. They call luminous that which strikes the imagination, and dark that which the imagination has to penetrate.

We do not mechanically connect the sensation of white with the idea of light, any more than we connect the sensation of black with the idea of darkness. We admit that a black jewel, even if of a dead black, may be more luminous than the white or pink satin of its case. Loving light, we refuse to measure it, and we avoid the geometrical ideas of the focus and the ray, which imply the repetition—contrary to the principle of variety which guides us—of bright planes and sombre intervals in a given direction. Loving colour, we refuse to limit it, and subdued or dazzling, fresh or muddy, we accept all the possibilities contained between the two extreme points of the spectrum, between the cold and the warm tone.

Here are a thousand tints which issue from the prism, and hasten to range themselves in the lucid region forbidden to those who are blinded by the immediate . . .

If we consider only the bare fact of painting, we attain a common ground of understanding.

Who will deny that this fact consists in dividing the surface of the canvas and investing each part with a quality which must not be excluded by the nature of the whole?

Taste immediately dictates a rule: we must paint so that no two portions of similar extent are to be found in the picture. Common sense approves, and explains: let one portion repeat another, and the whole becomes measurable; the work, ceasing to be an expression of our personality (which cannot be measured, as nothing in it ever repeats itself), fails to do what is expected of it.

The inequality of parts being granted as a prime condition, there are two methods of regarding the division of the canvas. According to the first, all the parts are connected by a rhythmic convention which is determined by one of them. This—its position on the canvas matters little—gives the painting a centre from which the gradations of colour proceed, or towards which they tend, according as the maximum or minimum of intensity resides there.

According to the second method, in order that the spectator, himself free to establish unity, may apprehend all the elements in the order assigned to them by creative intuition, the properties of each portion must be left independent, and the plastic continuum must be broken into a thousand surprises of light and shade.

Hence two methods apparently inimical.

However little we know of the history of art, we can readily mention names to illustrate either method. The interesting point is to reconcile the two.

The Cubist painters endeavour to do so, and whether they partially break the tie proclaimed by the first method, or confine one of those forces which the second method would leave free, they achieve that superior disequilibrium without which we cannot conceive lyrical art.

Both methods are based on the kinship of colour and form.

Although of a hundred thousand living painters only four or five appear to perceive it, a law here asserts itself which is to be neither discussed nor interpreted, but rigorously followed.

Every inflection of form is accompanied by a modification of colour, and every modification of colour gives birth to a form.

There are tints which refuse to wed certain lines; there are surfaces which cannot support certain colours, repelling them to a distance or sinking under them as under too heavy a weight.

To simple forms the fundamental hues of the spectrum are allied, and fragmentary forms should assume shimmering colours.

Nothing surprises us so greatly as to hear someone praising the colour of a picture and finding fault with the drawing. The impressionists afford no excuse for such absurdity. Although in their case we may have deplored the poverty of form and at the same time praised the beauties of their colouring, it was because we confined ourselves to regarding them as precursors.

In any other case we flatly refuse to perpetuate a division contrary to the vital forces of the painter's art.

Only those who are conscious of the impossibility of imagining form and colour separately can usefully contemplate conventional reality.

There is nothing real outside ourselves; there is nothing real except the coincidence of a sensation and an individual mental direction. Far be it from us to throw any doubts upon the existence of the objects which strike our senses; but, rationally speaking, we can only have certitude with regard to the images which they produce in the mind.

It therefore amazes us when well-meaning critics try to explain the remarkable difference between the forms attributed to nature and those of modern painting by a desire to represent things not as they appear, but as they are. As they are! How are they, what are they? According to them, the object possesses an absolute form, an essential form, and we should suppress chiaroscuro and traditional perspective in order to present it. What simplicity! An object has not one absolute form; it has many. It has as many as there are planes in the region of perception. What these writers say is marvellously applicable to geometrical form. Geometry is a science; painting is an art. The geometer measures; the painter savours. The absolute of the one is necessarily the relative of the other; if logic takes fright at this idea, so much the worse! Will logic ever prevent a wine from being different in the retort of the chemist and in the glass of the drinker?

We are frankly amused to think that many a novice may perhaps pay for his too literal comprehension of the remarks of one cubist, and his faith in the existence of an Absolute Truth, by painfully juxtaposing the six faces of a cube or the two ears of a model seen in profile.

Does it ensue from this that we should follow the example of the impressionists and rely upon the senses alone? By no means. We seek the essential, but we seek it in our personality and not in a sort of eternity, laboriously divided by mathematicians and philosophers.

Moreover, as we have said, the only difference between the impressionists and ourselves is a difference of intensity, and we do not wish it to be otherwise.

There are as many images of an object as there are eyes which look at it; there are as many essential images of it as there are minds which comprehend it.

But we cannot enjoy in isolation; we wish to dazzle others with that which we daily snatch from the world of sense, and in return we wish others to show us their trophies. From a reciprocity of concessions arise those mixed images, which we hasten to confront with artistic creations in order to compute what they contain of the objective; that is of the purely conventional.

from *Du Cubisme*, Paris, 1912, pp. 9–11, 13–14, 17–21, 25–32.
In English in Robert L. Herbert, *Modern Artists on Art*, New York, 1964

Of all the critical and theoretical writings on cubism, none had such influence as *Du Cubisme*. It was the first book devoted wholly to cubism, written by two of the artists most familiar to the public, and thus it immediately received attention in France and in advanced artistic circles throughout Europe.

Du Cubisme was a true collaborative effort, to which Metzinger contributed both his ideas and his literary talents. He had met Albert Gleizes (1881–1953) at the home of Alexandre Mercereau in 1910[1]; and their book grew out of a series of long conversations between the authors, but it also reflects the consensus of group discussions at Puteaux that included the Duchamp brothers[2]. Gleizes and Metzinger wrote the text during 1912; its publication was announced in March, 1912[3] and again in October[4], but the date of printing in the French edition is 27 December 1912. In 1913 there were numerous foreign editions: an English edition was published in London and two Russian editions in Moscow. A long excerpt was translated and published in Prague, which was the centre of a school of Czech cubists, largely as a result of the activities of the cubist collector Kramar.

The book contains much pure rhetoric that has little or nothing to do with its subject, but in the passages quoted here the essential theoretical ideas of the authors are clear. The cubists' debt to Cézanne; the anti-decorative yet autonomous qualities of a cubist painting; forms in cubist art as manifestations of previously existing ideas; most of these are themes which had been discussed by earlier writers, but which received their definitive expression here. Even the author's metaphorical reference to non-Euclidean geometry, of which they knew hardly anything at all, is only a restatement of the similarly poetic reference to the 'Fourth Dimension', which originated with Apollinaire in 1911[5]; both terms have ever since served only

to obscure the understanding of cubism with a pseudo-scientific mysticism. Metzinger went so far as to exhibit in early 1913 a painting to which he gave the title *Nature morte (4me dimension)*[6].

The sections on drawing, colour, and composition are almost dogmatic and reveal that unfortunate tendency toward orthodoxy and codification which would later emerge in the works of minor cubists during the 1920's. *Du Cubisme* all too easily became a manual for the numerous mediocre artists who were soon to form what might be called a school of academic cubism.

24 Guillaume Apollinaire

Modern Painting

1913

... Likewise there are new tendencies in modern painting; the most significant seem to me to be, on the one hand, Picasso's cubism and, on the other, Delaunay's orphism. Orphism sprang from Matisse and the movement of the 'fauves'; that is, from their anti-academic and luminous tendency.

Picasso's cubism arose from a movement that stems from Derain.

André Derain, a restless personality in love with form and colour, showed more than individual promise when he awoke to art, for when he came into contact with other painters, he showed that he was able to awaken their own individuality. In Matisse he aroused the feeling for symbolic colours, in Picasso the feeling for new and sublime forms. After this, Derain lived in retirement and forgot for a while to take part in the art of his time.—The most important of his works are the peaceful, deep pictures painted up to 1910, which exercised such an influence, and some woodcuts he made for my book *L'Enchanteur pourrissant*. These gave the signal for a renaissance of the woodcut, with a more pliant, broader technique than, for instance, Gauguin's; this revival of the woodcut spread all over Europe.

Now for the main tendencies of modern painting. Authentic cubism—if one wants to express oneself absolutely—would be the art of depicting new wholes with formal elements borrowed not from the reality of vision, but from that of conception.

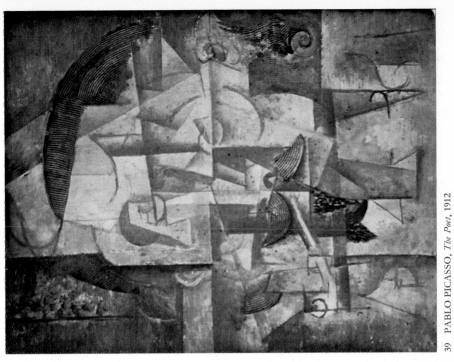

39 PABLO PICASSO, *The Poet*, 1912

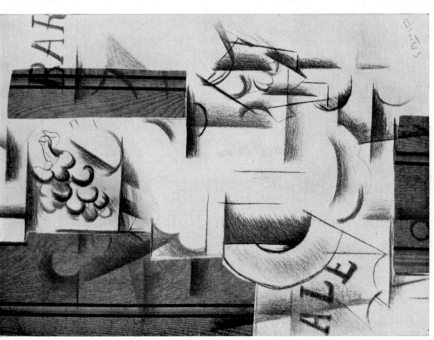

38 GEORGES BRAQUE, *Still-life with Fruit-dish and Glass*,
Sorgues September 1912

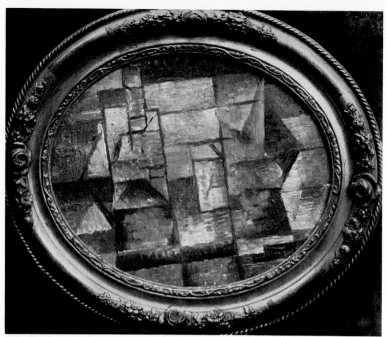

40 GEORGES BRAQUE, *Still-life with Decanter and Glass*, 1910–11

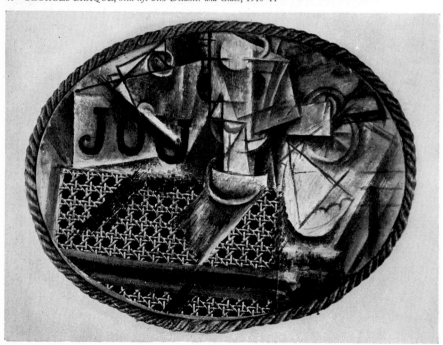

41 PABLO PICASSO, *Still-life with Chair-caning*, 1912

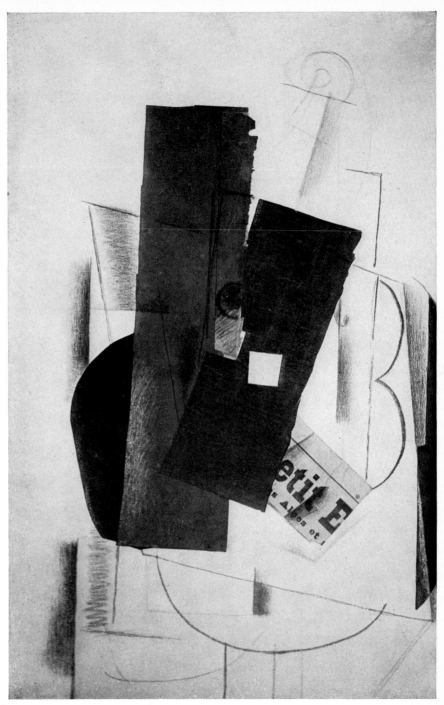

42 GEORGES BRAQUE, *Still-life with Mandoline, Violin and Newspaper*, 1913

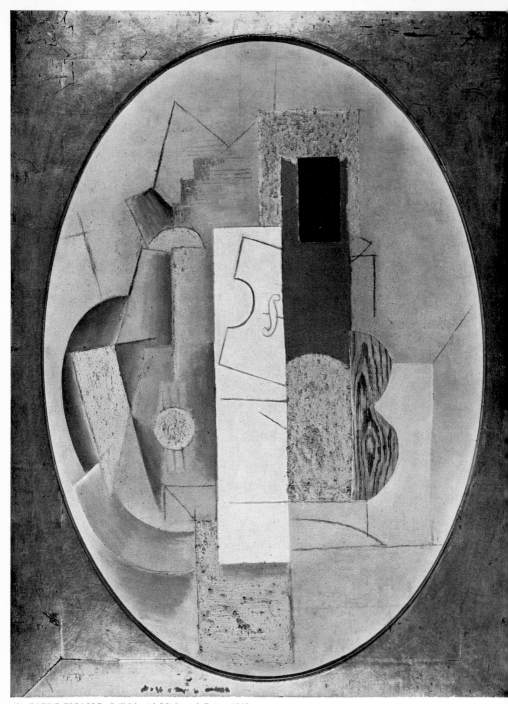

43 PABLO PICASSO, *Still-life with Violin and Guitar*, 1913

This tendency leads to a poetic kind of painting which stands outside the world of observation; for, even in a simple cubism, the geometrical surfaces of an object must be opened out in order to give a complete representation of it; and this compels the artist—especially when the object is a complex one—to produce an image which, even if one took the trouble to understand it, would itself look quite unlike the object whose objective reality it was intended to represent.

The legitimacy of such painting is not in question. Everyone must agree that a chair, from whichever side it is viewed, never ceases to have four legs, a seat and a back, and that, if it is robbed of one of these elements, it is robbed of an important part. And the Primitives painted a town not as the people in the foreground would have been able to see it, but as it was in reality: that is, complete, with its gates, streets and towers. A great many novelties that have been introduced into pictures of this kind bear witness daily to this human and poetical quality.

Picasso and Braque incorporated in some of their pictures letters from labels and other printed matter, because label, notice and advertisement play a very important aesthetic role in the modern city and are well-suited for incorporation into works of art. Picasso has sometimes dispensed with ordinary paints and made reliefs from cardboard and pictures from pieces of paper pasted together: when he does so he obeys a plastic inspiration, and these strange, uncouth and ill-matching materials become noble because the artist confers on them his own strong and sensitive personality . . .

'Die moderne Malerei', *Der Sturm*, No. 148–9, Berlin, February, 1913, p. 272

The essay from which this text is taken was originally given as a lecture by Apollinaire in Berlin during January, 1913. The occasion was an exhibition of Delaunay at the gallery of the review *Der Sturm*.

Two notable aspects of this essay deserve attention. Apollinaire describes the new freedom that Picasso and Braque had found with the invention of collage, which they had begun to make in 1912, using a wide range of materials; Apollinaire's is one of the earliest published references to this radical innovation. Gris, as we have already seen (text 21), was quick to adopt this new approach.

The second feature of this essay is Apollinaire's image of a chair and of the essentials it must have to be recognizable as such (see also text 22). In so doing he describes that characteristic of 'synthetic' cubism which relates it to the method of eidetic reduction in Husserl's phenomenology.

TOUS LES ARTS

COLLECTION

PUBLIÉE SOUS LA DIRECTION DE
M. GUILLAUME APOLLINAIRE

GUILLAUME APOLLINAIRE

Méditations Esthétiques]

Les Peintres Cubistes

PREMIÈRE SÉRIE

Pabl: PICASSO — Georges BRAQUE — Jean METZINGER
Albert GLEIZES Juan GRIS — Mlle Marie LAURENCIN
Fernand LÉGER — Francis PICABIA — Marcel DUCHAMP
Duchamp-VILLON, etc.

OUVRAGE ACCOMPAGNÉ DE 46 PORTRAITS ET REPRODUCTIONS HORS TEXTE

PARIS
EUGÈNE FIGUIÈRE ET Cᵉ, ÉDITEURS
7, RUE CORNEILLE, 7
MCMXIII

Tous droits réservés pour tous pays y compris la Russie, la Norvège et la Russie.

25 Guillaume Apollinaire

 The Cubist Painters

 1913

Chapter 2 [February 1912]

Many new painters limit themselves to pictures which have no real subjects, and the titles which we find in the catalogues are like proper names, which designate men without characterizing them.

There are men named Stout who are in fact quite thin, and others named White who are very dark; well now, I have seen pictures entitled *Solitude* containing many human figures.

In the cases in question, the artists even condescend at times to use vaguely explanatory words such as *Portrait, Landscape, Still-Life;* however, many young painters use as a title only the very general term *Painting.*

These painters, while they still look at nature, no longer imitate it, and carefully avoid any representation of natural scenes observed and reconstructed from preliminary studies.

Verisimilitude no longer has any importance, since everything is sacrificed by the artist to truth, to the necessities of a higher nature, whose existence he assumes but does not lay bare. The subject has little or no importance any more.

Generally speaking, modern art repudiates most of the techniques of pleasing devised by the great artists of the past.

While the goal of painting is today, as always, the pleasure of the eye, the art-lover is henceforth asked to expect delights other than those which looking at natural objects can easily provide.

Thus we are moving towards an entirely new art which will stand, with respect to painting as envisaged heretofore, as music stands to literature.

It will be pure painting, just as music is pure literature.

The music-lover experiences, in listening to a concert, a joy of a different order from the joy given by natural sounds, such as the murmur of the brook, the uproar of a torrent, the whistling of the wind in a forest, or the harmonies, based on reason rather than aesthetics, of human speech.

In the same way the new painters will provide their admirers with artistic sensations by concentrating exclusively on the problem of creating harmony with unequal lights . . .

The secret aim of the young painters of the extremist schools is to produce pure painting. Theirs is an entirely new plastic art. It is still in its beginnings, and is not yet as abstract as it would like to be. Most of the new painters depend a good deal on mathematics, without knowing it; but they have not yet abandoned nature, which they still question patiently, hoping to learn the way of Life.

A man like Picasso studies an object as a surgeon dissects a corpse.

This art of pure painting, if it succeeds in freeing itself from the art of the past, will not necessarily cause the latter to disappear; the development of music has not brought in its train the abandonment of the various genres of literature, nor has the acridity of tobacco supplanted the savour of food.

Chapter 3 [November 1911–April 1912]
The new artists have been violently attacked for their preoccupation with geometry. Yet geometrical figures are the essence of drawing. Geometry, the science of space, its dimensions and relations, has always determined the norms and rules of painting.

Until now, the three dimensions of Euclid's geometry have satisfied the restlessness of great artists yearning for the infinite.

The new painters do not propose, any more than did their predecessors, to be geometers. But it may be said that geometry is to the plastic arts what grammar is to the art of the writer. Today, scientists no longer limit themselves to the three dimensions of Euclid. The painters have been led quite naturally, one might say by intuition, to preoccupy themselves with the new possibilities of spatial measurement which, in the language of the modern studios, are designated by the term 'The Fourth Dimension'.

Regarded from the plastic point of view, the Fourth Dimension appears to spring from the three known dimensions: it represents the immensity of space eternalizing itself in all directions at any given moment. It is space itself, the dimension of the infinite; the Fourth Dimension endows objects with plasticity. It gives the object its right proportions on the whole, whereas in Greek art, for instance, a somewhat mechanical rhythm constantly destroys the proportions . . .

Chapter 4 [April 1912]

Wishing to attain the proportions of the ideal, to be no longer limited to the human, the young painters offer us works which are more cerebral than sensual. They discard more and more the old art of optical illusion and local proportion, in order to express the grandeur of metaphysical forms. This is why contemporary art, even if it does not directly stem from specific religious beliefs, nonetheless possesses some of the characteristics of great, that is to say, religious art.

Chapter 7 [October 1912]

Cubism differs from the old schools of painting in that it is not an art of imitation, but an art of conception which tends towards creation.

In representing conceptualized reality or creative reality, the painter can give the effect of three dimensions. He can to a certain extent cube. But not by simply rendering reality as seen, unless he indulges in *trompe-l'œil,* in foreshortening, or in perspective, thus distorting the quality of the forms conceived or created.

I can discriminate four tendencies in cubism. Of these, two are parallel and pure.

Scientific cubism is one of the pure tendencies. It is the art of painting new structures out of elements borrowed not from the reality of sight, but from the reality of insight. All men have a sense of this interior reality. A man does not have to be cultivated in order to conceive, for example, of a round form.

The geometrical aspect, which made such an impression on those who saw the first canvases of the scientific cubists, came from the fact that the essential reality was rendered with great purity, while visual accidents and anecdotes had been eliminated. The painters who follow this tendency are: Picasso, whose luminous art also belongs to the other pure tendency of cubism, Georges Braque, Albert Gleizes, Marie Laurencin and Juan Gris.

Physical cubism is the art of painting new structures with elements borrowed, for the most part, from visual reality. This art, however, belongs in the cubist movement because of its constructive discipline. It has a great future as historical painting. Its social role is very clear, but it is not a pure art. It confuses what is properly the subject with images. The painter-physicist who created this trend is Le Fauconnier.

Orphic cubism is the other important trend of the new school. It is the art of painting new structures with elements which have not been borrowed from the visual sphere, but have been created entirely by the artist himself, and been endowed by him with fullness of reality. The works of the orphic artist must simultaneously give a pure aesthetic pleasure; a structure which is self-evident; and a sublime meaning, that is, a subject. This is pure art. The light in Picasso's paintings is based on this conception, which Robert Delaunay is also in the process of discovering and towards which Fernand Léger, Francis Picabia, and Marcel Duchamp are also directing their energies.

Instinctive cubism is the art of painting new structures with elements which are not borrowed from visual reality, but are suggested to the artist by instinct and intuition; it has long tended towards orphism. The instinctive artist lacks lucidity and an aesthetic doctrine; instinctive cubism includes a large number of artists. Born of French impressionism, this movement has now spread all over Europe.

Cézanne's last paintings and his watercolours belong to cubism, but Courbet is the father of the new painters; and André Derain, whom I propose to discuss some other time, was the eldest of his beloved sons, for we find him at the beginning of the fauvist movement, which was a kind of introduction to cubism, and also at the beginning of this great subjective movement; but it would be too difficult today to write discerningly of a man who so wilfully stands apart from everyone and everything.

The modern school of painting seems to me the most audacious that has ever appeared. It has posed the question of what is beautiful in itself.

It wants to visualize beauty disengaged from whatever charm man has for man, and until now, no European artist has dared attempt this. The new

artists demand an ideal beauty, which will be, not merely the proud expression of the species, but the expression of the universe, in so far as it has been humanized by light.

The new art clothes its creations with a magnificence which surpasses anything else conceived by the artists of our time. Ardent in its search for beauty, it is noble and energetic, and the reality it brings us is marvellously clear. I love the art of today because above all else I love the light; for man loves the light more than anything; it was he who invented fire.

Picasso [Mid-1912]

Then Picasso sharply questioned the universe. He accustomed himself to the immense light of depths. And sometimes he did not scorn to make use of actual objects, a twopenny song, a real postage stamp, a piece of oil-cloth furrowed by the fluting of a chair. The painter would not try to add a single picturesque element to the truth of these objects.

Surprise laughs savagely in the purity of light, and it is perfectly legitimate to use numbers and printed letters as pictorial elements; new in art, they are already steeped in humanity.

It is impossible to envisage all the consequences and possibilities of an art so profound and so meticulous.

The object, real or represented in *trompe-l'œil*, is clearly called upon to play a more and more important role. The object is the inner frame of the picture and marks the limits of its depth just as the outer frame marks its external limits.

Representing planes to denote volumes, Picasso gives so complete and so decisive an enumeration of the various elements which make up the object that these do not take the shape of the object. This is largely due to the effort of the viewer, who is forced to see all the elements simultaneously just because of the way they have been arranged.

Is this art profound rather than noble? It does not dispense with the observation of nature, and acts upon us as intimately as nature herself . . .

As for me, I am not afraid of art, and I have not one prejudice with regard to the painter's materials.

Mosaicists paint with marble or coloured wood. There is mention of an Italian artist who painted with excrement; during the French revolution blood served somebody as paint. You may paint with whatever material you please, with pipes, postage stamps, postcards or playing cards, candelabra, pieces of oil-cloth, collars, wallpaper or newspaper . . .

from *Les Peintres cubistes*, Paris 1913, pp. 11–18, 24–7, 35–6, 38; English ed. *The Cubist Painters*, New York, 1944, pp. 11–14, 17–18, 21–3

Les Peintres Cubistes, published on 17 March 1913, is among the most misunderstood documents of modern art. It was not intended originally to be specifically a study of cubism; *Méditations Esthétiques*, the author's choice for the title, was virtually suppressed, with highly misleading results. The book was an assemblage of many previously published articles[1], stitched together here by Apollinaire and presented in no strict chronological order. The earliest parts date from 1905, and barely half the text was written after the early spring of 1912. A recent study of *Les Peintres Cubistes*, based on original manuscripts, has done much to clarify the confusion surrounding this book[2].

Les Peintres Cubistes may be divided into two main parts. The first, comprising seven chapters, is on contemporary painting in general; the second is a series of essays on each of ten artists. Chapter I was first published in 1908; chapters II–VI were published in their original versions in separate issues of the *Soirées de Paris*, early in 1912; chapter VII dates from the autumn of 1912. The section on Picasso contains excerpts from an article of 1905, followed by a section written in 1912; for the chapter on Braque, Apollinaire adapted his 1908 introduction to the exhibition at Kahnweiler's gallery (see text 3). It was only for the sections on Metzinger, Gleizes, Gris, Léger, Picabia, Duchamp, and Duchamp-Villon that Apollinaire wrote new texts in 1912.

Chapter II, first published as an article, 'Du sujet dans la peinture moderne'[3] was in its original form the source for the idea of 'pure' painting which became widespread in 1912 (see text 21) and after. But the parallel which Apollinaire draws with music is by no means new; it was a recurrent theme in later nineteenth-century aesthetics.

Chapter III, which began as a lecture given in November, 1911[4], was, when published in the spring of 1912[5], the first instance of speculation about the 'Fourth Dimension' and non-Euclidean geometry, ideas which became popular with later apologists for cubism. One can only conjecture as to where Apollinaire himself got this notion, unless possibly from contemporary popularizations of Einstein's 1905 special theory of relativity. It should be noted that there have been several recent attempts to draw parallels between cubism and science; the most interesting of these have been by Paul Laporte, who has sought to show the equivalence between the space-time relationship in cubist painting and the ideas of relativity in the work of Einstein and other twentieth-century scientists[6]. While undoubtedly a rough metaphorical parallel may legitimately be made, it would seem dangerous to extend it too far, or to seek exact correspondences in this period between the two realms of human activity, which in the early twentieth century were hardly as interrelated

as they were in the Renaissance or even in neo-impressionism. One may also question whether the idea of space-time in cubism is not in itself based on a misunderstanding; one may speak just as easily of the notation of a conception of reality derived from the accumulated memories of sense experience.

It is chapter VII of *Les Peintres Cubistes* that has caused the greatest mischief in the understanding of cubism. Apollinaire classes the artists by tendencies—'scientific', 'physical', 'orphic', 'instinctive'—which have only the most superficial relation to the real differences between the artists. This section began as a lecture Apollinaire gave in October 1912, at the exhibition of *La Section d'Or*, and it is really a defence in loose terms of all the *avant-garde* painters of whom Apollinaire approved.

The section on Picasso quoted here dates from mid-1912, with revisions in the autumn of that year. In it Apollinaire comments on the new development of collage which he was to discuss briefly elsewhere (see text 24), and describes Picasso's first collage of May 1912 *(Ill. 41)*. Apollinaire is furthermore quite aware of the great opportunities presented by this innovation: he recognizes that, with *papier collé* and collage, traditional pictorial space is finally discarded—that there is no illusionistic depth behind the pasted papers and other materials; and that these materials also are not illusory but must be understood as real objects, signifying themselves. Thus Apollinaire, despite the poetic vagueness of many of his writings on art, has here grasped and expressed the crucial importance of collage cubism, perhaps the most far-reaching invention of the entire cubist movement.

26 Charles Lacoste

On 'Cubism' and Painting

1913

In their turn the 'cubist' painters . . . realized one day that it would be interesting to paint things not as they appear before our eyes, but as one sees them in the mind: instead of confining oneself to reproducing an object as it looks when one observes nature—that is, from one point of view only—one could try to represent it as it appears in the imagination, where we have not only an awareness but a real simultaneous vision of all its faces. And since this has to be done on a plane the object must be given a form which will synthesize all its aspects, or rather the single complex aspect it has in our mind. This synthetic form will no longer show a profile of an object with its relief con-

veyed by the play of light and shade, but will express its *cube;* that is to say, it will show the sides we do not see together with the side we do see. It will depict the object as one knows it is—that is, from several angles at one time; and these angles will be those which we decide (each according to his temperament) to be the main ones, the ones capable of yielding a complete representation of the object. To render this inevitably complex synthetic form decipherable, it is necessary also to simplify it, to reduce it to its elements . . .

'Sur le "cubisme" et la peinture', *Temps present*, Paris, 2 April 1913, pp. 335–6

Charles Lacoste (1870–?) was a competent but far from revolutionary painter who exhibited in a late Impressionist style at the pre-World War I Paris salons. His essay on cubism is nevertheless noteworthy in that it introduces for the first time the idea of 'synthetic' cubism, in the same sense that critics use it today. Thus the term 'synthetic', like 'analytical' in 1910 (see text 10), was known and employed contemporaneously with this new phase of cubism and was not a later invention of Kahnweiler, as some writers have suggested.

27 Fernand Léger

The Origins of Painting and its Representational Value

1913

Without having the presumption to try to explain the aim and methods of an art that is already at quite an advanced stage of achievement, I shall try to answer, so far as this is possible, one of the questions most often asked by people who see modern pictures. I transcribe this question in all its simplicity: 'What does that represent?' In this talk I shall concentrate on this simple question, and try, very briefly, to prove its complete inanity.

If, in the field of painting, imitation of the object had a value in itself, every picture, by anybody at all, which possessed an imitative quality would also have a value as painting; since I do not think it is necessary to labour the point and discuss such a case, I shall therefore state something which has been said already but needs saying again here: 'The *realistic* value of a work is completely independent of all imitative quality.'

This truth should be recognized as axiomatic in the general understanding of painting.

I am using the word 'realistic' on purpose in its strictest sense, for the quality of a pictorial work is in direct proportion to its quantity of realism.

What is meant by realism in painting?

Definitions are always dangerous, for to enclose a whole concept in a few words requires a concision which over-simplifies and often obscures the issue.

I shall hazard a definition all the same. In my view, pictorial realism is the simultaneous ordering of the three great plastic qualities, line, form and colour.

No work can be truly classical—that is, last independently of the period of its creation—if one completely sacrifices one of these qualities to the detriment [sic] of the other two.

This sort of definition is inevitably rather dogmatic, I know; but I believe that it is necessary in order clearly to distinguish pictures which are classical from those which are not.

All periods have seen facile productions, whose success is as immediate as it is ephemeral, some sacrificing all depth for the sake of the charm of a coloured surface, others being content with a calligraphy and an external form which have even received a name: 'Character Painting'.

I repeat: all periods have had these productions, and despite all the talent they involve, such works remain no more than period pieces. They date; they may astonish, intrigue their own generation, but as they do not possess the factors needed to attain pure realism, they are bound in the end to disappear. In most of the painters who preceded the impressionists these three indispensable factors were closely bound up with the imitation of a subject which in itself carried an absolute value. Portraits apart, all compositions—whether decorative or not—served to illustrate either religious or mythological ideas or the facts of history.

The Impressionists were the first to reject *the absolute value of the subject* and instead to consider *its relative value only*.

That is the historical link which explains modern artistic evolution as a whole. The impressionists are the great originators of the present movement—they are its primitives, in the sense that, trying to free themselves from the imitative aspect, they considered painting in its colour only, almost entirely neglecting form and line.

Their admirable work, which issued from this conception, necessitates the comprehension of a new kind of colour. Their quest for real atmosphere is

still relative to the subject: trees, houses melt together and are closely connected, enveloped in a dynamism of colour which the means at their disposal did not as yet enable them to extend *beyond* colour.

The imitation of the subject that is still a part of their work is therefore still no more than a pretext for variety—a theme and nothing more. To the impressionists a green apple on a red carpet signifies, not the relationship between two objects, but the relationship between two tones, a green and a red.

When this truth had been formulated in living works of art, the present movement was bound to arise. I shall insist particularly on that period of French painting, for I think it is at that moment that the two great concepts of painting—*visual realism* and *realism of conception*—meet, the first completing its curve, which includes all the old painting down to the impressionists, and the second—realism of conception—beginning with them.

Visual realism, as I have said, necessarily involves an object, a subject, and perspective devices that are now considered negative and anti-realist.

Realism of conception, neglecting all this cumbersome baggage, has been achieved in many contemporary paintings.

Among the impressionists one painter, Cézanne, fully understood what was incomplete about impressionism. He felt the necessity of renewing *form* and *design* to match the new *colour* of the impressionists. His life and his work were devoted to the quest for this new synthesis . . .

The great movements in painting have one thing in common at least: they have always proceeded by revolution and reaction, not by evolution.

Manet destroyed in order to create in his own way. Let us go further back: the painters of the eighteenth century, too sensuous and too mannered, were succeeded by David and Ingres and their followers, who adopted—and misused—contrary formulae.

This school necessitates Delacroix who, breaking violently with the preceding idea, returns to sensuousness in colour and a great dynamism in forms and drawing.

These examples are enough to show clearly that the modern concept is not a reaction against the ideas of the impressionists but is, on the contrary, a further development of their ideas and a widening of their aims by the use of means which they neglected.

The 'divisionism'—the fragmentation of colour—which exists, however timidly, in the work of the impressionists, is being succeeded, not by a static contrast, but by a parallel research into the divisionism of form and of drawing.

And so the work of the impressionists is not the end of a movement, but the beginning of another, of which the modern painters are the continuers.

The relationship between volume, line and colour will prove to have been at the root of all the production of recent years and of all the influence exercised upon artistic circles both in France and abroad.

From now on, everything can converge towards an intensity of realism obtained by purely dynamic means.

Painterly contrasts in the purest sense (the use of complementaries in colours, lines and forms) are the basic structural elements of modern pictures.

As in the history of pre-impressionist painting, northern artists will still tend to seek their dynamic means by developing colour, while southern painters will probably give more importance to form and line.

This comprehension of the contemporary painting which has arisen in France is founded on a principle which has universal validity; the Italian futurist movement is one proof of this. Logically, as the picture itself is becoming something greater, output must be restricted.

Every dynamic tendency must necessarily move in the direction of an enlargement of formal means if it is to come to its full expression.

Many people are waiting patiently for the passing of what they call 'a phase' in the history of art; they are waiting for *something else*, and they think that modern artists are going through what is perhaps a necessary stage, but will return one day to 'painting for everyone'.

They are making a great mistake. When an art like this is in possession of all its means, and when these allow it to realize works that are absolutely complete, it is bound to impose itself for a very long time.

We are approaching, I am convinced, a conception of art as all-embracing as those of the great periods of the past: the same tendency to large dimensions, the same collective effort. I should like to dwell on this last point; it has its importance.

Most French literary and artistic movements have manifested themselves in the same way. It is a proof of great vitality and of power to spread. Doubt can be cast on creative work that is isolated; but the vital proof of a work comes when it translates itself *collectively* into highly distinct means of personal expression.

The conception of plastic art as the expression of sentiment is certainly the one closest to the heart of the majority of the public. The old masters, besides achieving purely plastic qualities, had to satisfy this need with their

paintings and to carry out a complex social task: to assist in the expressive function of architecture; and with literary values to instruct, educate and amuse the people. To this end they illustrated churches, monuments and palaces with decorative frescoes and pictures representing the great deeds of humanity. Descriptive art was a necessity of the age.

Modern painters lived like everyone else in an age which was neither more or less intellectual than those which preceded it, but only different. In order to impose a new way of seeing, to destroy all that perspective and sentiment together had helped to accumulate, it was necessary for them to have something more than their daring and their individual conception of art.

If their period had not lent itself to this—if their art had not had some affinity with their own time and if it had not been the result of evolution from the art of the past, it would not have been viable.

Present-day life, more fragmented and faster-moving than preceding periods, was bound to accept, as its means of expression, an art of dynamic 'divisionism'; and the sentimental side, the expression of the subject (in the vulgar sense of the word 'expression'), has reached a critical moment which we must define clearly . . .

Without attempting to make a comparison between the present evolution, with its scientific inventions, and the revolution accomplished at the end of the Middle Ages by Gutenberg's invention in the field of human expression, I am anxious to point out that modern mechanical achievements such as colour photography, the cinematograph, the profusion of more or less popular novels and the popularization of the theatres have made completely superfluous the development of the visual, sentimental, representational and popular subject in painting.

I wonder, indeed, how all those more or less historical or dramatic pictures shown at the French Salons can hope to compete with what is shown on the screen of any cinema in the world.

Visual realism has never been achieved with such intensity in art as it now is in the cinema.

It could still, a few years ago, be maintained that moving pictures at least lacked colour; but colour photography has been invented. 'Subject' pictures no longer have even this resource; their popular appeal, which was their only *raison d'être,* is no more, and the few working-class people who used to be seen in the museums, gaping in front of a cavalry charge by M. Detaille or a historical scene by M. J.-P. Laurens, are no longer to be seen; they are at the cinema.

The average bourgeois also—the man with a small business who, fifty years ago, provided a living for all the minor masters of the suburbs and the provinces—now manages very well without them.

Photography requires less sittings than portrait-painting, gives a more faithful likeness and costs less. The portrait painter is dying out, and genre and history painters will die too; not a heroic death, but simply killed by their period.

One thing will have killed another.

The means of expression having multiplied, plastic art was bound to restrict itself logically to its aim: realism of conception. This was born with Manet, developed in the work of the impressionists and Cézanne, and is coming to its fulfilment in the work of the painters of today.

Architecture itself, stripped of all those representational ornaments, is emerging from several centuries of false traditionalism and approaching a modern and utilitarian idea of its function.

Architectural art is confining itself to its own means: relationships between lines and the achievement of balance between large masses; decorative art itself is becoming plastic and architectural.

Each art is isolating itself and limiting itself to its own field.

Specialization is a characteristic of modern life, and pictorial art, like all other manifestations of the human mind, must submit to it. The law of specialization is a logical one, for by confining each man to the pursuit of a single aim it intensifies the character of his achievements.

This results in a gain in realism in visual art. The modern conception of art is thus not a passing abstraction valid for a few initiates only; it is the total expression of a new generation whose condition it shares and whose aspirations it answers.

'Les Origines de la peinture et sa valeur représentative', *Montjoie!* No. 8, Paris, 29 May 1913, p. 7; No. 9–10, Paris, 14–29 June 1913, pp. 9–10

Fernand Léger was not a member of the intimate circle around Picasso, although he knew Picasso by the end of 1910[1]. Léger lived from his earliest days as an artist on the Left Bank. By 1907 he had met Delaunay[2] with whom he shared many basic attitudes to painting, and an enthusiasm for the work of the Douanier Rousseau. Léger also knew the Puteaux group by 1910, as well as Gleizes, Metzinger, and Le Fauconnier, but as a cubist he always remained independent.

In this remarkable essay Léger concentrates on the new 'realism', in comparison to the imitative realism of older painting. He draws especially close on this point to Delaunay's thinking³. Léger's *Contrasts of Forms* series of 1913–14 (see *Ill. 47)* are in fact comparable to Delaunay's colour discs of 1912–13, despite the fact that Léger never abandoned the cubist references to visible objects as completely as did Delaunay at this time. Léger's use of intense primary colours in this series is also more akin to Delaunay than to the less brilliant palette of Picasso and Braque.

Léger's belief in large-scale paintings also contrasts with the usually modest dimensions of Picasso's and Braque's cubist canvases. Here Léger is akin not only to Delaunay but also to Gleizes, Metzinger, and others who were seeking an 'epic' scope for painting, in which would be included the modern city, ships, aeroplanes, sea, sky, and land. Léger, however, never went this far in the direction of 'simultaneity' (see text 30); he almost always maintained an attitude toward reality which corresponded roughly with that of Picasso, Braque, and Gris.

Montjoie! was, with *Soirées de Paris,* the leading avant-garde periodical of the pre-War years. Its director was the poet Ricciotto Canudo, who issued a 'Manifeste de l'art cérébriste' in the January–February 1914 number; Canudo published and reproduced most of the leading writers and painters in Paris during the two-year (1913–14) life of the review.

28 Albert Gleizes

 Opinion

 1913

Since the pictures of mine which appeared in the first group exhibition of the modern movement at the 1911 Indépendants, I have tried to clarify the new painterly possibilities which at the time I could only glimpse. In the canvases exhibited this year at the Salon d'Automne I have tried to assert clearly three main principles;

 1 *In composition,* an initial equilibrium established by the interplay of lines, surfaces and volumes.

 2 *In the relationships between forms,* the influence these exert on one another by virtue of their spatial position within the picture.

 3 *In the reality of the object,* the fact that this is no longer considered from one set point, but definitively reconstructed according to a choice of aspects which my own movement allows me to discover.

I shall go further by saying that here I have been aiming at *a realism*, but a new kind of realism, different from that of Courbet, for whom the impression of the eye sufficed; I place these impressions under the control of the intelligence and of knowledge. It is agreed that the anecdotal counts for nothing in a painting: it is a pretext, but it is a pretext that should not be rejected. There is a certain imitative coefficient by which we may verify the legitimacy of our discoveries, avoid reducing the picture merely to the ornamental value of an arabesque on an oriental carpet, and obtain an infinite variety which would otherwise be impossible.

And I shall have said all that can be said; in every respect unconnected with its 'architecture', a picture must be self-sufficient without its painter: its vital qualities will defend it, and any spectator will be able, following his personal preference, to find other reasons for liking it.

'Opinion', *Montjoie!* No. 11–12, November–December 1913, p. 14

This text is typical of the intellectual self-justifications that were to preoccupy Gleizes from 1913 onwards, save for a brief period he spent in New York during World War I, when he responded openly in his art to the dynamism of the city. It is included here as an example of the theorizing which has so confused the understanding of cubism; Gleizes' emphasis on the process of moving around an object is misleading and excessively literal-minded, even when applied to his own work. It has a degree of validity in Cézannian 'analytical' cubism, but by 1913 such an idea was already reactionary by comparison with the cubism of Picasso and Braque.

29 Maurice Raynal

What Is Cubism ?

1913

... First of all, we notice that the cubists are not the least bit revolutionary and that, on the contrary, their conceptions are based on ideas that are well known.

Their initial intention is to 'deduce from visible forms combinations of new forms'. The cubists justly regard as superficial and childish the old

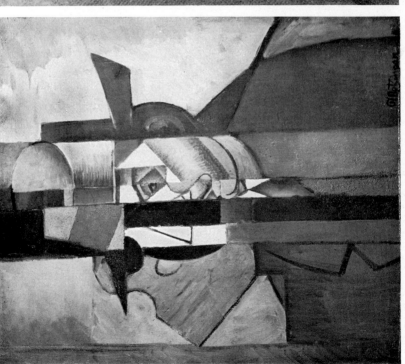

44 JEAN METZINGER, *Portrait of Albert Gleizes*, 1912

45 Albert Gleizes, *c.* 1912

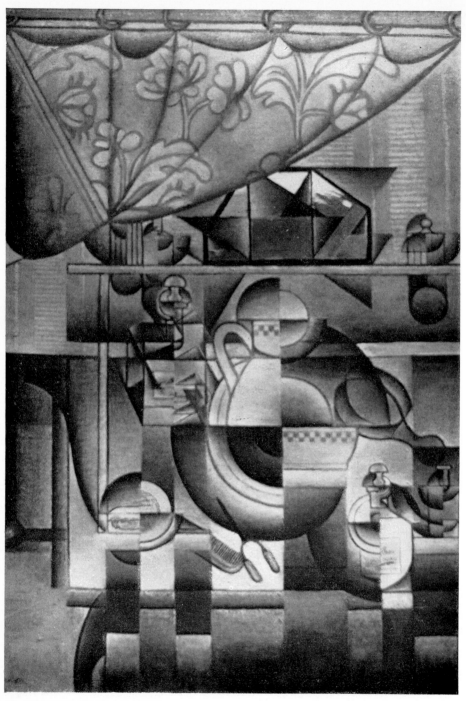

46 JUAN GRIS, *The Washstand*, 1912

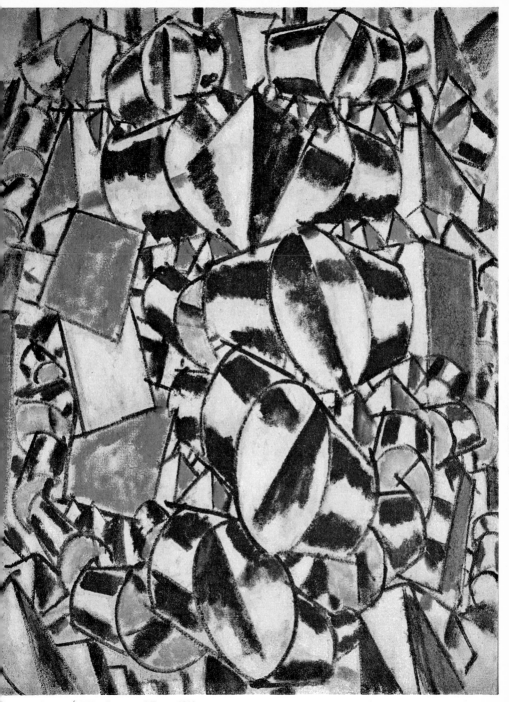

FERNAND LÉGER, *Contrasts of Forms*, 1913

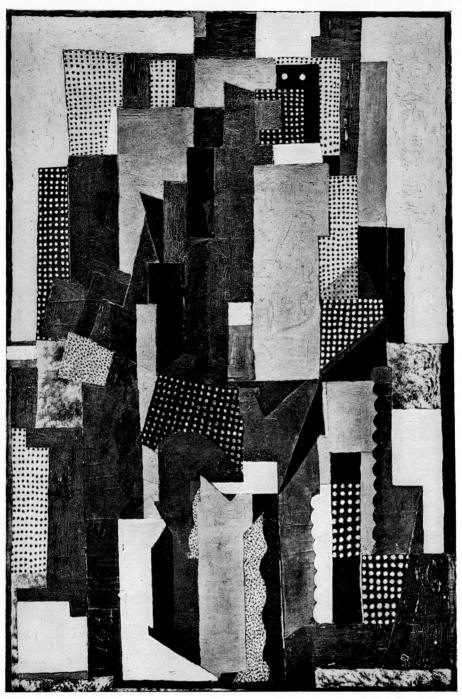

48 PABLO PICASSO, *Man Leaning on a Table*, 1915

principle which painters had of copying nature either slavishly or, as the saying goes, 'through the medium of their own personality'—which comes to the same thing, since the artist paints an object only as he sees it. They consider that photography does portraits quite as well as M. G. Ferrier or E. Carrière, and in this they are certainly right.

They also consider false and absurd the old compulsion to paint landscapes, storms, sunrises and sunsets; in a word, they have concluded that perhaps there is room for a kind of painting that would be neither descriptive, nor anecdotal, nor moral, nor psychological, nor educational, nor decorative. Decorative painting may exist, but it is very certain that to make an art serve a purpose is to degrade it singularly . . .

Moreover, we know that nothing is so false as sense-data—all the philosophers have demonstrated this.

If, for example, we perceive several passers-by about twenty yards away from us, they appear to us smaller than if they were walking close by us. We know this is false, and yet we shall paint them smaller than the pedestrians passing near us, in obedience to the laws of perspective.

This procedure is thus arbitrary and rather childish; it is mere visual imitation. And it is here that a law comes in, which some great artists—I mean the Primitives—obeyed in the days before skill, cleverness, cunning and trickery had deflected their art into that of the Renaissance artists.

The Primitives, men of learning for the most part, obeyed a very exalted *need,* that of the mysticism which illuminated their thinking. The Renaissance artists had a far less noble *aim,* that of decoration. By the very nature of their inspiration, the Primitives *thought* rather than *painted* their pictures; and so they worked in accordance with that remarkable idea, of painting one's *conception,* which the cubists have taken up again in response to a quite different need.

I will explain. When we look at certain pictures by Giotto, we are astonished to see, say, warriors crossing a bridge who are bigger than the bridge, or arches on the top of a tower which are bigger than the tower.

The Primitives painted in this way because, instead of fitting their work to the dimensions given by the eyes, they took into consideration the dimensions given by the mind or spirit. They thought that the figure or object which was most important in their thinking ought to be larger than the others in the picture. One must admit that there was more logic in this principle than in that of perspective. Instead of painting the objects as they saw them, they painted them as they thought them, and it is precisely

this law that the cubists have readopted, amplified and codified under the name of 'The Fourth Dimension'.

The cubists, not having the mysticism of the Primitives as a motive for painting, took from their own age a kind of mysticism of logic, of science and reason, and this they have obeyed like the restless spirits and seekers after truth that they are.

Therefore they no longer imitate the misleading appearances of vision, but the truer ones of the mind.

It would be pointless to quote many references on this subject, but let us remember that Pheidias, according to Cicero, did not look for his models among men but in his mind—'*in ipsius mente*'. And again, Bossuet said: 'I cannot *see* a chiliagon, but I can *conceive* it perfectly well' . . .

The cubists always try to know why they do what they do. We know, they say, that colour is a pure sensation and does not exist. For, strangely enough, when you think of one or more objects, you invariably conceive them without colour. A little reflection, and one can easily verify this curious phenomenon. But how does one conceive of an object without colour? As absolutely transparent! And the fact is that if I conceive—that is, if I represent in my own mind—a young woman at her dressing table, I find that I am seeing the objects concerned—body, mirror, bottles, etc.—charmingly blended together, as though there were no opacity to interpose itself and trouble their marvellous grouping.

And so the painter can be completely in agreement with the laws of reason if he paints opaque objects as absolutely transparent; although he may enhance them for clearer definition by adopting a purely conventional colour scheme.

'Qu'est-ce que . . . le "Cubisme"?'
Comœdia illustré, Paris, 20 December 1913

In this essay Raynal develops several of the ideas he had expounded in previous articles (see texts 19, 20, 21) and adds the misleading idea of a 'Fourth Dimension', which by the end of 1913 had become a popular cliché of criticism. Of far greater interest are his remarks on colour, which since the invention of *papier collé* had begun to play a major role in the works of Picasso and Braque. Gris and other cubists soon followed suit.

When Raynal speaks of the free and arbitrary use of planes in a cubist painting, by which an opaque object may become transparent (or a transparent object opaque), he touches on a basic characteristic of collage and of 'synthetic' cubism,

namely the arbitrary significance assigned to a given formal element. A form may directly signify a quality of an object, or it may signify literally itself, as in collage; or it may arbitrarily indicate an opposite quality, and it may even be used elsewhere in the same work to signify a different object altogether. Raynal's example of transparent solids is particularly applicable to the art of Gris, for whom it was a favourite device (see Pl. VII). The naïve explanation that objects are shown as transparent because conceptually they have no colour is, however, Raynal's own and is not supported by the cubists' far more sophisticated use of transparency. But Raynal is the first to observe, as he does here correctly, that in 'synthetic' cubism colour too is used arbitrarily; one of the greatest contributions of *papier collé* was that it taught the cubists that colour could be liberated from a solely localized, descriptive function and could be given a second, independent compositional life of its own.

30 Félix Mac Delmarle

Some Notes on Simultaneity in Painting

1914

For honest and uncorrupted minds, for enlightened intelligences, cubism as expounded by MM. Gleizes and Metzinger is a contribution of truths beyond dispute.

It will remain a necessary starting-point for every effort tending towards the futurist aesthetic . . .

'Simultaneity' in the work of art is one of those numerous aims that attract the most interesting painters of our time.

Where does this tendency come from?

To the quest for a 'simultaneity' of the aspects of the object—a quest close to the heart of cubism and manifest in the latest works of its protagonists—must be added the statement of the Italian futurists: 'Simultaneity of states of soul: this is the intoxicating aim of our art.'

It is a pity that, in the work of these latter artists, this remained only a cry, but it is incontestable that the way of simultaneity was open for all to try.

Simultaneity of the aspects of particular objects, including the human figure, is not enough for us. We want the simultaneity of the many sensations which converge to form our emotion.

This emotion, derived from a spectacle and capable of generating works of art, is formed by the contributions of all our senses; this is the only true simultaneity in the real meaning of the word.

Colours, shapes, sounds and smells reach our brain, thanks to the communications system of the senses. Our senses supplement each other; and who, today, would dare deny that a smell or a sound can influence our sensation of a spectacle? . . .

Another plastic element is the simultaneity of different materials.

What importance have the individual materials? In art the means are secondary . . .

This result will no longer, perhaps, be painting, but, as we have said before, we laugh at labels.

Speaking *personally*, if we wish to establish a contrast with some abstract part of our picture, we shall not hesitate to make use of so totally real an element as the material thing itself, while taking the necessary precautions so that the picture may last.

We are intoxicated with freedom, and we do not intend to become slaves to matter.

'Quelques notes sur la simultanéité en peinture',
Poème et Drame, Paris, 13 March 1914, pp. 17–19

The Belgian futurist Mac Delmarle (1889–1952) had issued during July 1913 a 'Manifeste futuriste contre Montmartre'[1]; now, in the review edited by Henri-Martin Barzun, Mac Delmarle applied to painting Barzun's ideas of simultaneity in poetry. Since 1912 there had been considerable discussion of the concept of simultaneity, especially among the Italian futurists and in the group of young poets around Barzun[2]. Barzun promoted simultaneity in poetry with a series of articles and manifestos[3], and found confirmation of his ideas in the art of the cubist sculptor Duchamp-Villon[4].

The entire concept of simultaneity in poetry was attacked and demolished in an article by Apollinaire entitled 'Simultanisme-librettisme'[5]; at the same time, however, he accepted the term as applied to cubist painting, citing examples in Picasso, Braque, and Léger[6].

Mac Delmarle's article, though strongly prejudiced in favour of futurism, is nevertheless representative of the thinking of numerous cubists, particularly Gleizes,

Metzinger, and their followers. Mac Delmarle also goes beyond previous writers in his praise of collage and his call for what is today know as the 'art of assemblage'.

The idea of simultaneity in cubist painting is basically a rephrasing of the 'Fourth Dimension' theory which had been widespread since early in 1912. Whether applied to the depiction of a single object seen from all sides, or to the simultaneous depiction of objects widely separated in time and space, 'simultaneity' is derived from the idea of the cumulative character of human memory as expounded by Bergson in such works as his *L'Evolution Créatrice* of 1907. But by 1914 the term was also being used in another sense, in specific reference to the purely colouristic art of Delaunay and his followers[7]. Apollinaire had called this tendency 'orphic' in 1912 (see text 25); in some of Delaunay's pre-War paintings the composition was based on the simultaneous contrasts of complementary colours.

31 Alexandre Mercereau

 Introduction to an Exhibition in Prague

 1914

The romanticism of Delacroix, the realism of Courbet, the impressionism of Manet, all caused great consternation because they contained within them the ultimate truth of their epoch. It is difficult at all times to make truth comprehensible; and like any other age, that of Delacroix, Courbet and Manet preferred artists to lie and flatter.

Our own age, too—an age of dynamism and intense drama, of electricity, motor cars and great factories, in which new inventions rapidly proliferate—multiplies our faculties of seeing and alternately contracts and extends the scope of our sensibilities. Our thoughts expand and fertilize one another mutually; they remould our common spirituality. Our age too feels offended by an art that embraces its whole truth, an art which . . . embodies and accumulates what is done and seen.

This does not mean in the least that artists, in order to arrive at a synthesis, should make a point of painting every kind of modern machinery, or drawing our means of locomotion. That would be a simple-minded idea. Just as an able photographer equipped with a perfected camera and choosing his subject and his light with care can produce the most beautiful static picture, nothing could match a good film-cameraman in producing a dynamic picture . . .

In the art of today a very singular and specific type of realism is manifest. Our artists are not mystics of painting like those of the thirteenth and fourteenth centuries; they are not rhetorical idealists, as were the artists of the Renaissance, or naturalists in the vein of the 1830 *Pléiade* or of Courbet; nor yet are they subtle analysts of ephemeral impressions as were the neo-impressionists. Our artists ardently desire to achieve an integral truth as opposed to an apparent reality. In harmony with the innovations of science, today's art seeks to discover ultimate laws more profound than those of yesterday. But just as the principles postulated by Bolyai, Lobatschewski, Riemann, Beltrami and de Tilly have not destroyed those of Euclid but merely relegated them to their true status as one postulate among many, . . . the modern painter does not presume to negate everything accomplished before his time. Old axioms are joined by new ones, and what used to be the summit is now . . . the plinth on which a new monument is erected.

<div align="center">Introduction to the catalogue of the forty-fifth exhibition of the
Mánes Society, Prague, February–March 1914</div>

Alexandre Mercereau's role in the history of cubism was as interesting and pervasive as Apollinaire's, although far less well-known. Like Apollinaire he was vastly but unevenly erudite, and a cosmopolitan European traveller. Mercereau (born 1884) began his career as a writer of mystical tales. He made the first of his many trips to Russia in 1906, where he edited for a short time the French section of an avant-garde review, *La Toison d'Or;* in 1907 he was a co-founder, with Barzun, Gleizes, and others, of the Abbaye de Créteil, near Paris, an intellectual colony with very idealistic intentions. In Paris he worked in the theatre, contributed to the small reviews, and in 1909 organized the literary section of the *Salon d'Automne*[1]. It was at Mercereau's home in Paris that Gleizes, Le Faucounier, Léger, Metzinger, and Delaunay met each other in 1909 and 1910[2].

Mercereau's real importance in the history of early twentieth century art arises from his role in introducing cubism to eastern Europe. He organized exhibitions in several Russian cities, of which the most influential were the 'Jack of Diamonds' exhibitions of 1910 and 1911 in Moscow. These Moscow exhibitions contributed substantially to the development of Malevich, Tatlin, and others who would later radically transform cubism into the brilliant but short-lived suprematist and constructivist movements. Mercereau also organized an exhibition of advanced Parisian art at Budapest in 1913; and in 1914 he organized, and wrote this intro-duction for, the great cubist exhibition held by the Mánes Society at Prague, which included six paintings by Delaunay, seventeen by Gleizes, ten by Metzinger, three

by Mondrian, five sculptures of Archipenko, five of Brancusi, and six of Duchamp-Villon. By 1914 Prague was the most fertile ground for cubist art outside of Paris; the Czech cubists Filla, Beneš and Gutfreund had already exhibited as a group in late 1913 at the gallery of *Der Sturm,* in Berlin (19th Exhibition, November 1913).

Mercereau was apparently wounded during the war, and he never fully recovered, although he wrote a monograph on Lhote, published in 1921.

In this extract from the introduction to the 1914 Prague exhibition catalogue, Mercereau speaks in a broad epic language which reflects similar attitudes to be seen in the paintings of Gleizes, Metzinger, and Delaunay. His is probably the most fantastic of all statements suggesting non-Euclidean geometries as the basis for cubism. Yet Mercereau has a poet's intuition of the breathtaking possibilities for art in the new man-made world of the twentieth century.

32 Fernand Léger

Contemporary Achievements in Painting

1914

A work of art must be significant in its own period, like any other intellectual manifestation whatever. Painting, because it is visual, is necessarily the reflection of outside conditions, and not psychological. Every pictorial work must possess both a momentary and an eternal value, if it is to last beyond the period when it was created.

If pictorial expression has changed, it is because modern life has made this necessary. The daily life of modern creative artists is much more condensed and more complex than that of people in earlier centuries. The thing that is imaged does not stay as still, the object does not exhibit itself as it formerly did. When one crosses a landscape in an automobile or an express train, the landscape loses in descriptive value, but gains in synthetic value; the railway carriage door or the car windscreen, along with the speed imparted to them, have altered the habitual look of things. A modern man registers a hundred times more sensory impressions than an eighteenth-century artist, so that, for instance, our language is full of diminutives and abbreviations. The condensation of the modern picture, its variety, its breaking up of forms, are the result of all this. It is certain that the evolution of means of loco-motion, and their speed, have something to do with the new way of seeing.

Many superficial people raise the cry 'anarchy!' on seeing these pictures, because they cannot follow, in the field of painting, all the evolution of current life which painting records. They think that painting has abruptly broken the chain of continuity when, on the contrary, it has never been so truly realist, so close to its own period, as it is today. An art of painting that is realist in the highest sense is beginning to appear; and it is here to stay.

It is a fresh measure, coming on to the scene in response to a new state of affairs. The breaks with the past that have occurred in our visual world are innumerable. I will choose the most striking. The advertisement hoarding, which brutally cuts across a landscape in obedience to the dictates of modern commerce, is one of the things that have aroused most fury among men of so-called good taste . . .

And yet that yellow or red billboard, shouting in a timid landscape, is the finest of possible reasons for the new painting; it knocks head over heels the whole sentimental and literary conception of art and announces the advent of true plastic contrast.

Naturally, to find in this break with time-honoured habits a reason for a new pictorial harmony, and a plastic means of achieving life and movement, required an artistic sensibility far in advance of the normal visual aptitudes of the multitude.

In the same way, modern means of locomotion have completely upset relationships which had been familiar since time immemorial. Formerly a landscape had a value in itself; a white and quiet road could cross it without changing the surroundings at all.

Now the railway trains and automobiles, with their plumes of smoke or dust, take all the dynamic quality for themselves, and the landscape becomes secondary and derivative . . .

In earlier periods it was impossible to exploit the possibilities of contrast to the full. There were several reasons for this, first and foremost of which was the necessity of subservience to the demands of a subject which had a sentimental value. I have developed this point in an earlier lecture.

Never, until the impressionists, had painting been able to shake off the spell of literature. The application of plastic contrasts was necessarily diluted by the need to recount some story; modern painters have recognized that this is futile.

As soon as the impressionists had liberated painting, the modern picture set out to build itself on contrasts instead of submitting to a subject; the painter uses the subject in the service of purely plastic *means.* All the artists

who have collided with public opinion in the last few years have sacrificed subject to pictorial effect . . .

This liberation leaves the present-day painter free use of these means to deal with a new condition of seeing, which I have just described; he will now have to find a way of giving a maximum of plastic effect to means which have not previously served purely plastic ends. His aim must be, not to imitate the new objective image of the visual world, but to achieve a purely subjective sensitivity to the new state of things.

Merely breaking up some object or placing a red or yellow square in the middle of his canvas will not make him original; he will be original by virtue of having caught the creative spirit of an external manifestation.

As soon as one admits that only realism of conception is capable of realizing, in the most plastic sense of the word, these new effects of contrast, one is bound to leave visual realism aside and concentrate all one's plastic means towards a specific goal.

Composition comes above all else: lines, forms and colours, to acquire their maximum expressiveness, will have to be employed with the utmost logic that is possible. It is the logical spirit that will obtain the greatest result, and by logic in art I mean a man's power to confer order on his sensibility, and to concentrate his means in order to achieve the maximum effect in the result.

It is certain that if I look at objects in their surroundings, in the real atmosphere, I do not perceive any line limiting the zones of colours; but this belongs to the field of visual realism and not to the quite modern one of realism of conception. To try to eliminate *a priori* certain means of expression, such as the line and the form apart from their significance in terms of colour, is childish and retrograde; the modern picture can have lasting value not by excluding some means of expression for the benefit of one alone, but by concentrating all the possible means of plastic expression towards a specific goal. To have understood this is one of the great achievements of modern painters; before them, a drawing had a value peculiar to it, and a painting another; henceforward one brings everything together, to obtain an essential variety together with a maximum of realism. A painter who calls himself modern, and who rightly considers perspective and sentimental value to be negative expedients, must be able to replace them in his pictures with something other than, for instance, a continual juxtaposition of pure tones.

The impressionists, being sensible people, felt that their somewhat meagre means did not allow of composition on the grand scale; they kept within

bounds. The big picture demands variety and, in consequence, the addition of other means than those of the neo-impressionists.

Contrast of tone can be summed up in the relation 1 and 2, 1 and 2, repeated to infinity. The ideal, with this formula, would be to apply it fully; this would lead us to a canvas divided into a quantity of equal planes in which tones of equal and complementary value are set against each other; one picture composed in this way can astonish for a time, but ten of them mean inevitable monotony.

To arrive at construction by colour it is essential that, from the value point of view (for in the end this is the only one that counts), the two tones should balance, *i. e.* neutralize each other: if the plane coloured green, for instance, is more important than the plane coloured red, there is no longer any construction. You can see where that leads. The neo-impressionists tried it out long ago, and to go back to it is obsolete.

Composition by multiplying contrast, by employing all the painter's means of expression, not only makes possible a greater range of realism, but also makes sure of variety; in fact, instead of setting two means of expression against each other in an immediate additive relation, you compose a picture so that groups of similar forms are set against other, contrary groups. If you distribute your colours in the same way—that is, by colouring each of these formal groupings in a combination of similar tones which contrast with the tones of another equivalent grouping, you obtain collective sources of tones, lines and colours acting against other, contrary and dissonant sources. Contrast = dissonance, and hence a maximum of expressive effect. I will take an example from a particular subject: the visual effect of round curls of smoke rising between buildings, You wish to render their plastic value; and here you have an excellent practical example on which to put into practice the results of this research into multiple contrasts of intensity. Concentrate your curves with the greatest variety possible, short of disuniting them; frame them by means of the hard, dry relationship of the surfaces of the houses—'dead' surfaces which will acquire mobility by the fact that they will be coloured contrarily to the central mass and that they are juxtaposed with 'live' forms; and you get a maximum effect . . .

In many pictures of Cézanne's one can see—barely hinted at—this restless sensitivity to plastic contrasts. Unfortunately—and this corroborates what I said just now—the thoroughly impressionist circle he belonged to, and his whole period, which was less condensed and less fragmented than ours, could not lead him as far as the concept of multiple contrast; he felt it, but he did

not understand it. All his pictures are painted in the presence of a subject, and in those landscapes of his, with the houses jammed awkwardly among the trees, he had sensed that the truth lay there. He did not manage to formulate it and create the concept. To abandon this discovery, which is an assurance of development and a first step into the creative, in order to go back to neo-impressionism, which is a last stage and an ending, is, I say, an error, which must be denounced. Neo-impressionism has said all it had to say, its curve was very, very short—in fact it was a very small circle, in which there remains nothing of worth.

Seurat was one of the great victims of this mediocre formula in many of his pictures, and he wasted a lot of time and talent by confining himself to that small touch of pure colour—which indeed does not colour at all, for the question of the effective power of colour also has to be taken into consideration. When you employ contrast of tone as a source of dynamic mobility to eliminate local colour, your colour loses some of its power; a yellow and a violet contrasted in equal volume are 'constructive', of course, but only at the expense of the power of colour; in this case the optical mixture is grey. Only local colour has its maximum colouristic effect. The system of multiple contrasts alone permits of using it; while the neo-impressionist formula has the paradoxical but inevitable result that pure tones are used to produce a final effect of grey.

Cézanne, through his sensitivity to contrasts of form, was the only one of the impressionists to lay his finger on the deeper nature of the plastic contrasts inherent in a work of art.

'Les Réalisations picturales actuelles', *Soirées de Paris*,
15 June 1914, pp. 349–54 (a lecture given at the Académie Wassilieff)

In the second of his pre-1914 essays Léger glorifies speed as a uniquely modern element of visual experience; his words could be those of a futurist, except that he is interested in speed not for its own sake but for its generalizing, synthetic effect on the eyes of the observer. Léger finds, as did the futurists, that art must respond to these new conditions, with all their speed, sudden changes, and contrasts, greater than had ever existed before. For him the artefacts of mass culture, such as billboards, begin to take on a positive value in comparison to what are now the passive, neutral qualities of landscape; this affirmation of popular life and culture was to remain part of Léger's outlook all the rest of his life.

For Léger as artist the problem is to find pictorial equivalents that will express adequately this new external environment; his solution at this time was, as he explains, the principle of contrast, the most powerful formal device available to painting. But Léger proposes to make contrasts not only of colours, but also of lines and forms; he attempts to show how the impressionists and neo-impressionists never fully exploited colour contrasts, and how in the late nineteenth century only Cézanne made contrasts of both form and colour. Referring to paintings of his own, Léger then shows how he has achieved maximum pictorial vitality by contrasts of colour, tone and straight and curved lines, thus arriving at what he calls multiple contrast.

This approach reached a climax in his series of *Contrasts of Forms* of 1913–14 *(Ill. 47)*.

33

André Salmon

Anecdote

1914

The painter Georges Braque, a fervent disciple of Picasso, comes from the class of artisans who have prospered, entrepreneurs on a considerable scale. His family painted, or saw to the painting of, the interior walls of nearly all ⌐he buildings constructed in Le Havre at the end of the last century. I am convinced that Georges Braque owes some of his most brilliant qualities to his descent from such a family.

One day he was talking with Picasso about the things that cannot be imitated in a painting. This is a favourite theme of the modern artists. Should one, if one is painting a newspaper held in someone's hands, take pains to reproduce the words PETIT JOURNAL, or reduce the business to sticking a part of the newspaper itself on to the picture? This led to praise for the skill of the house-decorators who extract large amounts of marble and precious wood from imaginary quarries and forests.

Naturally Georges Braque contributed some useful information, with no lack of amusing technical details.

At one point he spoke of the services rendered to house-decorators, in the production of imitation marble and imitation wood, by a particular kind

of steel comb, which is drawn over the painted surface to get the lines that simulate grain and mottling . . .

In short, Picasso and his companions were agreed on the usefulness of the house-decorator's comb; but note that, even so, nobody thought of imitating these skilful artisans.

This is extremely important. An artist increases his stature by meditating on these things, he may even want this tool because it amuses him, but that is enough. He must not adopt either the tool or the technique. It is better, as one of them (Marcoussis) did, to imitate the imitation.

But a Maecenas who happened to be there thought otherwise.

He went down to the nearest café to consult the telephone-book, jumped into a taxi and had himself driven to a tool-cutter's in the Marais, a maker of the wonderful comb for painting wood and marble.

Trembling with excitement, as though he were the bearer of the radium of the new art, Maecenas drove back to Picasso's, into whose skilful hands he thrust his purchase.

Then the painter's eyes shone with the gleam of childlike pleasure his friends knew well.

This man, whose one aspiration is to create, to pin down new forms, was delighted to possess a new toy. He promised to set to work, and gave the art-lover an appointment for next morning.

He would spend the night making pseudo-wood and pseudo-marble.

But when morning came, the Maecenas saw merely a portrait of a well-dressed engineer.

With the comb for faking wood and marble, Picasso had painted and waved his subject's hair and beard.

from *La jeune sculpture française*, Paris 1919, pp. 12–14

Salmon's *La jeune sculpture française*, although not published until after the War, was written in 1914 as a companion to his earlier book on painting (see text 18). The incident which Salmon relates is most revealing of the close artistic relationship between Picasso and Braque, as well as their concern to avoid illusionistic imitation. Salmon's anecdote, if true, probably took place in the spring of 1912, when both artists were in Paris; and the painting by Picasso was probably his *The Poet (Ill. 39)*, or another similar work of the same period.

Carl Einstein

Negro Sculpture

1915

... A few years ago, in France, we lived through the epoch-making crisis. By means of a tremendous effort at awareness, men recognised the irrelevance and questionableness of the accepted method. Some painters were able to command sufficient strength to turn away from mechanical, repetitive craftsmanship; shaking free from the customary means of expression, they investigated the elements of the perception of space—what this leads to, and what conditions it imposes. The results of this important struggle are sufficiently well known. At the same time they necessarily discovered Negro sculpture, and recognised that it has, on its own, given birth to the pure plastic forms.

The efforts of these painters are usually referred to as abstraction, although no one could possibly deny that a direct spatial awareness could not have been approached without an immense critical effort in clearing away erroneous paraphrases. This is the essential point; and it sharply distinguishes Negro art from the art which has a taken it as a guide. What appears in the latter as abstraction is, in the former, a direct experience of nature. From a formal point of view Negro sculpture will be found to be out-and-out realism.

The contemporary artist cannot concentrate on working towards pure form; he still feels himself to be in opposition to what has gone before. His creative effort involves an excessive element of reaction. His inevitably critical approach strengthens the analytical in his work.

from *Negerplastik*, Munich, 1915, 2nd ed. 1920, pp. XI–XII

Carl Einstein (1885–1940) was a poet, a novelist, and one of the most gifted of twentieth-century writers on art; his *Negerplastik*, written by 1915, still commands respect for its profound analyses of the formal qualities of African art. Einstein recognized more clearly than any of his predecessors the parallel between African sculpture and certain aspects of cubism, without, however, defining it precisely.

Einstein wrote a second book on African sculpture, published in 1921[1], in which he amplified the ideas of his *Negerplastik* and indicated the generally superior spatial qualities of African sculpture compared to the flatter, more decorative qualities of much Oceanic art.

35 Pierre Reverdy

On Cubism

1917

The movement in painting which began about ten years ago and has been given the name cubism may not be the one that has most astonished the world, or the one that, after having the largest number of enemies, has reaped the largest number of adepts; but it is beyond question the artistic Effort which, being the most important of our time, has introduced into it the greatest confusion.

This confusion, with which people initially seemed well content, has now lasted long enough.

The attempts being made separately by each artist to put an end to it are proof of this.

On all sides there is the feeling of a need to come together and understand one another better. I am speaking of the artists, for it is not only among the public but among the artists themselves that the ambiguity existed from the start and still unfortunately persists.

It is not merely a question of divergencies of taste—these have always existed among artists and will fortunately never cease.

But there are certain essential points that it might be a good thing to take as common ground with a view to constituting a theoretical basis for an art to which so many lay claim for different, or even opposite, reasons.

And yet the art in question is one that, by its persistence and development, has sufficiently proved its reasons for existing and its right to do so.

Certainly the opinion of one man alone could not bring everyone into agreement; but it may be useful to attempt a few general statements that will throw some light, a few precise formulations of particular points that will at least help to establish some clear distinctions.

The serious efforts of some artists can only gain from not being confused with the more or less justified, more or less (artistically) honest fantasies of painters who, having nothing to contribute to the movement, are attracted merely by modernity—if not for other, less avowable reasons.

Some have claimed to go beyond cubism—which is the evolving art of our time—and, in trying to escape from it, have gone backwards.

Having fallen back into imitative art by merely choosing the most modern objects they could find and representing them, they have believed they were solving an arduous problem by skirting its difficulties.

By the titles with which they were obliged to complete their works, they left the plastic domain and entered a literary symbolism which, in the field of painting, is absolutely worthless.

Also, difficult though it is to hit on new means of expression in an art, true merit lies only in finding means that are proper to that art, not in taking them from some other art.

That is to say, literary means applied to painting (and *vice versa*) can only give us a facile and dangerous appearance of novelty.

Cubism is an eminently plastic art; but an art of creation, not of reproduction or interpretation.

But what can one create in painting, if not the picture—and this with the aid of such new means as are appropriate? The first cubist painters found these appropriate means, with which their followers have not concerned themselves enough. These latter painters have taken the appearance of the works already produced and have painted 'in the manner', while claiming to be inaugurating a new art. It is time we were aware of this; otherwise a profound art, of which people have managed to see only the superficial side, would be turned into a superficial art. This disastrous attitude has led people to see only incoherence where there was, from the very start, a quest for discipline. Today, for a few chosen individuals, the discipline has been established; and since there was never any thought of a cold, mathematical, anti-plastic, merely cerebral art, the works of these few artists address themselves directly to the eye and the senses of lovers of painting.

But, before one can come to like this kind of painting, one must understand why it looks so different from the art to which our eye has been accustomed.

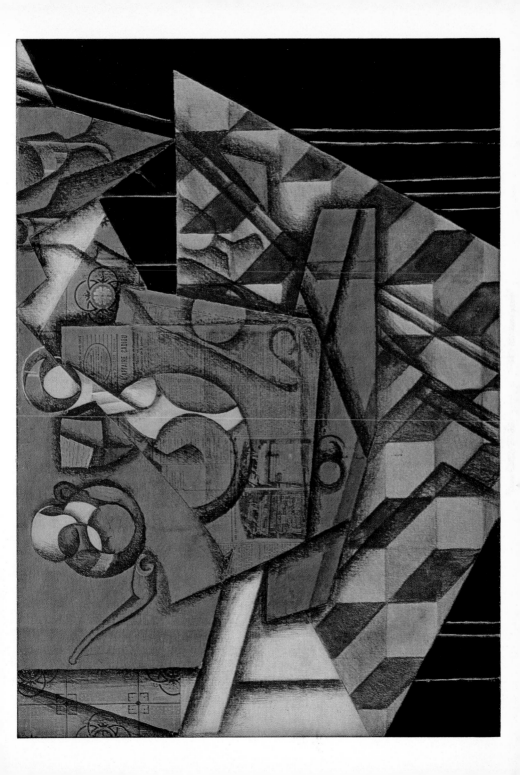

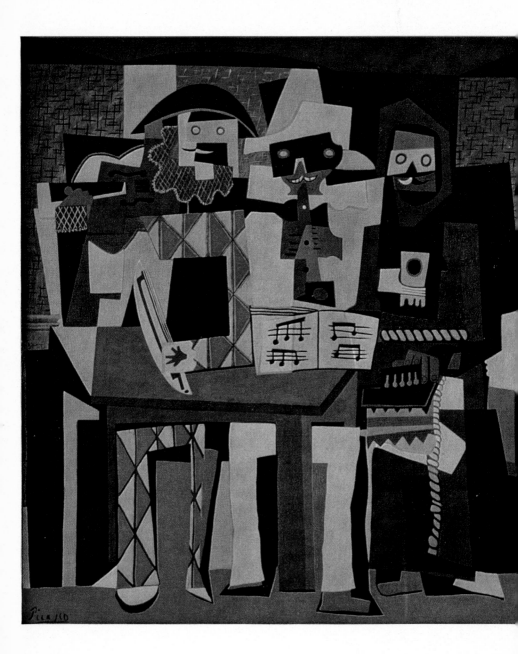

The aim is different; the means must be different, and so must the result. Pleasing the public, which will be the consequence of the result, is only a matter of the public becoming educated.

Nothing so important had been discovered in Art since the creation of perspective as a pictorial means.

Our period is the time when men have discovered the equivalent of that wonderful invention.

Just as perspective is a means of representing objects in accordance with their visual appearance, cubism contains the means of constructing a picture by taking the object as a pictorial element only, quite apart from the anecdotal standpoint.

It next becomes necessary to state clearly the difference between object and subject. The subject is the result of the use of the means of creation one has acquired: it is the picture itself. Since the object comes in only as an element, it will be evident that what has to be done is not to reproduce its appearance but to extract from it—in the service of the picture—what is eternal and constant (for example, the round form of a glass, etc.) and to exclude the rest.

There lies the explanation, which the public has never had, of the distortion of the object. It is a necessary consequence and would be inadmissible if it were an arbitrary fantasy of the painter. Otherwise we should not have progressed beyond those caricaturish distortions whose only excuse is the phrase—obsolete for us—'the artist's vision'.

After the foregoing it will be understood that no cubist painter should execute a portrait. Things should not be confused. What has to be created is a work of art, in this case a picture, not a head or an object constructed according to new laws which would not sufficiently justify the resulting appearance.

It is this creation, of which I shall have more to say later in connection with poetry, that will distinguish our period. We are at a period of artistic creation in which people no longer tell stories more or less agreeably, but create works of art that, in detaching themselves from life, find their way back into it, because they have an existence of their own apart from the evocation or reproduction of the things of life. Because of that, the Art of today is an art of great reality. But by this must be understood artistic reality, and not realism—which is the genre most opposed to us.

One is therefore justified in saying that cubism is painting itself, just as poetry today is of the kind that is poetry itself. And what, after that, does it

matter what objects one uses—what significance has their newness if they are treated with means that are not born with them and for them? Only the choice of means wholly appropriate to the end can produce a style which will characterize a whole period.

In the field of art it is never the creations of another order that prove to have shown the way, and when I say 'period' I mean 'artistic period'—because I am not a taxi-driver.

'Sur le cubisme', *Nord-Sud*, Paris, 15 March 1917, pp. 5–7

Pierre Reverdy (1889–1960) is slowly being recognized as one of the greatest of twentieth-century French poets. He came to Paris in 1910, settled in Montmartre, and by 1912 knew most of the cubists. Several of his early volumes of poetry were illustrated by cubists, and Reverdy dedicated his aesthetic *credo*, the pamphlet *Self-Defense*[1], to his friend Gris. In 1917 Reverdy founded *Nord-Sud*, a review named after the Paris subway line running from Montmartre to Montparnasse. Although it lasted only two years, *Nord-Sud* was one of the best reviews of art and literature in the twentieth century, publishing the most gifted writers and painters of the cubist period.

Reverdy, like Gris and the sculptor Jacques Lipchitz, was sufficiently younger than Picasso and Braque to have reached artistic maturity only during the 'synthetic' phase of cubism, and his thought almost immediately bears its imprint; he had tried his hand at painting and had also made collages[2]. This essay is among the most intelligent of all defences of the synthetic cubist aesthetic[3]. Reverdy stresses the internal consistency of the work of art, and he emphasizes that this consistency reflects not an interpretation of nature but the internal formal necessities of the work itself. He was shortly to draw general conclusions from synthetic cubism which would be as relevant to poetry as to painting (see text 37; also his *Self-Defense*). Max Jacob, the poet and intimate pre-War friend of Picasso, had come to the same point of view by 1916[4] and had for some time been practising a poetry which, with its hermetic self-sufficiency and elaborate phonetic puns, variations, and transformations, may justly be considered an equivalent of synthetic cubist painting[5].

Kahnweiler and others have suggested that the cubists, painters and poets, were influenced by Mallarmé[6]; Raynal mentions that Picasso's library included works by Mallarmé[7]. There are certainly precedents for the cubist aesthetic in Mallarmé, but what influence he had was greater on the poets than on the painters.

Thoughts on Painting

1917

1. In art progress consists not in extension but in the knowledge of its limits.
2. The limits of the means employed determine the style, engender the new form and impel to creation.
3. The charm and the force of children's paintings often stem from the limited means employed. Conversely the art of decadence is a product of extension.
4. New means, new subjects.
5. The subject is not the object; it is the new unity, the lyricism which stems entirely from the means employed.
6. The painter thinks in forms and colours.
7. The aim is not to *reconstitute* an anecdotal fact but to *constitute* a pictorial fact.
8. Painting is a mode of representation.
9. One must not imitate what one wishes to create.
10. One does not imitate the appearance; the appearance is the result.
11. To be pure imitation, painting must make an abstraction of appearances.
12. To work from nature is to improvise. One must beware of an *all-purpose* formula, suitable for interpreting the other arts as well as reality, and which, instead of creating, would produce only a style or rather a stylization.
13. The arts that make their effect by their purity have never been all-purpose arts. Greek sculpture and its decadence, among others, teach us this.
14. The senses deform, the mind forms. Work to perfect the mind. There is no certainty except in what the mind conceives.
15. A painter trying to make a circle would only make a ring. Possibly the look of it may satisfy him but he will have doubts. The compass will restore his certainty. The *papiers collés* in my drawings have also given me a kind of certainty.
16. *Trompe-l'œil* is due to an *anecdotal* accident that makes its effect through the simplicity of the facts.
17. The *papiers collés*, the imitation wood—and other elements of the same nature—which I have used in certain drawings, also make their effect through

the simplicity of the facts, and it is this that has led people to confuse them with *trompe-l'œil*, of which they are precisely the opposite. They too are simple facts, but *created by the mind* and such that they are one of the justifications of a new figuration in space.

18. Nobility comes from contained emotion.

19. Emotion must not be rendered by an emotional trembling. It is not something that is added, or that is imitated. It is the germ, the work is the flowering.

20. I love the rule which corrects emotion.

'Pensées et réflexions sur la peinture', *Nord-Sud*, Paris, December 1917.

Colour absorbs or is absorbed.

Valori Plastici, No. 2, Rome, February–March 1919, p. 2

In contrast to Picasso's eruptive intensity, Braque's gifts expressed themselves more slowly and carefully, whether in painting or in words. These polished and concise aphorisms are characteristic of his temperament. The great majority were published in *Nord-Sud* after the editor Reverdy, a friend of Braque, had noticed them on the margins of Braque's drawings[1]. A few were published separately in a special number of *Valori Plastici* (Rome) devoted to cubism. Until the end of his life Braque used an aphoristic form to express his thoughts on art.

Although few of these early aphorisms provide new insights into cubism, many, such as Nos. 7–12, are a felicitous condensation of what Reverdy and others were also saying. No. 9 in particular is a restatement of what Raynal and Apollinaire had been thinking since 1912 (see text 20), and it echoes Picasso's famous maxim that art is a lie used to tell the truth (see text 45). Braque also underlines in No. 17 the conceptual freedom offered by *papier collé* precisely because as art it was no longer an illusionistic medium but a new, literally tangible reality in itself.

Some Advantages of Being Alone

1918

A work of art cannot content itself with being a *representation;* it must be a *presentation.* A child that is born is presented, he represents nothing.

A representational work of art is *always* false. It never represents except conventionally what it claims to represent. The convention may be of the eyes or of the mind. The greater the number of those who stand outside this convention and the more people there are who are incapable of identifying the representation and the fact represented, the falser this kind of art will be.

It is obvious that the *presentational* work escapes this criterion. The mind, the senses apprehend or do not apprehend. In either case the absolute value of the work is unaffected.

It is false to want the emotion in which the work comes into being to be identical with the one the work will bring into being in its turn. The one is a starting-point, the other a result. All art stands between these two poles.

An artist uses, as a pure element, the *result* of an emotion that has arisen in him; for everyone else art consists in explaining an emotion that has been felt, in order to make others share it.

Little that is new can come of this. It is a representation (attempt at evocation). It is the exploitation, through explanation, of a germ of an element. It is a useless and vain thinning-out, instead of a creation through concentration . . .

'Certains avantages d'être seul', *Sic!*, Paris, October 1918

Sic!, the other leading *avant-garde* review in Paris during the War years, lasted hardly any longer (1916–19) than *Nord-Sud;* its editor, Pierre-Albert Birot, had as contributors both the cubist generation and the young future surrealists, and *Sic!* became towards the end of its life a proto-surrealist organ.

This essay is an expansion of Reverdy's ideas in his article on cubist art (see text 35); here Reverdy seeks to establish a general aesthetic principle which, though based on his understanding of cubist painting, shall be relevant to literature as well. It is interesting to contrast Reverdy's attitude towards artistic emotion with that of Braque (see text 36, Nos. 18 and 19); Reverdy's position is actually closer to that of Juan Gris.

Tradition and Cubism

1919

Taking no account of accident, pushing aside anecdote, neglecting the particular, the 'cubist' artists tend towards the constant and the absolute. Instead of reconstituting an aspect of nature, they seek to construct the plastic equivalents of natural objects, and the pictorial fact so constituted becomes an aspect created by the mind. The construction realised in this way has not a comparative value but a strictly intrinsic value, or, to use a Platonic phrase, is 'beautiful in itself'. There is nothing arbitrary in its architecture; on the contrary, everything in it is the consequence of a feeling, and is subject to the eternal laws of equilibrium.

To make a picture, the artist begins by choosing and grouping certain elements from external reality; in other words, by synthesis he draws from some object the *elements*—forms and colours—necessary to the assembling of his subject. The transition from object to subject constitutes his aesthetic, which is governed by the mind. After this, to pass from the subject to the work, he employs a variety of *means* proper to the expression of his subject; this process constitutes his technique, and it is inspired by emotion. This effort defies analysis; it carries within itself all the mystery of Art. The final result is the *picture*, whose emanation is Beauty.

Valori Plastici, Rome, February–March 1919, p. 2.

Léonce Rosenberg supported the cubists during the First World War by acting as their dealer in the absence of Kahnweiler, who as a German national took refuge in Switzerland, where he wrote *Der Weg zum Kubismus* (see text 41). By 1919 Rosenberg represented almost all the major cubists, and some, such as Valmier, who were very minor indeed. He served as expert in the post-War auction sales of Kahnweiler's sequestered stock, a role which earned him little sympathy from Braque and other cubists. Rosenberg was a far better connoisseur than businessman, and he had been forced as early as 1918 to sell a portion of his stock of cubist works at public auctions. He later suffered financial reverses, but not before having held numerous exhibitions of the cubists at his Galerie de l'Effort Moderne, as well as publishing the *Bulletin de l'Effort Moderne*. This periodical, which lasted for 40 issues between

1924 and 1927, is one of the most important sources for texts and illustrations relative to later cubism.

The short text reproduced here is a most lucid description of the process involved in the creation of a synthetic cubist work[1]. It was published in a pamphlet entitled *Cubisme et Tradition* (Paris, 1920); and Rosenberg also used it as a preface to the large exhibition of cubism which he organized at the Galerie Moos, Geneva (February, 1920).

39 Maurice Raynal

Some Intentions of Cubism

1919

The comfortable truths will be those suggested by our senses, which love the direct and the precise, which hate effort and the exigences of the mind, our idle senses, the lovers of well-being and facility: in a word, the truths of the senses.

The uncomfortable truths, on the contrary, will be, as always, the prerogative of the efforts of reason; they will tend towards the knowledge of things in their essential and abstract nature; they will be the truths of the mind.

So it is that the quest for truth in art has brought about an attempt at pictorial notation which is not exactly comfortable. However, cubism has never claimed to be an art 'for everyone'. Non-Euclidean geometry, the poetry of Mallarmé, chamber music, science—these are not for the public at large; and let us not forget that art is and must be 'a finality apart from any end'.

Education and traditional doctrine have taught us, in fact, that it is not possible to assign an absolute value to the injunctions of the senses. Ever since Antiquity, philosophy has taught us this, and with the best will in the world modern philosophy cannot prove the contrary. 'The truth is not in our senses,' said Malebranche, 'but in the mind,' and Helmholtz—and indeed Bossuet before him—showed that the senses tell us nothing but their own sensations. Finally, Kant said very rightly that 'the senses give us simply and solely the matter of knowledge, while on the contrary the understanding gives us its form.'

This idealist conception, so fertile in artistic and poetic beauties, forms the traditional basis of great art, and modern minds have accepted it almost without reserve.

We can thus agree with Plato that 'the senses perceive only that which passes, the understanding that which endures.' What nobler aspiration could an artist have than to capture, on canvas or in marble, not just a portion of time, but the whole of duration; not just one particular dimension, but space itself. And observe here how art joins philosophy at its most poetic and its boldest.

I know, too, that we are often criticized for our appeal to Plato, but please note that we bring philosophy to bear on art with reference to the artist's intellectual intentions only, and that aesthetics will never meddle with the means by which he expresses his sensibility. The cubists do not profess to be philosophers. Even if they did, that would do little harm, for in our days, philosophy is scarcely of value any more except considered as an art. Also, I can remember the joy of the first cubists when in the far-off days—it will soon be ten years ago—I showed them, by quotations from the philosophers, how their deductions had re-created most of these great thoughts.

'The senses perceive only that which passes, the understanding that which endures.' This thought was one of those that troubled the cubists most seriously; and can you conceive what it was capable of suggesting to their minds? . . .

To conceive an object is, in fact, to aim at knowing it in its essence, at representing it in the mind,—that is to say, for this purpose, as purely as possible, as a sign, as a *totem* if you like, absolutely free of all the useless details such as its aspects—accidental factors which are too numerous and too changeable. In fact the aspects, arbitrarily situating it in time or space, can only deflower its primary quality. And just as he will capture, on canvas or in marble, not what passes but what endures, the artist will not situate the object in a particular place, but in space, which is infinite. We might then add to Plato's phrase, as a corollary, this one: 'The senses perceive only that which is situated; the mind that which is in space.'

Pursuing this conception, the picture will offer a guarantee of certainty in itself; that is to say, of absolutely pure truth. A rich carpet is a fugitive image, which warms you with all its colours, but which we quickly forget. Now, the same will be true of any picture which merely glows with sensuous richness, more or less in harmony with the objects that surround it. But the true picture will constitute an individual object, which will possess an exist-

ence of its own apart from the subject that has inspired it. It will itself *sur-round everything*. In its combination of elements it will be a work of art, it will be an object, a piece of furniture if you like; better still, it will be a kind of formula; to put it more strongly, *a word*. In fact it will be, to the objects it represents, what a word is to the object it signifies; and we know well what art is contained in words, with their variety, their richness, their colour or their sobriety.

In this way we shall possess the very idea of the objects, in their purest externalization; we shall have a new representation of them, and so it is that the artist will make the Beautiful, in Hegel's words, into a 'sensible manifestation of the Idea' . . .

Remember, only, that cubism is simply an attempt at a new notation susceptible of improvement, and that it has no other aim than to submit, for examination by your sensibility, new wholes made up of elements from perfectly familiar objects—and this with the help of means chosen in the most judicious and the most traditional way.

from *Quelques intentions du cubisme*, Paris 1919

By 1919 cubism was no longer a novelty, and many critics had begun to look at the movement from a more detached point of view than had been possible before the War. This change of attitude took several forms. Artists whose own work was an outgrowth of cubism criticized its shortcomings[1]; others, notably Gleizes, sought to codify the achievements of the style in a set of laws. Raynal here seeks simply to give to cubism intellectual and philosophical justifications, doing so in his characteristically austere manner.

References to Plato among defenders of cubism may be found as early as 1916, when Ozenfant quoted the passage from Philebus on the beauty of geometrical forms[2]. Raynal's theory of cubism as an art of formal signs is indeed relevant to synthetic cubism and was later expanded by Kahnweiler in his *Juan Gris*[3]. Raynal, however, is vague about the precise nature of these signs in cubism, the degree of their ideal purity, and their relation to visual reality[4].

Why is the 'Cube' Disintegrating?

1919

... One can already foresee the day, near at hand now, when the term
'CUBISM' will have ceased to have more than a nominative value, indicating
in the history of contemporary painting the researches of certain painters
between 1907 and 1914. To refuse to recognize the importance of the cubist
movement would be fatuous, just as to laugh at it was idiotic. But it is quite
as idiotic and fatuous to try to stop at a doctrine which today is dated, and
to refuse to recognise that cubism no longer offers enough novelty and surprise
to provide nourishment for a new generation.

It has lasted now for ten years.

The stage seems to have been passed.

The 'home from the Front' generation has its mind aroused by other prob-
lems, and its researches point in a new direction. First of all, it feels very
much its own master. It wants to construct. And it does not seem to me likely
to lose itself in long theoretical researches, for it has elements to hand: colour.
It will therefore construct by means of colour.

I shall not produce a history of cubism or an exposition of its doctrine. I
refer to the books about it: they have demonstrated the high standards main-
tained by this school of painting. Here I shall confine myself to criticizing
the initial error of cubism, an entirely theoretical error, which is today the
second cause—an external cause—of the crumbling of the 'cube'.

What have been the four main theoretical concerns of the cubist painters?

(1) *The pursuit of depth* (reality, super-reality, life);
(2) *The study of volumes* (space);
(3) *The study of measure* (time);
(4) *Criticism and revision of everything to do with 'craftsmanship' in
 painting* (technique).

I formulate: *To attain depth through the radiating influence of volumes
and the multiplication of measures with the aid of a reasoned technique.*

This formula was never observed in its entirety. From the start, the cubist
painters have strangely diminished it by losing sight of point (1) and con-

fusing it with an amalgamation of points (2) and (3). In fact, on the pretext of coming to grips with *reality*, they have to all intents and purposes multiplied *space* by *time*—which they naïvely called the 'Fourth Dimension', thus creating a heresy, in which they always drew near to the *reality of the object* only, instead of *reality itself*. In other words, they studied *progression in space*, that is to say *matter* (the matter *of the object*) and not *progression in depth*, that is to say *the principle (of reality)**.

Reduced to the *reality of the object*, of syntheses, the researches became analytical. And so we quickly saw the cubist painters putting themselves on a diet of painting nothing but still-lifes and—taking effect for cause—soon introducing actual bits of matter into their pictures, such things as broken bottle ends, stiff collars, papers, wood, imitation wood, cloth, hair, even the 'object' itself as found in the shops! Thus they found the opposite of what they had been looking for. For the incongruous object had to be 'arranged' pictorially, and in this way they ended up in the field of 'fashion'. This is why cubism, which was meant to renovate painting, has never escaped from the confines of 'taste'. It has established the reign of the simulacrum; this is the supreme heresy in art.

At this point we touch on sorcery, and I am sure that, examined from the point of view of occultism, cubism will yield some alarming and terrible secrets. Some cubist paintings remind one of black magic rites; they exhale a strange, unhealthy, disturbing charm; they almost literally cast a spell. They are magic mirrors, sorcerers' tables.

This is why the younger generation, being healthy, muscular and full of life, is turning away from cubism. In spite of its more sinister aspects, in spite of the purity of the means employed, cubism does not succeed in troubling the young. They lay their emphasis on precisely the point which was left out of the cubist experiment: the study of depth. The young have a sense of reality. They abhor a vacuum; they abhor destruction. They do not rationalize vertigo. They stand on their feet. They are alive. They want to construct; and one can construct only in depth. Colour is balance. Colour is a sensuous element. The senses are reality. This is why the world is coloured. The senses construct. There you have mind. Colours sing. In neglecting colour

* The futurists, for their part, divided space by time and always studied the *dynamism* of the object and not the *rhythm* of matter, that is to say *progression in a plane* and not *progression in space:* the *mechanics* and not the *chemistry* (of which some of the cubists did have an inkling).

the cubist painters neglected the emotive principle which decrees that, to be alive (alive in itself, super-real), every work should include a sensuous, un-reasoned, absurd, lyrical element, the vital element that hoists the work out of limbo.

Compared with the constructive painting of tomorrow, theoretical cubism is like the Trocadéro compared with the Eiffel Tower: no future, no mor-row, no possible use. This comparison applies to the theorists of the group. And if, in spite of them, the cubist experiment has not been entirely negative, we owe it to the three antitheorists of the group, the three painters with temperament who represent the three successive aspects of cubism: Picasso, Braque, Fernand Léger.

'Pourquoi le "Cube" s'effrite?', *La Rose rouge*, Paris, 15 May 1919, pp. 33–5

Blaise Cendrars (1887–1961), world-wanderer and anarchic free spirit, must be counted among the major figures in early twentieth-century French poetry. In his poetry as in his life he embraced the dynamism and artifice of the new century, be it the aeroplane, the cinema, the skyscrapers of New York, jazz, or the fantasy world of Hollywood. Cendrars knew all the greatest artists of his time and was a close friend of Robert and Sonia Delaunay, but especially of Léger, with whom he shared an instinctive affinity for the common people and the popular life of city streets.

Cendrars' assessment of cubism is surely among the most unusual and unexpected in the critical literature of the movement. Instead of starting from any of the usual critical tenets he boldly proposes general categories of artistic problems, the attempted solutions to which in his opinion define the cubist enterprise. Cendrars rejects the subleties of the style and completely misunderstands collage; he looks for a less complex, less intellectual art in which colour would be preeminent. In so doing he was perhaps unconsciously thinking back to his close personal and artistic association with the Delaunays before 1914. In his brusque directness, Cendrars nevertheless raises general questions about cubism which may easily be overlooked in the theoretical intricacies of other critics.

Several times during the spring of 1910 Picasso attempted to endow the forms of his pictures with colour. That is, he tried to use colour not only as an expression of light, or *chiaroscuro,* for the creation of form, but rather as an equally important end in itself. Each time he was obliged to paint over the colour he had thus introduced; the single exception is a small nude of the period (about 18 x 23 centimetres in size) in which a piece of fabric is coloured in brilliant red.

At the same time Braque made an important discovery. In one of his pictures he painted a completely naturalistic nail casting its shadow on a wall. The usefulness of this innovation will be discussed later. The difficulty lay in the incorporation of this 'real' object into the unity of the painting. From then on, both artists consistently limited the space in the background of the picture. In a landscape, for instance, instead of painting an illusionistic distant horizon in which the eye lost itself, the artists closed the three-dimensional space with a mountain. In still-life or nude painting, the wall of a room served the same purpose. This method of limiting space had already been used frequently by Cézanne.

During the summer, again spent in l'Estaque, Braque took a further step in the introduction of 'real objects', that is, of realistically painted things introduced, undistorted in form and colour, into the picture. We find lettering for the first time in a *Guitar Player* of the period. Here again, lyrical painting uncovered a new world of beauty—this time in posters, display windows and commercial signs which play so important a role in our visual impressions.

Much more important, however, was the decisive advance which set cubism free from the language previously used by painting. This occurred in Cadaquès (in Spain, on the Mediterranean near the French border) where Picasso spent his summer. Little satisfied, even after weeks of arduous labour, he returned to Paris in the autumn with his unfinished works. But he had taken the great step; he had pierced the closed form. A new tool had been forged for the achievement of the new purpose.

Years of research had proved that closed form did not permit an expression sufficient for the two artists' aims. Closed form accepts objects as contained by their own surfaces, *viz.* the skin; it then endeavours to represent this closed body, and, since no object is visible without light, to paint this 'skin' as the contact point between the body and light where both merge into colour. This *chiaroscuro* can provide only an illusion of the form of objects. In the actual three-dimensional world the object is there to be touched even after light is eliminated. Memory images of tactile perceptions can also be verified on visible bodies. The different accommodations of the retina of the eye enable us, as it were, to 'touch' three-dimensional objects from a distance. Two-dimensional painting is not concerned with all this. Thus the painters of the Renaissance, using the closed form method, endeavoured to give the illusion of form by painting light as colour on the surface of objects. It was never more than 'illusion'.

Since it was the mission of colour to create the form as *chiaroscuro,* or light that had become perceptible, there was no possibility of rendering local colour or colour itself. It could only be painted as objectivated light.

In addition, Braque and Picasso were disturbed by the unavoidable distortion of form which worried many spectators initially. Picasso himself often repeated the ludicrous remark made by his friend, the sculptor Manolo, before one of his figure paintings: 'What would you say if your parents were to meet you at the Barcelona station with such faces?' This is a drastic example of the relation between memory images and the figures represented in the painting. Comparison between the real object as articulated by the rhythm of forms in the painting and the same object as it exists in the spectator's memory inevitably results in 'distortions' as long as even the slightest verisimilitude in the work of art creates this conflict in the spectator. Through the combined discoveries of Braque and Picasso during the summer of 1910 it became possible to avoid these difficulties by a new way of painting.

On the one hand, Picasso's new method made it possible to 'represent' the form of objects and their position in space instead of attempting to imitate them through illusionistic means. With the representation of solid objects this could be effected by a process of representation that has a certain resemblance to geometrical drawing. This is a matter of course since the aim of both is to render the three-dimensional object on a two-dimensional plane. In addition, the painter no longer has to limit himself to depicting the object as it would appear from one given viewpoint, but, wherever necessary for fuller comprehension, he can show it from several sides, and from above and below.

Representation of the position of objects in space is done as follows: instead of beginning from a supposed foreground and going on from there to give an illusion of depth by means of perspective, the painter begins from a definite and clearly defined background. Starting from this background the painter now works toward the front by a sort of scheme of forms in which each object's position is clearly indicated, both in relation to the definite background and to other objects. Such an arrangement thus gives a clear and plastic view. But if only this scheme of forms were to exist it would be impossible to see in the painting the 'representation' of things from the outer world. One would only see an arrangement of planes, cylinders, squares, etc.

At this point Braque's introduction of undistorted real objects into the painting takes on its full significance. When 'real' details are thus introduced the result is a stimulus which carries with it memory images. Combining the 'real' stimulus and the scheme of forms, these images construct the finished object in the mind. Thus the desired physical representation comes into being in the spectator's mind.

Now the rhythmization necessary for the coordination of the individual parts into the unity of the work of art can take place without producing disturbing distortions, since the object in effect is no longer 'present' in the painting, that is, since it does not yet have the least resemblance to actuality. Therefore, the stimulus cannot come into conflict with the product of the assimilation. In other words, there exist in the painting the scheme of forms and small real details as stimuli integrated into the unity of the work of art; there exists, as well, but only in the mind of the spectator, the finished product of the assimilation, the human head, for instance. There is no possibility of a conflict here, and yet the object 'recognized' in the painting is now 'seen' with an intensity of which no illusionistic art is capable.

As to colour, its utilization as *chiaroscuro* had been abolished. Thus, it could be freely employed, as colour, within the unity of the work of art. For the representation of local colour, its application on a small scale is sufficient to effect its incorporation into the finished representation in the mind of the spectator.

In the words of Locke, these painters distinguish between primary and secondary qualities. They endeavour to represent the primary, or most important qualities, as exactly as possible. In painting these are the object's form and its position in space. They merely suggest the secondary characteristics such as colour and tactile quality, leaving their incorporation into the object to the mind of the spectator.

This new language has given painting an unprecedented freedom. It is no longer bound to the more or less verisimilar optic image which describes the object from a single viewpoint. It can, in order to give a thorough representation of the object's primary characteristics, depict them as stereometric drawing on the plane surface, or, through several representations of the same object, it can provide an analytical study of that object which the spectator then reassembles in his mind. The representation does not necessarily have to be in the closed manner of the stereometric drawing; coloured planes, through their direction and relative position, can bring together the formal scheme without uniting in closed forms. This was the great advance made at Cadaqués. Instead of an analytical description, the painter can, if he prefers, also create in this way a synthesis of the object, or in the words of Kant, 'put together the various conceptions and comprehend their variety in one perception'.

from *Der Weg zum Kubismus,* Munich, 1920, pp. 27–34;
English ed. *Way of Cubism,* New York, 1949, pp. 10–12

Daniel-Henry Kahnweiler (born 1884) is as essential a part of the history of cubism as are the poets and painters themselves. He has been its principal dealer since the beginnings of cubism, and through his energetic activities in exhibiting cubist works outside France, starting in 1910, he is responsible in large part for its spread as a style throughout the world. In addition to his activities as an art dealer, Kahnweiler has also written numerous books and articles, of which *Der Weg zum Kubismus* was the first, which have played an influential role in critical thinking about modern art.

This book was written during the First World War when Kahnweiler was in Switzerland; a short version of its first four chapters was published in 1916[1]. It is coloured by his interest in philosophy, which had been stimulated by reading and study during the War years[2].

Although he was later to change his ideas somewhat, Kahnweiler here places the crucial moment in the evolution of cubism in the summer of 1910, when Picasso at Cadaqués began to disregard the contours of figures and objects and to use arbitrary geometrical planes which linked the figure with its background. Elsewhere in this book Kahnweiler does not consider *papier collé* and collage as particularly significant innovations, although he had been forced to leave France as a German national too soon after the development of these new media to be able to grasp their historical importance. Except for Salmon, however (see text 18), Kahnweiler was one of the few to recognize the seminal importance of *Les Demoiselles d'Avignon,* which he discusses in this book without referring to it by its present name.

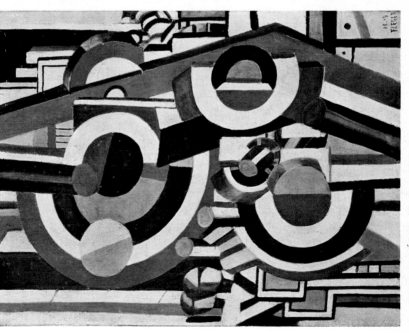

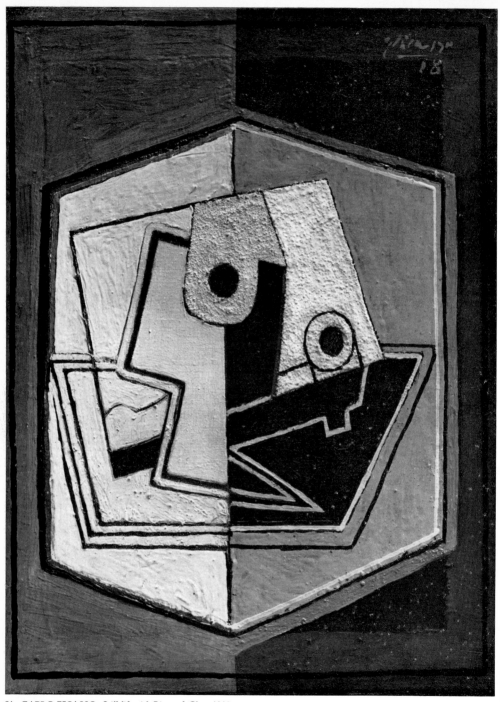

51 PABLO PICASSO, *Still-life with Pipe and Glass*, 1918

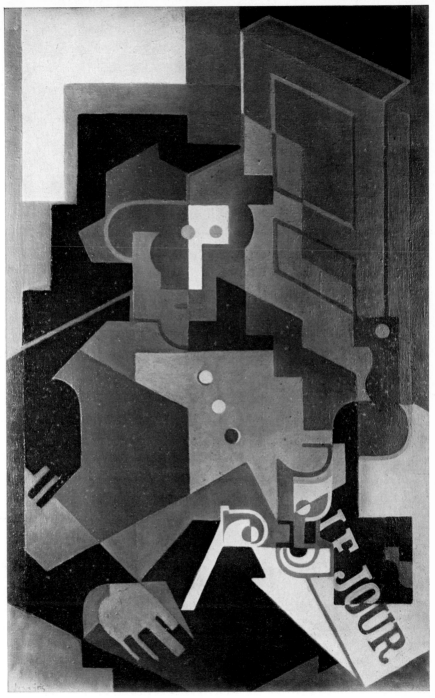

52 JUAN GRIS, *The Man from Touraine*, 1918

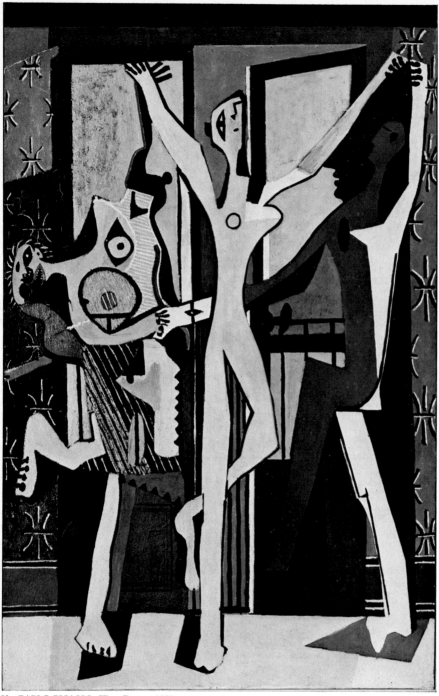

53 PABLO PICASSO, *Three Dancers*, 1925

Picasso with New Caledonian sculptures in the Bateau-Lavoir, Montmartre 1908

Picasso in his studio at 11 Boulevard de Clichy, Paris c. 1911

56 Braque's studio in the Hotel Roma, Paris 1913

57 Georges Braque, 1908

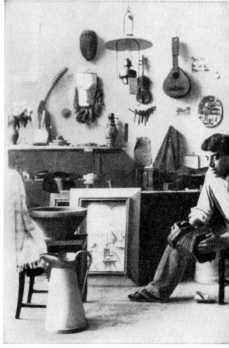

58 Georges Braque in his studio, 4 Rue d'Orsel, c. 1911

60 Guillaume Apollinaire, before 1914

59 Jean Metzinger, c. 1912

62 André Salmon

61 Pierre Reverdy

Waldemar George

Foreword to an Exhibition held by *Der Sturm*, Berlin

1921

Cubism is entirely based on the theory of equivalents: an equivalent for volume, an equivalent for aerial perspective, an equivalent for form. These three elements in a picture—elements drawn from nature—are reduced to their plastic condition and so become unrecognizable. This is because the cubist painter does not translate reality, any more than he evokes or interprets it, but takes his inspiration from the objects about him and coordinates them on the plane surface of his canvas, not according to the laws of nature, but according to the laws proper to that surface. Because of this, he is nearer than anyone else to the truth: the truth of his work. As for nature itself, the cubist painter—whether from modesty or from deference to old prejudices—suggests it directly, more directly than his predecessors, by introducing into his picture realist elements—labels, inscriptions, etc.,—which strike the spectator's imagination directly like attributes.

Cubism is an end in itself, a constructive synthesis, an artistic fact, a formal architecture independent of external contingencies, an autonomous language and not a means of representation. This granted, the problem is still intact. The cubist aesthetic does not constitute an insurance against mediocrity. Within the framework, however rigid, of the structural laws, there is still room for all the gifts of imagination. Cubism does not mean levelling. Outstanding personalities can express themselves with the same ease everywhere. Cubism does not exclude freedom and fantasy; it does not bar the way to the imagination.

Cubism is an art which acts by attacking the retina and the plastic sensibility of the spectator, without appealing to his emotive faculties. Like impressionism and chromo-luminarism, cubism has contributed to the solution of a certain number of problems of a technical nature. It substitutes for the artificiality of lighting the internal light which becomes in this way an organic function of the picture. It replaces aerial perspective by an equivalent for the third dimension.

'Vorwort zur 93. Sturm-Ausstellung', *Der Sturm*,
Berlin, January 1921, pp. 1–3

This essay was published on the occasion of an exhibition in Berlin of Gleizes, Villon, and Marcoussis; it was reprinted in *L'Esprit Nouveau*[1]. Waldemar George (born 1893) has been a defender and critic of cubism since the First World War and in recent years has been instrumental in securing proper recognition for the minor followers of the movement. Although he here somewhat oversimplifies the issues of synthetic cubism, he very correctly refers to the fact that, by 1921, the style had become common property, available to artists of the most varied sensibilities and gifts.

43 Juan Gris

Personal Statement

1921

I work with the elements of the intellect, with the imagination. I try to make concrete that which is abstract. I proceed from the general to the particular, by which I mean that I start with an abstraction in order to arrive at a true fact. Mine is an art of synthesis, of deduction, as Raynal has said.

I want to endow the elements I use with a new quality; starting from general types I want to construct particular individuals.

I consider that the architectural element in painting is mathematics, the abstract side; I want to humanize it. Cézanne turns a bottle into a cylinder, but I begin with a cylinder and create an individual of a special type: I make a bottle—a particular bottle—out of a cylinder. Cézanne tends towards architecture, I tend away from it. That is why I compose with abstractions (colours) and make my adjustments when these colours have assumed the form of objects. For example, I make a composition with a white and a black and make adjustments when the white has become a paper and the black a shadow: what I mean is that I adjust the white so that it becomes a paper and the black so that it becomes a shadow.

This painting is to the other what poetry is to prose.

Though in my system I may depart greatly from any form of idealistic or naturalistic art, in practice I cannot break away from the Louvre. Mine is

the method of all times, the method used by the old masters: there are technical *means* and they remain constant.

> *L'Esprit nouveau*, No. 5, Paris, February 1921, pp. 533–4. English text in D.-H. Kahnweiler: *Juan Gris*, New York 1947, p. 138

Juan Gris was as clear and rigorous in his thinking as he was in his painting; and of all his contemporaries it was he who developed the purest version of synthetic cubism. In this, his most famous published statement, he formulates his deductive method, by which he progressed from the purely non-objective architecture of design and colour on a canvas, toward the representation of specific objects in the visible world.

Perhaps Gris exaggerates when he claims to start from a completely abstract composition in creating his works, but it is known that he used mathematical drawings as part of his working methods[1]; and most of his compositions after 1911 are based either on the golden section or on strict mathematical ratios of whole numbers.

44

Jean Cocteau

Picasso

1923

The life of a picture is independent of the life it imitates. A masterpiece such as the portrait of Madame Rivière [by Ingres, 1805, collection the Louvre], results from the marriage of the two forces.

We can go on to imagine an arrangement of living lines in which the object which motivates the lines ceases to play the leading part and becomes merely a pretext. From this stage to conceiving the disappearance of the pretext is only a step. The end has become the means—and this is the stroke of audacity we witnessed in 1912, the most dramatic in the history of painting. An artist's sense of decorum used to lead him to take away the 'scaffolding' when he had finished drawing a bottle or a lady; Picasso carries the same sense of deco-

rum to the point of considering the lady or the bottle as the scaffolding which made his construction possible; so he makes them disappear in their turn.

What is left? A picture. This picture is nothing but a picture. And the difference between this picture and the decorative arrangement which it threatens to be—and which ill-will sees in it—is the intrinsic life of the forms that compose it.

One day Picasso wanted to paint a screen, and tried to find for it some simple arabesque decoration. He gave this up; the screen was already alive.

It is therefore—contrary to what the public imagines—much less easy to dupe the eyes with an illegible picture than with a representational picture, because the latter, if in itself dead, may still get an appearance of life from its model, while a closed work by Picasso owes its life to no artifice . . .

Here, then, is a Spaniard, provided with the oldest French recipes (Chardin, Poussin, Lenain, Corot), in possession of a charm. Objects and faces follow him where he wishes. A dark eye devours them and they undergo, between that eye through which they go in and the hand through which they come out, a strange kind of digestion. Furniture, animals, people, mingle like lovers' bodies in love. During this metamorphosis, they lose nothing of their objective power. When Picasso changes the natural order of the numbers, he still reaches the same total.

Scarcely has he possession of the charm before he uses it. On what shall he try it out? One imagines Midas after Bacchus has conferred on him the power to change what he touches into gold. A tree, a column, a statue intimidate him. He dares not. He hesitates; he touches a fruit.

Picasso tests himself first on what happens to be in reach. A newspaper, a glass, a bottle of Anis del Mono, a piece of oilcloth, a flowered wallpaper, a pipe, a packet of tobacco, a playing-card, a guitar, the cover of a song: *Ma Paloma.*

He and Georges Braque, his miraculous companion, ransack humble objects. Do they leave their studios? The Butte de Montmartre can still show us the objects that gave rise to their harmonies: ready-made ties in haberdasheries, imitation marble and imitation wood in the bars, absinthe and Bass beer advertisements, soot and wallpaper in houses under demolition, bits of chalk from a game of hopscotch, tobacconists' signs naively painted with two Gambier pipes tied in a sky-blue ribbon.

At first the pictures, often oval, are beige cameos with an abstract grace. Later, they become humanized, and the still-lifes begin to throb with that strange life which is no other than the very life of the painter. The grapes

in a painting no longer decoy the birds. Mind alone recognises mind. *Trompe-l'esprit* exists. *Trompe-l'œil* is dead.

<div align="right">from Picasso, Paris, 1923, pp. 9–13</div>

Jean Cocteau (1889–1963) met Picasso in 1916; in 1917 they went to Italy together to work with Diaghilev on the spectacle *Parade,* and the two remained lifelong friends. Cocteau was almost too ubiquitous a talent to describe—poet, painter, dramatist, film maker, and master of most of the other arts; in 1955 he was named to the Académie Française.

As a critic Cocteau was more sensitive to music than to the plastic arts, and his own painting is little more than a mannered reflection of Picasso. But in this selection from his early book on Picasso he reveals that astonishing power of intuitive clarity and precision that was never to fail him.

45 Pablo Picasso

Statement to Marius de Zayas

1923

I can hardly understand the importance given to the word *research* in connection with modern painting. In my opinion to search means nothing in painting. To *find* is the thing. Nobody is interested in following a man who, with his eyes fixed on the ground, spends his life looking for the purse that fortune should put in his path. The one who finds something no matter what it might be, even if his intention were not to search for it, at least arouses our curiosity, if not our admiration.

Among the several sins that I have been accused of, none is more false than that I have, as the principal objective in my work, the spirit of research. When I paint, my object is to show what I have found and not what I am looking for. In art intentions are not sufficient and, as we say in Spanish, love must be proved by deeds and not by reasons. What one does is what counts and not what one had the intention of doing.

We all know that Art is not truth. Art is a lie that makes us realize truth, at least the truth that is given us to understand. The artist must know how

to convince others of the truthfulness of his lies. If he only shows in his work that he has searched, and re-searched, for the way to put over lies, he would never accomplish anything.

The idea of research has often made painting go astray, and made the artist lose himself in mental lucubrations. Perhaps this has been the principal fault of modern art. The spirit of research has poisoned those who have not fully understood all the positive and conclusive elements in modern art and has made them attempt to paint the invisible and, therefore, the unpaintable.

They speak of naturalism in opposition to modern painting. I would like to know if anyone has ever seen a natural work of art. Nature and art, being two different things, cannot be the same thing. Through art we express our conception of what nature is not.

Velazquez left us his idea of the people of his epoch. Undoubtedly they were different from the way he painted them, but we cannot conceive a Philip IV in any other way than the one Velazquez painted. Rubens also made a portrait of the same king and in Rubens' portrait he seems to be quite another person. We believe in the one painted by Velazquez, for he convinces us by his right of might.

From the painters of the origins, the primitives, whose work is obviously different from nature, down to those artists who, like David, Ingres and even Bouguereau, believed in painting nature as it is, art has always been art and not nature. And from the point of view of art there are no concrete or abstract forms, but only forms which are more or less convincing lies. That those lies are necessary to our mental selves is beyond any doubt, as it is through them that we form our aesthetic view of life.

Cubism is no different from any other school of painting. The same principles and the same elements are common to all. The fact that for a long time cubism has not been understood and that even today there are people who cannot see anything in it, means nothing. I do not read English, an English book is a blank book to me. This does not mean that the English language does not exist, and why should I blame anybody else but myself if I cannot understand what I know nothing about?

I also often hear the word evolution. Repeatedly I am asked to explain how my painting evolved. To me there is no past or future in art. If a work of art cannot live always in the present it must not be considered at all. The art of the Greeks, of the Egyptians, of the great painters who lived in other times, is not an art of the past; perhaps it is more alive today than it ever was. Art does not evolve by itself, the ideas of people change and with them

their mode of expression. When I hear people speak of the evolution of an artist, it seems to me that they are considering him standing between two mirrors that face each other and reproduce his image an infinite number of times, and that they contemplate the successive images of one mirror as his past, and the images of the other mirror as his future, while his real image is taken as his present. They do not consider that they are all the same images in different planes.

Variation does not mean evolution. If an artist varies his mode of expression this only means that he has changed his manner of thinking, and in changing, it might be for the better or it might be for the worse.

The several manners I have used in my art must not be considered as an evolution, or as steps toward an unknown ideal of painting. All I have ever made was made for the present and with the hope that it will always remain in the present. When I have found something to express, I have done it without thinking of the past or of the future. I do not believe I have used radically different elements in the different manners I have used in painting. If the subjects I have wanted to express have suggested different ways of expression I have never hesitated to adopt them. I have never made trials or experiments. Whenever I had something to say, I have said it in the manner in which I have felt it ought to be said. Different motives inevitably require different methods of expression. This does not imply either evolution or progress, but an adaption of the idea one wants to express and the means to express that idea.

Arts of transition do not exist. In the chronological history of art there are periods which are more positive, more complete than others. This means that there are periods in which there are better artists than in others. If the history of art could be graphically represented, as in a chart used by a nurse to mark the changes of temperature of her patient, the same silhouettes of mountains would be shown, proving that in art there is no ascendant progress, but that it follows certain ups and downs that might occur at any time. The same occurs with the work of an individual artist.

Many think that cubism is an art of transition, an experiment which is to bring ulterior results. Those who think that way have not understood it. Cubism is not either a seed or a foetus, but an art dealing primarily with forms, and when a form is realized it is there to live its own life. A mineral substance, having geometric formation, is not made so for transitory purposes, it is to remain what it is and will always have its own form. But if we are to apply the law of evolution and transformation to art, then we have

to admit that all art is transitory. On the contrary, art does not enter into these philosophic absolutisms. If cubism is an art of transition I am sure that the only thing that will come out of it is another form of cubism.

Mathematics, trigonometry, chemistry, psychoanalysis, music and what-not, have been related to cubism to give it an easier interpretation. All this has been pure literature, not to say nonsense, which has only succeeded in blinding people with theories.

Cubism has kept itself within the limits and limitations of painting, never pretending to go beyond it. Drawing, design and colour are understood and practised in cubism in the spirit and manner in which they are understood and practised in all other schools. Our subjects might be different, as we have introduced into painting objects and forms that were formerly ignored. We have kept our eyes open to our surroundings, and also our brains.

We give to form and colour all their individual significance, as far as we can see it; in our subjects, we keep the joy of discovery, the pleasure of the unexpected; our subject itself must be a source of interest. But of what use is it to say what we do when everybody can see it if he wants to?

'Picasso Speaks', *The Arts*, New York, May 1923, pp. 315–26; reprinted in Alfred Barr: *Picasso*, New York 1946, pp. 270–1

Picasso (1881–1973) has always avoided theorizing[1], especially in public. This was his first published statement on art[2], although by no means the last. Nor should it be surprising that the most inventive European artist in several hundred years prefers to create rather than to construct theories. Thus, with the exception of indirect quotations and more or less apocryphal remarks attributed to him, we have no personal statements by the principal creator of cubism until almost ten years after he had invented the essential elements of the style.

And even in 1923, what does Picasso say about his art? That cubism is neither a transitional phenomenon, nor painted philosophy, but an art primarily of forms that has much in common with previous styles; and that to understand cubism, all that is necessary is to look at the paintings! Picasso tells us little if anything specifically about cubism; but he does show us inadvertently how his mind works: with a complete confidence in its own powers, a ruthless directness and freshness of comprehension in the face of any issue, and an ironic wit that is never long in abeyance.

Reply to a Questionnaire

1925

Cubism? As I never consciously, and after mature reflection, became a cubist but, by dint of working along certain lines, have been classed as such, I have never thought about its causes and its character like someone outside the movement who has meditated on it before adopting it.

Today I am clearly aware that, at the start, cubism was simply a new way of representing the world.

By way of natural reaction against the fugitive elements employed by the impressionists, painters felt the need to discover less unstable elements in the objects to be represented. And they chose that category of elements which remains in the mind through apprehension and is not continually changing. For the momentary effects of light they substituted, for example, what they believed to be local colours of objects. For the visual appearance of a form they substituted what they believed to be the actual quality of this form.

But that led to a kind of representation which was purely descriptive and analytical, for the only relationship that existed was that between the intellect of the painter and the objects, and practically never was there any relationship between the objects themselves.

Moreover, this is perfectly natural, for each new branch of intellectual activity always begins with description: that is to say, with analysis, classification. Before the existence of physics as a science, men described and classified physical phenomena.

Now I know perfectly well that when it began cubism was a sort of analysis which was no more painting than the description of physical phenomena was physics.

But now that all the elements of the aesthetic known as 'cubist' can be measured by its pictorial technique, now that the analysis of yesterday has become a synthesis by the expression of the relationships between the objects themselves, this reproach is no longer valid. If what has been called 'cubism' is only an appearance, then cubism has disappeared; if it is an aesthetic, then it has been absorbed into painting.

'Chez les cubistes', *Bulletin de la vie artistique*, Paris, 1 January 1925, pp. 15–17; English text in D.-H. Kahnweiler: *Juan Gris,* New York 1947, pp. 144–5

In this short essay Gris makes a most important distinction between later, 'synthetic' cubism and the earlier phases of cubism. His insistence on the descriptive character of early cubism, with its emphasis on the relationship of the painter to the object, serves by way of contrast to underline the essentially artistic concerns of cubism after 1914. Gris' own paintings provide almost the best example of a solution to the artistic problem of relating forms to each other in later cubism *(Ill. 52)*. This new emphasis on the internal structure of the work of art, rather than on description of the external visual world, corresponds to a similar attitude on the part of such poets as Max Jacob and Pierre Reverdy (see texts 35 and 37).

47 Amédée Ozenfant and Charles-Édouard Jeanneret

 Towards the Crystal

 1925

We see, then, the true cubists continuing their work imperturbably; we see them also continuing their influence upon men's minds; while the others are plundering in the neighbouring orchards, they keep steadily on.

They will end by seeking—more or less firmly according to the ups and downs of their nature, their tenacity or their concessions and the gropings that are characteristic of artistic creation—a state of clarification, condensation, firmness, intensity, synthesis; they will end by achieving a real virtuosity in the play of forms and colours, as well as a highly developed science of composition. On the whole, and in spite of personal co-efficients, one can detect a tendency which might be described metaphorically as a *tendency towards the crystal.*

The crystal, in nature, is one of the phenomena that touch us most, because it clearly exemplifies to us this movement towards geometrical organization. Nature sometimes reveals to us how its forms are built up by the interplay of internal and external forces. The crystal grows, and stops growing, in accordance with the theoretical forms of geometry; man takes delight in

these forms because he finds in them what seems to be a confirmation for his abstract geometrical concepts. Nature and the human mind find common ground in the crystal as they do in the cell, and as they do wherever order is so perceptible to the human senses that it confirms those laws which human reason loves to propound in order to explain nature.

In genuine cubism there is something organic, which proceeds outwards from within; most of the paintings of its predecessors maintain themselves by artifices of arrangement, juxtaposition and agglomeration which stem from the need to hold together the objects represented. Cubism was the first to try to make the picture an *object;* the old picture was a sort of panorama— a window open on to a scenario.

from *La Peinture Moderne,* Paris, 1925, pp. 137–8

Ozenfant (1886–1966) and the great architect Jeanneret (1887–1965), who is better known by his pseudonym of Le Corbusier, began an intellectual collaboration during the First World War with their book *Après le Cubisme* (Paris, 1918); and it culminated in their review *L'Esprit Nouveau* (Paris, 1920–1925, 29 issues). Most of *La Peinture Moderne,* from which this text is taken, first appeared in *L'Esprit Nouveau,* which was one of the most brilliant and influential periodicals of the decade. Its editors were quick to discover and to support the most advanced tendencies in painting, sculpture, architecture, design, and scientific thought. *L'Esprit Nouveau* took its name from the title of an essay by Apollinaire[1], but it had a different and more explicit meaning for Ozenfant and Jeanneret than the general sense of literary freedom and potential surrealism which Apollinaire gave to the term; for Ozenfant and Jeanneret were seeking to bring about a culture and a society based on technology, purity of design, and planning in all spheres of life.

Both were artists, Jeanneret having exhibited realistic watercolours as early as 1912 in the Paris Salon d'Automne. By 1920 the two had formulated in both word and deed a programme called 'purism', which they hoped would succeed cubism in the visual arts. First announced in Ozenfant's article of 1916, 'Notes sur le cubisme'[2], and then elaborated in their book *Après le Cubisme,* purism, like Mondrian's neo-plasticism, would retain the structural aspects of cubism but go beyond it to its unexploited implications. Unfortunately, the purist paintings of Ozenfant and Jeanneret are cubism stripped of all its spatial and formal tension, wit, and ambiguity: a sort of heretical, Calvinist cubism.

Similarly, in such manifestos as their *Après le Cubisme,* Ozenfant and Jeanneret find cubism too decorative and too chaotic, and they believe that the time has come for a more rigorous style, with a basis in laws of structure and composition.

Purism was but one of several symptoms, appearing by the early 1920s, of a crisis in cubism[3]. In Picasso's work it appears decisively in his *Three Dancers* of 1925 *(Ill. 53)*. Long before 1925, however, this crisis appears in the guise of a call, from others than the purists, for a more disciplined, codified cubist art[4]. The trend toward a cubist orthodoxy was soon recognized and seen as a crystallization, both literally and figuratively, of the style. Delaunay in 1924 believed it to be a dangerous symptom[5]; Ozenfant and Jeanneret were encouraged because they thought that cubism was at last turning 'purist'[6], as they explain here in a text which, ironically, foreshadows not a new stage of cubism but the end of its life as a style.

48 Albert Gleizes

Two Salons in 1911

c. 1944

THE 1911 SALON DES INDEPENDANTS, ROOM 41

... We formed two sections of exhibitors, one headed by Signac and Luce, the other composed of the artists of the new generation. The series of rooms on one side of the central hall would be filled by the old school, on the other the young painters would take on the arrangement of the rooms allotted to them. We took Room 41. André Lhote, Segonzac, La Fresnaye, etc., installed themselves in the rooms that followed on. It was at this moment that we became acquainted.

In Room 41 we—Le Fauconnier, Léger, Delaunay, Metzinger and myself—grouped ourselves, adding to our number, at the request of Guillaume Apollinaire who was following the arrangements with the most lively interest, Marie Laurencin...

Le Fauconnier was exhibiting his big picture, *Abundance*. Léger, his *Nudes in a landscape*, in which the volumes were treated according to the method of graduated zones used in architecture or mechanical models. Delaunay, *The Eiffel Tower* and *The City*. Marie Laurencin, pictures with figures... I, two landscapes and two pictures with figures—*The Woman with the Phlox* and *Nude Man Emerging from the Bath*.

This is precisely how Room 41 of the 1911 Indépendants was made up. The next room, if my memory can be trusted, must have had in it Lhote, Segonzac, Moreau . . .

I arrived at the Cours-la-Reine at about four in the afternoon—the opening of the exhibition had taken place at two. It was a wonderful Paris spring day, sunny and warm. I began walking through the first bays of rooms, where there were not many people. But as I moved on the crowd thickened, and at last I met my friends who, having arrived before me, now told me what was happening. People were packing into our room, shouting, laughing, raging, protesting, giving vent to their feelings in all sorts of ways; there was jostling at the doors to force a way in, there were arguments going on between those who supported our position and those who condemned it. We were completely at sea. It was like this all the afternoon: the room never emptied. We adjourned to the exhibition café and waited quietly for what would happen next. At five o'clock *L'Intransigeant* appeared, with Guillaume Apollinaire's article. He stressed the importance of our demonstration and defended us vehemently. In the papers that had come out that morning the more timid critics, including Louis Vauxcelles of *Gil Blas*, attacked us with surprising violence; some younger critics, who had the art columns in *Comœdia, Excelsior, Action, L'Oeuvre*, etc., showed more reserve, a few even gave us a sympathetic welcome; in *Paris-Journal* André Salmon, like the poet and free spirit he is, wrote an article full of intelligence and sensibility. We were, in short, violently savaged by the old guard of criticism, while the young critics, those of our own generation, were, in principle, on our side. And that was what mattered.

THE 1911 SALON D'AUTOMNE, ROOM VIII.

It was a memorable day, that opening-day of the 1911 Salon d'Automne! In an artist's life such moments leave an ineffaceable impression. This impression remains so clear that in a way it enhances the reality. When I conjure up that scene from the distant past, everything instantly re-establishes itself in a sensible present. Room VIII. Unlike Room 41 of the Indépendants, a few months earlier, it had not been arranged by us. We were not on the hanging committee. I suppose Duchamp-Villon and La Fresnaye must have been responsible. Duchamp-Villon we did not know, and La Fresnaye we had first met at the Indépendants. However that may

be, the room looked well. It was almost square, with one corner cut off by a cant-wall flanked by two doors. Standing with one's back to the cant-wall one faced two walls hung with pictures. On the extreme right was Fernand Léger's big picture *Essay for Three Portraits.* Then came André Lhote's *The Harbour at Bordeaux,* two or three etchings by Jacques Villon (including, if I am not mistaken, a *Portrait of an Actor),* and a female nude by Luc-Albert Moreau. In the corner and on the left-hand wall were a big picture by Marcel Duchamp, *The Sonata, Le Goûter* and a landscape by Jean Metzinger, some pictures by La Fresnaye, my picture *The Hunt,* and some Savoy landscapes by Le Fauconnier. Finally, on the cant-wall, my portrait of Jacques Nayral and Dunoyer de Segonzac's *The Boxers.*

The whole lacked the homogeneity of Room 41. The representatives of orthodox cubism, Le Fauconnier, Léger, Metzinger and myself, were side by side with artists who resembled us only remotely, artists who started from a different point and who were to continue, perhaps for ever, to deny that they belonged to cubism, artists who were therefore fiercely opposed to its inescapable consequences. My purpose in saying this is to stress the distinction that needs to be made between talent and state of mind. Unquestionably André Lhote and La Fresnaye are painters of very great talent. On the other hand, if they are to be allowed to discuss our state of mind, we must also not be refused the right to disagree with them about states of mind—and this from the very first. At the same time, here are new and talented artists who find themselves involved in this fusion of orthodoxy and dissidence, which has been 'decided by the hanging committee'. I refer to Marcel Duchamp and Jacques Villon, whom we did not know, and whom we got to know only at the end of the exhibition; in what circumstances, I will describe later.

In spite of its lack of homogeneity the thing as a whole has a fine irreverent swagger. From these pictures there rises a wind of battle. And at once the storm breaks. The opening-day crowd quickly condenses into this square room and becomes a mob like the one at the Indépendants. People struggle at the doors to get in, they discuss and argue in front of the pictures; they are either for or against, they take sides, they say what they think at the tops of their voices, they interrupt one another, protest, lose their tempers, provoke contradictions; unbridled abuse comes up against equally intemperate expressions of admiration; it is a tumult of cries, shouts, bursts of laughter, protests. The artists, painters, sculptors, musicians are there; some of the writers, poets, critics; and that unholy Parisian opening-day mob, in which socialites, genuine art-lovers and picture-dealers jostle one another, along

with the dairyman and the concierge who have been given an invitation by the artist who is a customer of theirs or lives in their block. This extraordinary flood of people was greater in this year 1911 than in previous years, because the newspapers had announced that the 'cubists' (whose arrival six months earlier had been a surprise) would be taking part. People scrambled for copies of the papers with special editions and of the magazines which gave 'a complete review of the exhibition, room by room', which the newsvendors were offering at the Avenue d'Autun and Rue Jean-Goujon entrances. Most of the papers abused us with unusual violence; the critics lost all restraint, and it rained invective. We were accused of the worst intentions, of seeking scandal, of making fun of the public, of trying to get rich quick by milking the snobs; we were accused of all the sins of Israel; hanging was too good for us. The great charge levelled at us was that of illegibility; people claimed that they could 'see' nothing in our pictures. And it was not only the philistines who voiced this complaint; half sincerely, half strategically, several painters of merit joined in the chorus . . .

<div align="right">

from *Souvenirs—le Cubisme 1908–1914*, Audin, Paris, 1957, pp. 15–29

</div>

Albert Gleizes wrote his *Souvenirs* during World War II[1]; they furnish a unique record of the first two important public manifestations of cubism. It was largely as a result of the scandal caused by the paintings in Room 41 of the 1911 Indépendants that the term cubism came into general use. By autumn 1911 the public was unwilling to accept cubism as anything more than a passing joke, and its reaction to Room VIII in the Salon d'Automne was therefore one of outrage, particularly since this Salon was chosen by a jury and was therefore considered to be more respectable than the Indépendants. It was only by political action and a stuffed ballot box that Gleizes and his friends managed to have their works hung together a second time.

After the Salon d'Automne Gleizes met the brothers Jacques Villon and Marcel Duchamp for the first time; and it was probably at this time also that Gleizes met Picasso, through Apollinaire.

Bibliography

A Brief Survey

There have been surprisingly few attempts thus far at a critical and historical evaluation of cubism. The first was Ozenfant's and Jeanneret's *La Peinture Moderne*, Paris, 1925, based on a series of articles in their review *L'Esprit Nouveau*. While inevitably prejudiced in favour of their own aesthetic interests, they did however give a broader view than many more recent critics, and they saw correctly that cubism continued as a living style until the mid-1920s; they also saw 1912 as a moment of decisive change, but overemphasized the role of Cézanne in pre-1914 cubism.

Carl Einstein in his excellent study of twentieth-century art, *Die Kunst des 20. Jahrhunderts*, Berlin, 1926, dealt individually with Picasso, Braque, Gris and Léger, and discussed some of the problems which he would later treat in 'Notes sur le cubisme', *Documents*, Paris, 1929, pp. 146–55, and in his *Georges Braque*, Paris, 1934.

In 1929 Guillaume Janneau attempted without great success to make a critical study of the movement in *L'Art Cubiste. Théories et Réalisations*, Paris, 1929. His account was based largely on a questionnaire he had organized while editor of the *Bulletin de la Vie Artistique*, and although he occasionally offered worthwhile insights, his book is rather disappointing. Far more ambitious was the contribution of Germain Bazin and René Huyghe in a series of articles published in *L'Amour de L'Art*, Paris, in 1933. Despite a prejudice in favour of French artists, they provided the first extensive documentary and bibliographical basis for the study of cubism.

All previous efforts were overshadowed by the brilliant and still indispensable *Cubism and Abstract Art* by Alfred Barr, published in New York in 1936, which was the first serious attempt to deal with both cubism and its consequences in a systematic and historical fashion; Barr's approach to the stylistic distinctions between analytical and synthetic cubism was to become a basis for much subsequent criticism. Barr was also one of the first to see the crucial role of collage and *papier collé* in the development of the style. His *Picasso, 50 Years of his Art*, New York, 1946, is also a fundamental study both of the artist and of cubism.

Almost as influential was Daniel-Henry Kahnweiler's *Juan Gris*, (Paris, 1946; English translation New York, 1947), which was for more than a monograph; besides providing uniquely first-hand documentation, Kahnweiler gave to cubism a cultural and philosophical framework that, although sometimes highly debatable, has not been surpassed.

Christopher Grey's *Cubist Aesthetic Theories* (Baltimore, 1953) was the first comprehensive study of the theoretical texts of the cubist movement in relation both to the paintings and to contemporary developments in French literature; notwithstanding omissions of important material, he provided useful guides to the study of interrelations between the painting, poetry, and philosophy of the cubist period.

The most intensive and best documented study of cubism is John Golding's *Cubism. A History and an Analysis 1907–1914*, London and New York, 1959. Drawing on a large body of both published and unpublished documentation, Golding made an authoritative and detailed analysis of the evolution of cubist style. Unfortunately he did not carry his study beyond 1914, and his indispensable concentration on the nuances of stylistic change during the 1907–14 period is gained at the expense of a discussion of the intellectual issues involved.

There have been several other important

published studies of cubism beside that of Golding in the past few years. Guy Habasque's *Le Cubisme* (Skira, 1959; translated into several languages) is notable for its historical perspective, thorough documentation, and reasoned examination of the philosophical issues under lying cubism. One of the most extensive treatments of cubism thus far is Robert Rosenblum's *Cubism and Twentieth-Century Art* (New York and London, 1960), which surveys the evolution of cubism in Paris and also, continuing Barr's work of 1936, examines the influence of the style on the growth of other early twentieth-century artistic movements. Rosenblum's book is further distinguished by his avoidance of the critical clichés of previous writers in favour of a fresh and intensive examination of the visual properties of the works of art themselves.

Apart from pictorial anthologies and brief or popularized introductions to the subject, the only other recent study of cubism is that of Carlo Ragghianti in 1961, in a series of articles entitled 'Revisioni sul Cubismo' in *Critica d'Arte*, Florence, No. 46, pp. 1–16; No. 47, pp. 1–15; and No. 48, pp. 1–11. It was reprinted in his *Mondrian e l'arte del XX. secolo*, Milan, 1962. Ragghianti analyses and dismissed as irrelevant many of the early critical and pseudo-scientific explanations of cubism, retraces the development of the style in the hands of its principal creators, and then proceeds to classify cubist painting according to an interesting but meaningless set of compositional categories.

Since this book was first published in 1966 several other studies have appeared: John Berger, *The Moment of Cubism and other Essays*, London, 1969; Douglas Cooper, *The Cubist Epoch*, London, 1970; Daniel-Henry Kahnweiler and Francis Crémieux, *My Galleries and Painters*, London, 1971; N. Wadley, *Cubism*, London, 1972; William Rubin, *Picasso in the Collection of the Museum of Modern Art*, New York, 1972; Dore Ashton, *Picasso on Art*, New York, 1972; Max Kozloff, *Cubism/Futurism*, New York, 1975; J. M. Nash, *Cubism, Futurism and Constructivism*, London, 1974.

Select Bibliography

Books and articles dealing with a single artist have not been included unless they have a general documentary value. Items of particular importance are marked with an asterisk (*).

I General

1 GOLBERG, Mécislas. *La Morale des lignes*. Paris, 1908 (see text 1).

2 STEIN, Gertrude. 'Picasso', *Camera Work*, New York, August 1912, pp. 29–30; written in 1909 (see text 7).

3 FORTHUNY, P. *Conférence sur les tendances de la peinture moderne*, Nantes, 1910.

4 *BURGESS, Gelett. 'The Wild Men of Paris', *Architectural Record*, New York, May 1910, pp. 400–14, *ill.*

5 *METZINGER, Jean. 'Note sur la peinture', *Pan*, Paris, October–November 1910, pp. 649–52 (see text 9).

6 PUY, Michel. *Le dernier état de la peinture*. Paris, no date (1910); first published in *Mercure de France*, Paris, 16 July 1910; reprinted in his *L'Effort des peintres modernes*, Paris, 1933.

7 FILLA, Emil. 'O Cnosti Novoprimitivismo', *Volné Směry*, Prague, 1911, pp. 62–70; *ill.*

8 *ALLARD, Roger. 'Sur quelques peintres', *Les Marches du Sud-Ouest*, Paris, June 1911, pp. 57–64, *ill.* (see text 11).

9 ALLARD, Roger. 'Les Beaux-Arts', *La Revue indépendante*, Paris, August 1911, pp. 128–33.

10 SOFFICI, Ardengo. 'Picasso e Braque', *La Voce*, Florence, 24 August 1911.

11 *METZINGER, Jean. 'Cubisme et tradition', *Paris-Journal*, 18 August 1911 (see text 13).

12 *GLEIZES, Albert. 'Jean Metzinger', *La Revue indépendante*, Paris, September 1911, pp. 161–72.

13 SALMON, André. 'Albert Gleizes', *Paris-Journal*, 14 September 1911.

14 SALMON, André. 'Pablo Picasso', *Paris-Journal*, 21 September 1911 (see text 14).

15 SALMON, André. 'Jean Metzinger', *Paris-Journal*, 3 October 1911.

16 SALMON, André. 'Georges Braque', *Paris-Journal*, 13 October 1911.

17 SALMON, André. 'La dernière découverte', *Paris-Journal*, 21 November 1911.

18 SALMON, André. 'Le Fauconnier', *Paris-Journal*, 9 December 1911.

19 COELLEN, Ludwig. *Die neue Malerei*, Munich 1912.

20 *Museum Folkwang. Band 1. Moderne Kunst. Plastik. Malerei. Graphik*, Hagen 1912. (Catalogue of the Museum).

21 MERCEREAU, Alexandre. *La Littérature et les idées nouvelles*. Paris 1912.

22 *ALLARD, Roger. 'Die Kennzeichen der Erneuerung in der Malerei', *Der Blaue Reiter*, Munich, 1912; second edition 1914. Reprinted in Czech in *Volné Směry*, Prague, 1912, pp. 227–38 (see text 15).

23 *OLIVIER-HOURCADE. 'La Tendance de la peinture contemporaine. Notes pour une causerie sur L'Art Contemporain', *Revue de France et des Pays français*, Paris, February 1912, pp. 35–41 (see text 16).

24 *APOLLINAIRE, Guillaume. 'Du sujet dans la peinture moderne', *Soirées de Paris*, February 1912, pp. 1–4. Reprinted in his *Les Peintres Cubistes*, Paris, 1913 (see text 25).

25 OLIVIER-HOURCADE. 'Enquête sur le cubisme', *L'Action*, Paris, 25 February, 17 March, 24 March 1912; *ill*.

26 *RIVIÈRE, Jacques. 'Sur les tendances actuelles de la peinture', *Revue d'Europe et d'Amérique*, Paris, 1 March 1912, pp. 384–406 (see text 17).

27 *SALMON, André. *La jeune peinture française*. Paris 1912 (see text 18).

28 *APOLLINAIRE, Guillaume. 'La Peinture nouvelle', *Soirées de Paris*, April–May 1912, pp. 89–92, 113–5. Reprinted in his *Les Peintres Cubistes*, Paris, 1913 (see text 25).

29 OLIVIER-HOURCADE. 'Le Mouvement pictural: vers une école française de peinture', *Revue de France et des Pays français*, Paris, June 1912, pp. 254–8.

30 ARCOS, René. 'La Perception originale et la peinture', *Les Bandeaux d'or*, Paris, July–August 1912, pp. 401–6.

31 *RAYNAL, Maurice. 'Conception et vision', *Gil Blas*, Paris, 29 August 1912 (see text 21).

32 TUDESQ, André. Interview with Albert Gleizes. 'Une querelle autour de quelques toiles', *Paris–Midi*, 4 October 1912.

33 *REVERDY, Pierre, editor, *La Section d'Or*, Paris, 9 October 1912, includes Raynal's 'L'Exposition de La Section d'Or', pp. 2–5 (see text 21).

34 *APOLLINAIRE, Guillaume. 'Les commencements du cubisme', *Le Temps*, Paris, 14 October 1912 (see text 22).

35 OLIVIER-HOURCADE. 'Discussions. A M. Vauxcelles', *Paris-Journal*, 23 October 1912.

36 RAYNAL, Maurice. 'Essai d'une définition de la peinture cubiste', *Correo de la Letras y de las Artes*, Barcelona, December 1912.

37 GLEIZES, Albert. Personal statement, in *Les Annales politiques et littéraires*, Paris, 1 December 1912, pp. 473–5.

38 *GLEIZES, Albert, and METZINGER, Jean. *Du Cubisme*. Paris, 1912. English edition, London, 1913; two editions in Russian, Moscow, 1913; excerpts published in *Poème et Drame*, Paris, March 1913, pp. 44–51 and in *Volné Směry*, Prague, 1913, pp. 279–92; complete new translation in HERBERT, R. L., *Modern Artists on Art*, New York, 1964 (see text 23).

39 GRANIÉ, Joseph. 'Du Cubisme', *Le Figuier*, Paris, December 1912–January 1913.

40 DERI, Max. *Die neue Malerei*. Munich, 1913; *ill*. Many later editions.

41 LAURVIK, J. Nilson. *Is It Art? Post Impressionism, Futurism, Cubism*. New York, 1913; *ill*.

42 ARP, Hans, and NEITZEL, L. H. *Neue französische Malerei*. Leipzig, 1913; *ill*.

43 MAHLBERG, Paul, editor. *Beiträge zur Kunst des XIX. Jahrhunderts und un-*

serer Zeit. Düsseldorf, Galerie Alfred Flechtheim, 1913; *ill.*

44 *SOFFICI, Ardengo 'Il Cubismo e oltre', *Lacerba*, Florence, 15 January 1913.

45 *APOLLINAIRE, Guillaume. 'Die moderne Malerei', *Der Sturm*, Berlin, February 1913, p. 272 (see text 24).

46 GLEIZES, Albert. 'La tradition et le cubisme', *Montjoie!*, Paris, 10 February, 1913, p. 4, and 25 February, 1913, pp. 2–3.

47 ZAYAS, Marius de. *A Study of the Modern Evolution of Plastic Expression.* New York, 1913; *ill.*

48 *APOLLINAIRE, Guillaume. 'Pablo Picasso', *Montjoie!*, Paris, 18 March 1913, p. 6; Reprinted in his *Les Peintres Cubistes. Méditations Esthétiques.* Paris, 1913, *ill.* Later French editions: Paris, 1922, Geneva, 1950, Paris, 1965. English edition, New York, 1944; German edition, Zurich, 1956 (see text 25).

49 *LACOSTE, Charles. 'Sur le "Cubisme" et la peinture', *Temps Présent*, Paris, 2 April 1913, pp. 332–40 (see text 26).

50 REBOUL, Jacques. 'La révolution de l'œuvre d'art et la logique de notre attitude présente', *Montjoie!*, Paris, 29 May 1913, pp. 5–6.

51 *LÉGER, Fernand. 'Les origines de la peinture et sa valeur représentative', *Montjoie!*, Paris, 29 May 1913, p. 7; 14–29 June 1913, pp. 9–10 (see text 27).

52 LA FRESNAYE, Roger de. 'De l'imitation dans la peinture et la sculpture', *Grande Revue*, Paris, 25 July 1913.

53 HAUSENSTEIN, Wilhelm. 'Der Kubismus', *Der Sturm*, Berlin, July 1913, pp. 67–70.

54 GALVEZ, Pedro Luis de. 'Deviazioni Artistiche: Chi è L'Evangelista del Cubismo', *La Domenica del Corriere*, Milan, 27 July–3 August 1913.

55 GLEIZES, Albert. 'Opinion', *Montjoie!*, Paris, November–December 1913, p. 14 (see text 28).

56 *RAYNAL, Maurice. 'Qu'est-ce que . . . le cubisme?', *Comœdia Illustré*, Paris, 20 December 1913 (see text 29).

57 *SOFFICI, Ardengo. *Cubismo e Futurismo.* Florence, 1914, *ill.*

58 RAPHAEL, Max, *Von Monet zu Picasso.* Munich, 1914, second edition 1920; *ill.*

59 *HAUSENSTEIN, Wilhelm. *Die bildende Kunst der Gegenwart.* Stuttgart and Berlin, 1914; later editions 1920, 1923.

60 *EDDY, A. J., *Cubists and Post-Impressionism.* Chicago and London 1914; *ill.*; second edition 1919. Bibliography ***.

61 FECHTER, Paul. *Der Expressionismus.* Munich, 1914, *ill.*; second edition 1920.

62 *MAC DELMARLE, F., 'Quelques notes sur la simultanéité en peinture', *Poème et Drame*, Paris, January–March 1914, pp. 17–21 (see text 30).

63 COQUIOT, Gustave. *Cubistes, Futuristes, Passéistes.* Paris, 1914, *ill.*; second edition 1923.

64 *LÉGER, Fernand. 'Les réalisations picturales actuelles', *Les Soirées de Paris*, 15 June 1914, pp. 349–56 (see text 32).

65 GALANTI, M.-B. 'Du cubisme et de la possibilité de le continuer', *Montparnasse*, Paris, 15 July 1914.

66 BEHNE, Adolphe. *Zur neuen Kunst.* Berlin, 1915: second edition 1917.

67 WRIGHT, W. H. *Modern Painting, Its Tendency and Meaning.* New York and London, 1915.

68 SHEVCHENKO, A. *Kubizm.* Moscow, 1916.

69 OZENFANT, Amédée. 'Notes sur le cubisme', *L'Elan*, Paris, 1 December 1916.

70 WALDEN, Herwarth. *Einblick in die Kunst: Expressionismus, Futurismus, Kubismus.* Berlin, 1917, *ill.*; second edition 1924.

71 SACS, Joan. *La pintura francesa moderna fins al cubisme.* Barcelona, 1917.

72 *REVERDY, Pierre. 'Sur le cubisme', *Nord–Sud*, Paris, 15 March 1917 (see text 35).

73 SEVERINI, Gino. 'La peinture d'avant-garde', *Mercure de France*, Paris, 1 June 1917, pp. 451–68.

74 *BRAQUE, Georges. 'Pensées et réflections sur la peinture', *Nord–Sud*, Paris, December 1917, pp. 3–5 (see text 36).

75 CHAVENON, Roland. *Une Expression de l'art français moderne: Le Cubisme.* Paris, no date (1918).

76 OZENFANT, Amédée, and JEANNERET, Charles-Edouard. '*Après le Cubisme*'. Paris, 1918.

77 REVERDY, Pierre. 'Certains avantages d'être seul', *Sic!*, Paris, October 1918 (see text 37).

78 BEHNE, Adolphe. *Die Wiederkehr der Kunst*. Leipzig, 1919.

79 *SALMON, André. *La jeune sculpture française*. Paris, 1919 (see text 19).

80 *RAYNAL, Maurice. *Quelques intentions du cubisme*. Paris, 1919 (see text 39).

81 REVERDY, Pierre. 'Le Cubisme, poésie plastique', *L'Art*, Paris, February 1919.

82 *Valori Plastici*. Special number on cubism, Rome, February–March 1919.

83 SALMON, André, 'Les origines et intentions du cubisme', *Demain*, Paris, 26 April, 1919, pp. 485–89.

84 ALLARD, Roger, editor. *Le nouveau spectateur*, Paris 1919–21.

85 CENDRARS, Blaise. 'Le "cube" s'effrite', *La Rose Rouge*, Paris, 15 May 1919; reprinted in his *Aujourd'hui*, Paris, 1931 (see text 40).

86 *ROSENBERG, Léonce. *Cubisme et Tradition*. Paris, 1920 (see text 38).

87 KÜPPERS, P. E. *Der Kubismus*. Leipzig, 1920. Bibliography*.

88 COQUIOT, Gustave. *Les Indépendants (1884–1920)*. Paris, no date (1920).

89 *KAHNWEILER, Daniel-Henry. *Der Weg zum Kubismus*. Munich, 1920, *ill.*; second German edition, Stuttgart, 1958. English edition, New York, 1949. French edition, in his *Confessions Esthétiques*, Paris, 1963 (see text 41).

90 SALMON, André. *L'Art Vivant*. Paris, 1920.

91 GLEIZES, Albert. *Du Cubisme et des moyens de le comprendre*. Paris, 1920.

92 GOLL, Iwan. 'Über Kubismus', *Kunstblatt*, Potsdam, 1920, pp. 215–22.

93 *Sélection*. Special issue on cubism, Brussels, 15 September 1920.

94 *RAYNAL, Maurice. *Picasso*. Munich, 1921. French edition, Paris, 1922.

95 SEVERINI, Gino. *Du cubisme au classicisme*. Paris, 1921.

96 BLUEMNER, Rudolf. *Der Geist des Kubismus und die Künste*. Berlin, 1921.

97 VAN DOESBURG, Theo. Series of articles on cubism, in Dutch. *De Stijl*, Leiden, 1921.

98 GRAUTOFF, Otto. *Die neue Kunst*. Berlin, 1921. Bibliography **.

99 GRAUTOFF, Otto. *Die Französische Malerei seit 1914*. Berlin, 1921.

100 KRAMAR, Vincenc. *Kubismus*. Prague, 1921.

101 SALMON, André. *Propos d'atelier*. Paris, 1922; second edition 1938.

102 KASSÁK, Ludwig, and MOHOLY-NAGY, L. *Buch neuer Künstler*. Vienna, 1922. Bibliography **.

103 LANDSBERGER, Franz. *Impressionismus und Expressionismus*. Leipzig, 1922. Bibliography **.

104 ZAHN, Leopold. 'Picasso und der Kubismus', *Jahrbuch der jungen Kunst*, Leipzig, 1922, pp. 116–52.

105 *PUNI, Ivan. 'Contemporary Painting' (in Russian). Berlin, 1923.

106 GLEIZES, Albert. 'La peinture et ses lois. Ce qui devait sortir du cubisme', *Vie des Lettres et des Arts*, Paris, March 1923, pp. 26–77.

107 *DASBURG, Andrew. 'Cubism, Its Rise and Influence', *The Arts*, New York, November 1923, pp. 279–84.

108 PACH, Walter. *The Masters of Modern Art*. New York, 1924.

109 *'Enquête sur le cubisme', *Bulletin de la Vie Artistique*, Paris, November 1924– 15 January 1925, in six instalments.

110 ARP, Hans, and LISSITSKY, El. *Ismes/Ismus/Isms*. Zurich, 1925.

111 KRÖLLER-MÜLLER, Mme. H. *Die Entwicklung der Modernen Malerei*. Leipzig, 1925.

112 *OZENFANT, Amédée, and JEANNERET, Charles-Edouard. *La Peinture moderne*. Paris, 1925 (see text 47).

113 *EINSTEIN, Carl and WESTHEIM, Paul. *Europa-Almanach*. Potsdam, 1925.

114 *FELS, Florent. *Propos d'Artistes*. Paris, 1925.

115 ROSENBERG, Léonce. Interview with Geo-Charles: 'Le cubisme. Ce qu'en pense M. Léonce Rosenberg', *Montparnasse*, Paris, June 1926, pp. 2–4.

116 KURTZ, Rudolf. *Expressionismus und Film.* Berlin 1926.

117 PAVOLINI, Corrado. *Cubismo, Futurismo, Espressionismo.* Bologna 1926.

118 *EINSTEIN, Carl. *Die Kunst des 20. Jahrhunderts.* Berlin, 1926; later editions in 1929, 1932.

119 OZENFANT, Amédée. 'Ecoles cubistes et post-cubistes', *Journal de psychologie normale et pathologique,* Paris, 15 January–15 March 1926, pp. 290–302.

120 MALEVICH, Kasimir. *Die Gegenstandslose Welt.* Munich, 1927; English edition, Chicago, 1959.

121 *RAYNAL, Maurice. *Anthologie de la Peinture en France de 1906 à nos jours.* Paris 1927; English edition, New York, 1928.

122 GLEIZES, Albert. *Der Kubismus.* Munich, 1928. French edition was published as: 'L'Epopée: de la forme immobile à la forme mobile', *Le Rouge et le Noir,* Paris, June–July 1929, pp. 57–90.

123 *JANNEAU, Guillaume. *L'Art Cubiste. Théories et réalisations. Etude critique.* Paris, 1929.

124 *EINSTEIN, Carl. 'Notes sur le cubisme', *Documents,* Paris, 1929, pp. 146–55.

125 GOMEZ DE LA SERNA, Ramon. *Ismos.* Madrid, 1931; second edition, Buenos Aires, 1943.

126 *BAZIN, Germain, and HUYGHE, René, editors. Special issue on cubism of *L'Amour de l'Art,* Paris, November 1933. Bibliography ***. Reprinted in their *Histoire de l'Art contemporain: La Peinture.* Paris, 1935.

127 *BARR, Alfred. *Cubism and Abstract Art.* New York, 1936. Bibliography ***.

128 ZERVOS, C. *Histoire de l'art contemporain.* Paris, 1938.

129 PACH, Walter. *Queer Thing, Painting.* New York, 1938.

130 *GUGGENHEIM, Peggy. *Art of this Century.* New York 1942.

131 *BARR, Alfred. *Picasso. 50 Years of his Art.* New York, 1946. Bibliography ***.

132 *KAHNWEILER, Daniel-Henry. *Juan Gris.* Paris, 1946; English edition, New York, 1947. Bibliography ***.

133 CRASTRE, Victor. *La Naissance du Cubisme, Ceret 1910.* [Gap, 1948].

134 *HAMILTON. G. H. 'The Dialectic of Later Cubism. Villon's Jockey', *Magazine of Art,* Washington D. C., November 1948, pp. 268–72.

135 KAHNWEILER, Daniel-Henry. 'Ursprung und Entwicklung des Kubismus', in *Die Meister französischer Malerei der Gegenwart,* Baden-Baden, 1948.

136 *KAHNWEILER, Daniel-Henry. L'Art nègre et le cubisme', *Présence Africaine,* No. 3, Paris–Dakar, 1948, pp. 367–77; English translation, *Horizon,* London, December 1948, pp. 412–20.

137 JUDKINS, Winthrop. 'Towards a Reinterpretation of Cubism', *Art Bulletin,* New York, December 1948, pp. 270–81.

138 FORNARI, Antonio. *Quarant' anni di Cubismo. Cronache, Documenti, Polemiche.* Rome, 1948.

139 *HABASQUE, Guy. 'Cubisme et phénoménologie', *Revue d'Esthétique,* Paris, April–June 1949, pp. 151–61.

140 AZOAGA, Enrique. *El Cubismo.* Barcelona, 1949.

141 KAHNWEILER, Daniel-Henry. *Les Années héroiques du cubisme.* Paris, 1950; second edition 1954.

142 *Ver y Estimar.* Special number on cubism, Buenos Aires, October 1950.

143 *GREY, Christopher. *Cubist Aesthetic Theories.* Baltimore, 1953. Bibliography **.

144 *Art d'aujourd'hui.* Special number on cubism, May–June 1953.

145 CARMODY, Francis. *Cubist Poetry. The School of Apollinaire.* Berkeley, 1954.

146 *BATES, A. S. *The Aesthetics of Guillaume Apollinaire.* Unpublished dissertation, University of Wisconsin, 1954.

147 *Le Flâneur des Deux Rives,* Paris, 1954–5. A periodical devoted to Apollinaire, containing many cubist documents.

148 WESCHER, Herta. 'Les collages cubistes', *Art d'Aujourd'hui,* Paris, March–April 1954, pp. 4–7.

149 *CHIPP, Herschell. *Cubism.* Unpublished dissertation, Columbia University, 1955.

150 *JOHNSON. Ellen. 'On the Role of the Object in Analytic Cubism', *Bulletin of the Allen Memorial Museum,* Oberlin, 1955, pp. 11–25.

151 KAHNWEILER, Daniel-Henry. 'Cubism: The Creative Years', *Art News Annual,* New York, 1955, pp. 107–16.

152 *COOPER, Douglas. *Letters of Juan Gris.* London, 1956.

153 LINDE, Ulfe. *Kubism.* Stockholm, 1956.

154 DESCARGUES, Pierre. *Le Cubisme.* Paris, 1956. English edition, with additional text by Alfred Schmeller, London, 1956. German edition, Vienna 1956.

155 FOSCA, François. *Bilan du Cubisme.* Paris 1956.

156 *BEAUDUIN, Nicolas. 'Les temps héroiques. A propos de *La Section d'Or',* Masques et Visages,* Paris, June 1956.

157 AZNAR, José Camon. *Picasso y el Cubismo.* Madrid 1956.

158 SCHMIDT, Georg. *Juan Gris und die Geschichte des Kubismus.* Baden-Baden 1957.

159 *FRANCASTEL, Pierre. *Du Cubisme à l'Art Abstrait.* Paris, 1957.

160 SHATTUCK, Roger. *The Banquet Years.* New York, 1958.

161 *GREENBERG, Clement. 'Pasted Paper Revolution', *Art News,* New York, September 1958, pp. 46–9, 60–1.

162 *GOLDING, John. *Cubism: A History and an Analysis 1907–1914.* London, 1959. French edition, Paris, 1962. Bibliography ***.

163 *HABASQUE, Guy. *Le Cubisme.* Skira, 1959. Translations into several languages.

164 *GOTTLIEB, Carla. 'The *Joy of Life:* Matisse, Picasso, and Cézanne', *College Art Journal,* New York, Winter 1959, pp. 106–16.

165 *ROSENBLUM, Robert. *Cubism and Twentieth Century Art.* New York and London, 1960. Also editions in German and Italian.

166 SYPHER, Wylie. *Rococo to Cubism in Art and Literature.* New York, 1960.

167 AMBROZIČ, Katarina. *Kubizam.* Belgrade, 1960.

168 LAUDE, Jean. 'Du cubisme à l'art abstrait', *Critique,* Paris, May 1960, pp. 426–51.

169 *RAGGHIANTI, Carlo. 'Revisioni sul Cubismo', *Critica d'arte,* No. 46 (pp. 1–16), No. 47 (pp. 1–15), No. 48 (pp. 1–11), Florence, July–December 1961.

170 BREUNIG, L.-C. 'Apollinaire et le cubisme', *Revue des Lettres Modernes,* No. 69–70, Paris, Spring 1962, pp. 7–24.

171 *BERGMAN, Pär. 'Modernolatria' et 'Simultaneità', Uppsala, 1962.

172 *CABANNE, Pierre. *L'Epopée du Cubisme.* Paris, 1963.

173 SERULLAZ, V. *Le Cubisme,* Paris, 1963.

174 *RAPPAPORT, Ruthann. *Robert Delaunay and Cubism, 1909–1913.* Unpublished thesis, New York University, 1963.

175 *KAHNWEILER, Daniel-Henry. *Confessions Esthétiques.* Paris 1963.

176 LAUDE, Jean. 'Vue d'ensemble: le cubisme', *Critique,* Paris February 1964, pp. 185–191.

177 MATUSTIK. Radislav. *Kubizmus.* Bratislava, 1965.

178 *POREBSKI, Mieczyslaw. *Granica Wspolczesnosci.* Warsaw, 1965.

II Eye-witness Accounts and Reminiscences

Billy, André. *Le Pont des Saints-Pères.* Paris, 1947.

*Carco, Francis. *Du Montmartre au Quartier Latin.* Paris, 1937.

Carco, Francis. *L'Ami des Peintres.* Geneva, 1944; Paris, 1953.

Chagall, Marc. *Ma Vie.* Paris 1931.

Dorgelès, Roland. *Bouquet de Bohème.* Paris, 1947.

Dorgelès, Roland. *Au Beau Temps de la Butte.* Paris 1949.

Fuss-Amore, Gustave, and Des Ombiaux, Maurice. *Montparnasse.* Paris, 1925.

Georges-Michel, Michel. *Peintres et sculpteurs que j'ai connus.* New York, 1942.

*Gleizes, Albert. *Souvenirs. Le Cubisme 1908–1914.* Lyon, 1957. (See text 48).

Halicka, Alice. *Hier*. Paris, 1946.
Hamnet, Nina. *Laughing Torso*. London, 1932.
Jacob, Max. *Chronique des Temps Héroiques*. Paris 1956.
*Kahnweiler, Daniel-Henry. 'Du temps que les cubistes étaient jeunes', *L'Oeil*, Paris, 15 January 1955, pp. 27–31.
*Kahnweiler, Daniel-Henry. *Entretiens*. Paris, 1961; German edition, Cologne, DuMont Dokumente, 1961.
Level, André. *Souvenirs d'un Collectionneur*. Paris, 1959.
*(Lipchitz, Jacques) Patai, Irene. *Encounters. The Life of Jacques Lipchitz*. New York, 1961.
Mac Orlan, Pierre. *Rue St. Vincent*. Paris 1928.
*Olivier, Fernande. *Picasso et ses Amis*. Paris 1933.
*Raynal, Maurice. 'Montmartre au temps du "Bateau-Lavoir"', *Médecine de France*, No. 35, Paris, 1952, pp. 17–30.
Salmon, André. *L'Air de la Butte*. Paris, 1945.
Salmon, André. *Montparnasse*. Paris, 1950.
Salmon, André. *Souvenirs sans Fin*. (Part 2.) Paris, 1956.
Salmon, André. *Souvenirs sans Fin*. (Part 3.) Paris, 1961.
*Severini, Gino. *Tutta la Vita di un Pittore*. Rome, 1946.
*Soffici, Ardengo. *Fine di un Mondo. IV. Virilità*. Florence 1955.
*Stein, Gertrude. *Autobiography of Alice B. Toklas*. New York 1933.
*Stein, Gertrude. *Picasso*. Paris, 1938 (in French). English edition, New York, 1939.
Stein, Leo. *Appreciation. Painting, Poetry and Prose*. New York, 1947.
Toklas, Alice B. *What is Remembered*. New York, 1963.
Vanderpyl, Fr. *Peintres de Mon Temps*. Paris, 1931.
*Warnod, André. *Les Berceaux de la Jeune Peinture*. Paris 1925.
*Warnod, André. *Ceux de la Butte*. Paris, 1947.
Warnod, André. *Fils de Montmartre*. Paris, 1955.

*Weill, Berthe. *Pan! Dans L'Oeil! ou Trente Ans dans les Coulisses de la Peinture Contemporaine, 1900–1930*. Paris, 1933.
Yaki, Paul. *Montmartre de nos vingt ans*. Paris, 1933.
Yaki, Paul. *Montmartre*. Paris, 1947.

Cubist Exhibitions

Note: Braque is abbreviated as B, Gleizes as G, Gris as Gr, Léger as L, Metzinger as M and Picasso as P.

1908 *Paris*. Salon des Indépendants. 20 March–2 May. B, M.
Paris. Salon d'Automne. 1 October–8 November. L, M.
Paris. Galerie Kahnweiler. Exposition Braque. 9–28 November. Introduction by Apollinaire (see text 3). For reviews see texts 4,5.

1909 *Paris*. Salon des Indépendants. 25 April–2 May. B, M.
Paris. Salon d'Automne. 1 October–8 November. L, M. Also a large retrospective exhibition of Corot.
Paris. Galerie Vollard. Exposition Picasso (no catalogue).
Paris. Galerie de L'Art Contemporain, 3 Rue Tronchet. 18 November 1909–15 January 1910. Included P.

1910 *Moscow*. 'Jack of Diamonds' Exhibition. Included G, Lhote, Le Fauconnier.
Paris. Salon des Indépendants. 18 March–5 May. G, L, M.
Paris. Galerie Notre-Dame des Champs. May. P (no catalogue). For review see text 8.
Düsseldorf. Ausstellung des Sonderbundes Westdeutscher Kunstfreunde und Künstler. 16 July–9 October. B, P.
Munich. Galerie Thannhäuser. Neue Künstler-Vereinigung. II. Ausstellung. 1–14 September, B, P.

Paris, Salon d'Automne. 1 October–8 November. G, L, M. For review see text 10.
London. Grafton Galleries. Manet and the Post-Impressionists. 8 November 1910–15 January, 1911. Included P.
Paris. Galerie Vollard. December 1910, January–February 1911. P. (no catalogue).

1911 *Moscow.* 'Jack of Diamonds' Exhibition. Included G.
New York. Gallery *291.* Picasso. April 1911.
Paris. Salon des Indépendants. 21 April–13 June. G, M, L. For review see texts 11, 12. See also text 48.
Berlin. XXII. Ausstellung der Berliner Sezession. May 1911. B, P.
Brussels. Les Indépendants. 10 June–3 July. G, L.
Düsseldorf. Ausstellung Sonderbund. 20 May–2 July. B, P.
Paris. Salon d'Automne. 1 October–8 November. G, L, M. See text 48.
Amsterdam. Moderne Kunst Kring. 6 October–5 November. Included B, P.
Paris. Galerie d'art ancien et d'art contemporain, 3 Rue Tronchet. 20 November–16 December. Included G, L, M.

1912 *Budapest.* Gallery Muveszhaz. February. B, P.
Munich. Galerie Goltz. *Der Blaue Reiter,* 2nd Exhibition. February 1912. Graphics, included B, P.
Paris. Salon des Indépendants. 20 March–16 May. G, Gr, M, L.
Berlin. Galerie *Der Sturm.* Erste Ausstellung. March 1912. Included B.
Barcelona. Galeries J. Dalmau. Exposicio d'art cubista. 20 April–10 May. Included G, Gr, L, M.
Berlin. Ausstellung der Berliner Sezession. Included P.
Cologne. Sonderbund. 25 May–30 September. Included B, P.
Berlin. Galerie *Der Sturm.* 3. Ausstellung. May. Graphics and drawings, included Gr, P.
Rouen. Salon de Juin (Société nor-

mande de peinture moderne). 15 June–15 July. Included L, G, Gr. For introduction by Maurice Raynal see text 19.
Prague. Exhibition of the Mánes Society. September–November. Included P.
Paris. Salon d'Automne. 1 October–8 November. G, L, M.
Paris. Galerie de la Boëtie. *La Section d'Or.* 10–30 October. Included G, Gr, L, M, Marcoussis, Villon. See text 21.
Amsterdam. Moderne Kunst Kring. 6 October–7 November. Included B, G, L, M, P. Introduction to catalogue by Henri Le Fauconnier, 'La Sensibilité moderne et la tableau', pp. 17–27; German translation, Munich, Galerie Goltz, 1913; Czech translation, *Volné Směry,* Prague, 1913, pp. 67 ff.
London. Grafton Galleries. Second Post-Impressionist Exhibition. 5 October–31 December. Included B, P.
Hagen. Museum Folkwang. Ausstellung Le Fauconnier und Archipenko. December. Introduction by Apollinaire: 'Archipenko'.
Moscow. 'Jack of Diamonds' Exhibition. Included G, L, P, Le Fauconnier.

1913 *Paris.* Galerie Berthe Weill. 17 January–1 February. Introduction to catalogue by Joseph Granjé. G, M, L.
Munich. Galerie Thannhauser. Picasso. February. This exhibition was later sent to Prague and then to Berlin.
Berlin. Galerie *Der Sturm.* 13. Ausstellung.February–March.AlfredReth.
Moscow. 'Jack of Diamonds' Exhibition. Included B, P.
New York. International Exhibition of Modern Art (The 'Armory Show'). 17 February–15 March. Included B, P, L, G. Subsequently travelled to Chicago and to Boston.
Paris. Salon des Indépendants. 19 March–18 May. G, M.
Budapest. Exhibition of Modern Art. May. Included P, M.

Prague. Exhibition of the Mánes Society. May–June. B, Gr, P.

Florence. Società delle Belle Arti. International exhibition. 30 March–30 June. Included G.

Munich. Galerie Goltz. Die neue Kunst. 11. Gesamtausstellung. August–September. Catalogue prefaces by Wilhelm Hausenstein and André Salmon. Included B, G, P, Gr.

Berlin. Erster Deutscher Herbstsalon. 20 September–1 November. Included G, L, M, also Beneš and other Czech cubists.

London. Doré Galleries. Post-Impressionist and Futurist Exhibition. 12 October 1913–16 January 1914. Included P.

Paris. Salon d'Automne. 15 November 1913–5 January 1914. Included G, M. Also, early cubist paintings of Diego Rivera.

Berlin. Galerie *Der Sturm.* 19. Ausstellung. Expressionisten, Kubisten, Futuristen. November. Included the Czech cubists Filla, Beneš, Gutfreund.

1914 *Paris.* Galerie Berthe Weill. Alfred Reth. February.

Prague. Mánes Society. February–March. Included G, M, de la Fresnaye, Marcoussis, Villon. Introduction by Alexandre Mercereau (see text 31).

Paris. Salon des Indépendants. 1 March–30 April. G, M, Marcoussis, Rivera, Reth, Rossine, and many other adherents of cubism.

Tokyo. Hibiya Art Museum, 14–28 March. Included L.

Paris. Galerie Berthe Weill. Diego Riviera. May.

Paris. Galerie Vildrac. Andre Lhote. May–June.

Paris. Galerie Berthe Weill. Metzinger. June.

Exhibitions after August 1914 (one-man exhibitions not included)

New York. Gallery *291.* 9 December–11 January, 1915. Included B, P.

1915 *New York.* Carroll Galleries. January. Included G, P.

New York. Carroll Galleries. March. Included G, M, Villon.

1916 *New York.* Modern Gallery. Included B, P.

Paris. Salon d'Antin. Organized by André Salmon. Included L, P, Hayden, Severini, Modigliani (no catalogue).

New York. Montross Gallery. 4–22 April. Included G, M.

New York. Bourgeois Galleries. 3–29 April. G, M.

Oslo. Den Franske Utstilling. November–December. Included P, G, M, L. Catalogue prefaces by Jean Cocteau and André Salmon.

1917 *New York.* Bourgeois Galleries. 10 February–10 March. B, G.

New York. Society of Independent Artists. 10 April–6 May. Included G, M, P, Rivera.

1918 *New York.* The Penguin Club. March. Included B, G, M, P, Gr, L.

New York. Bourgeois Galleries. 25 March–20 April. M, P.

1920 *Geneva.* Galerie Moos. La Jeune Peinture Française. Les Cubistes. February. B, Gr, L, M, P. Introduction by Léonce Rosenberg (see text 38.)

1920 *Paris.* Galerie de la Boëtie. *La Section d'Or.* March. Included G, L, B, Marcoussis, Villon. This exhibition travelled to Rome.

Brussels. Exhibition of cubism organized by review *Sélection.* 18 September–8 October. Included B, Gr, P.

Paris. Galerie Berthe Weill. Fauves, Cubistes, et Post-Cubistes. December 1920–January 1921.

Geneva. Exposition Internationale d'Art Moderne. 26 December 1920–25 January 1921.

1921 *Berlin.* Galerie *Der Sturm.* 93. Ausstellung. January. G, Villon, Marcoussis (see text 42).
Berlin. Galerie Der Sturm. 100. Ausstellung. September. Included B, G, L, Marcoussis, M, Villon.

1921 *New York.* Wanamaker Gallery, Belmaison. 22 November–17 December. Included B, Gr, L, M, P.

1922 *New York.* Wanamaker Gallery, Belmaison. 9–31 March. M, G, P.

1925 *Paris.* Galerie Vavin-Raspail. *La Section d'Or.* 13–21 January. B, G, Gr, L, M, P.
Zurich. Kunsthaus. Internationale Ausstellung. August–September. B, G, L, P.
Paris. Exposition 'L'Art d'aujourd-d'hui'. December. G, Gr, L, P.

1926 *Paris.* Grand Palais. Vingt Ans d'art indépendant. 20 February–21 March. G, L.

1927 *Mannheim.* Kunsthalle. Wege und Richtungen der abstrakten Malerei in Europa. 1 January–27 March. B, G, Gr, L, M, P.

1930 *New York.* Gallery De Haucke & Co. Exhibition of Cubism (1910–1913). April. G, P, L, B, M, Gr, Marcoussis.

1932 *Paris.* Galerie Jacques Bonjean. L'Epoque heroïque du Cubisme (1910–1914). 28 April–14 May. B, G, Gr, L, M, P.

1935 *Paris.* Galerie des Beaux-Arts. Les Créateurs du Cubisme. March–April. B, G, Gr, L, M, P.

1936 *New York.* Museum of Modern Art. Cubism and Abstract Art. Included all major cubists.

1937 *Paris.* Petit Palais. Les Maîtres de l'Art indépendant. June–October. G, B, L, P, Gr.

1938 *Paris.* Galerie de Beaune. Guillaume Apollinaire et ses Peintres. June.
New York. Julien Levy Gallery. Documents of Cubism. 13 December 1938–3 January 1939. Included P, B, Gr, G, L, M.

1939 *Berne.* Kunstmuseum. 6 May–4 June. Included P, B, Gr, L, G.

1943 *Paris.* Galerie Breteau. Présence d'Apollinaire. December 1943–January 1944. Included all major and minor cubists.

1945 *Paris.* Galerie de France. Le Cubisme, 1911–1918. 25 May–30 June. Included B, G, Gr, L, M, P.

1946 *New York.* Gallery Jacques Seligmann. 1910–1912: The Climactic Years in Cubism. 16 October–6 November. Included B, L, M, P.

1947 *London.* The London Gallery. The Cubist Spirit in its Time. All major and minor cubists.

1949 *New York.* Buchholz Gallery-Curt Valentin. Cubism. 5–30 April. Included B, Gr, L, P.

1950 *Venice.* Biennale. Included special section on cubism, with P, B, Gr, L. Introduction by Douglas Cooper.
Brussels-Verviers-Ghent. La Peinture sous le signe d'Apollinaire. Travelling exhibition, October–December 1950.

1952 *Paris,* Galerie Suzanne Michel. Le Bateau-Lavoir: Naissance du Cubisme, 1900–1915. 2–12 May. Included personal statements by artists.
Stockholm. Svenska-Franska Konstgalleriet. Den Unga Kubismen. 25 October–16 November. Included B, G, Gr, L, M, P.

1953 *Paris.* Musée National d'Art Moderne. Le Cubisme, 1907–1914. 30 January–9 April.

1954 *New York.* Perls Galleries. Picasso-Braque-Gris: Cubism to 1918. 4 January–6 February.

1955 *Chicago.* The Arts Club of Chicago. An Exhibition of Cubism. 10 March–11 April. Included B, P, Gr, G, L, M.
Paris. Galerie de L'Institut. Evocation de l'époque heroïque. 18 March–13 April. Included all major and minor cubists.

1956 *New York.* Sidney Janis Gallery. Cubism 1910–1912. 3 January–4 February. Included B, G, Gr, L, M, P.
Paris. Galerie Fricker. Autour du Cubisme. 4–31 December. Included P, B, Gr, G, and minor cubists.

1957 *London.* Gimpel Fils gallery. Autour du Cubisme. December. Included G, M, and many minor cubists.

1958 *Paris.* Galerie Knoedler. Les Soirées de Paris. 16 May–30 June. Catalogue by Guy Habasque. Included many major and minor cubists, and many documents.

1959 *Chicago.* Main Street Gallery. 13 October–9 November. Included P, M, B, G.

1960 *Paris.* Musée National d'Art Moderne. Les Sources du XXme Siècle. 4 December 1960–23 January 1961. Included B, G, Gr, L, M, P.

1962 *Cologne.* Wallraf-Richartz Museum. Europäische Kunst 1912. 12 September–9 December. Included P, B, Gr, L.
 Paris. Galerie Knoedler. Le Cubisme. 9 October–10 November. An exhibition organized jointly with Galerie Beyeler, Basel. Included P, B, Gr, L.

1963 *Paris.* Galerie Suillerot. 6–21 June. Included G, M, and minor cubists.
 Grenoble. Musée. Albert Gleizes et Tempête dans les Salons, 1910–1914. 19 June–31 August. Included Gr, G, L, M.
 London. Kaplan Gallery. Cubist Painters. 23 October–16 November. Included G, M, and many minor cubists.

1964 *Cologne.* Wallraf-Richartz Museum. Autour du Cubisme. 3 April–18 May. Included P, Gr, L, M, G, and many minor cubists.
 Paris. Galerie de L'Institut. Les Aspects méconnus du Cubisme. 10 June–10 July. Included many minor cubists.
 New York. Leonard Hutton Galleries. Albert Gleizes and the *Section d'Or.* 28 October–5 December. Included G, Gr, M, L, and many minor cubists.
 University Park (Pennsylvania). Pennsylvania State University. Cubism, Selected Works. 1–30 November. Included P, B, Gr, L, M, G.

1965 *Lille.* Palais des Beaux-Arts. Apollinaire et le cubisme. 3 April–14 May.

Included P, B, Gr, L, M, G, and many minor cubists; also cubist documents.

1966 *Paris.* Musée National d'Art Moderne. Paris–Prague 1906–1930. March–April. P, B, and Czechoslovak cubists.

Important Early Auction Sales of Cubism

1918 *New York.* Anderson Galleries. The Alexandre Rosenberg Collection. 3 May. Included Picasso, Gris, Metzinger, Rivera, Laurens, Lipchitz.

1921 *Amsterdam.* A. Mak. Collection Léonce Rosenberg. 22 February. Included Braque, Gris, Metzinger, Rivera, and many others.
 Paris. Hôtel Drouot. Collection Wilhelm Uhde. 30 May. Included Picasso, Braque, and others.
 Paris. Hôtel Drouot. Collection Kahnweiler. 13–14 June. Picasso, Braque, Léger, Gris.
 Amsterdam. A. Mak. Collection Léonce Rosenberg. 19 October. Included Metzinger, Picasso, Gris.
 Paris. Hôtel Drouot. Collection Kahnweiler, Part II. 17–18 November.

1922 *Paris.* Hôtel Drouot. Collection Kahnweiler, Part III. 4 July.

1923 *Paris.* Hôtel Drouot. Collection Kahnweiler, part IV. 7–8 May.

1927 *New York.* American Art Association. The John Quinn collection. 9–12 February.

1935 *Paris.* Hôtel Drouot. Collection Jacques Zoubaloff. 27–8 November. Included Braque, Picasso, Gris, Léger, Gleizes, Metzinger.

List of Illustrations

6 PABLO PICASSO, *Landscape,* La Rue des Bois August 1908. Oil on canvas, 0.735 x 0.60 m.; 29 x 23³/₄ in. Private collection, Paris (formerly in the collection of Gertrude Stein) (Photo: Galerie Leiris)

7 PABLO PICASSO, *Three Women,* 1908–9. Oil on canvas, 1.94 x 1.73 m; 76¹/₂ x 68¹/₄ in. Hermitage, Leningrad (formerly in Stein and Shchukin collections) (Photo: Galerie Leiris)

8 André Salmon in Picasso's studio in the Bateau-Lavoir with Picasso's *Three Women* and *Les Demoiselles d'Avignon,* Montmartre 1908 (Photo: Hachette)

9 GEORGES BRAQUE, *Grand Nu,* Paris 1908. Oil on canvas, 1.40 x 0.99 m.; 55¹/₄ x 39 in. Collection Mme Cuttoli, Paris (Photo: Galerie Leiris)

10 Houses at L'Estaque, photographed by D.-H. Kahnweiler, 1909. (Photo: D.-H. Kahnweiler)

11 GEORGES BRAQUE, *Houses at L'Estaque,* L'Estaque summer 1908. Oil on canvas, 0.73 x 1.60 m.; 28³/₄ x 23¹/₂ in. Kunstmuseum, Berne, Rupf Collection (Photo: Galerie Leiris)

12 HENRI ('Le Douanier') ROUSSEAU, *Village Street-scene,* 1909. Oil on canvas, 0.412 x 0.33 m.; 16¹/₄ x 13 in. Philadelphia Museum of Art, Louise and Walter Arensberg Collection (Photo: Philadelphia Museum of Art)

13 GEORGES BRAQUE, *Still-life with Fruit,* Paris late 1908. Oil on canvas, 0.53 x 0.67 m.; 20⁷/₈ x 26¹/₂ in. Modern Museet, Stockholm (Photo: Galerie Leiris)

14 Houses at Horta de San Juan, photographed by Pablo Picasso, summer 1909. Formerly in the collection of Gertrude Stein. (Photo: *Transition,* No. 11, Paris, February 1928, p. 91)

15 PABLO PICASSO, *Houses on a Hill,* Horta de San Juan summer 1909. Oil on canvas, 0.65 x 0.815 m.; 25¹/₂ x 32¹/₄ in. Private collection, Paris; formerly in the collection of Gertrude Stein (Photo: Galerie Leiris)

16 FERNAND LÉGER, *The Bridge,* 1909. Oil on canvas, 0.925 x 0.725 m.:

36¹/₂ x 28¹/₂ in. Leonard Hutton Galleries, New York (Photo: Galerie Beyeler, Basle)

17 PABLO PICASSO, *Still-life,* spring 1910. Watercolour on cardboard, 0.12 x 0.17 m.; 4³/₄ x 6³/₄ in. Private collection, Paris (Photo: Galerie Leiris)

18 FERNAND LÉGER, *Nudes in the Forest,* 1909–10. Oil on canvas, 1.20 x 1.70 m.; 51¹/₄ x 67 in. Rijksmuseum Kröller-Müller, Otterlo, The Netherlands (Photo: Archives Photographiques, Paris)

19 GEORGES BRAQUE, *Pitcher and Violin,* 1909–10. Oil on canvas, 1.17 x 0.735 m.; 46¹/₄ x 28³/₄ in. Kunstmuseum, Basle (Photo: Galerie Leiris)

20 PABLO PICASSO, *Portrait of Ambroise Vollard,* 1909–10. Oil on canvas, 0.92 x 0.65 m.; 36¹/₄ x 25⁵/₈ in. Hermitage, Leningrad (Photo: Giraudon, Paris)

21 PAUL CÉZANNE, *Portrait of Ambroise Vollard,* 1899. Oil on canvas, 1.00 x 0.81 m.; 39¹/₂ x 32 in. Musée du Petit Palais, Paris (Photo: Giraudon, Paris)

22 Ambroise Vollard. (Photo: from Ambroise Vollard, *Recollections of a Picture Dealer,* Boston, 1936, frontispiece)

23 PABLO PICASSO, *Portrait of Wilhelm Uhde,* spring 1910. Oil on canvas, 0.81 x 0.60 m.; 30³/₄ x 22³/₄ in. Collection Sir Roland Penrose, London (Photo: Galerie Leiris)

24 Wilhelm Uhde, 1906. Sonia Delaunay collection, Paris

25 PABLO PICASSO, *Female Nude,* Cadaquès summer 1910. Oil on canvas, 0.98 x 0.77 m.; 38³/₄ x 30³/₈ in. Philadelphia Museum of Art, Louise and Walter Arensberg Collection (Photo: Philadelphia Museum of Art)

26 PAUL CÉZANNE, *Gardanne,* 1885–6. Oil on canvas, 0.65 x 1.00 m.; 25⁵/₈ x 39¹/₂ in. The Barnes Foundation, Merion, Pa. (Photo: copyright 1966 The Barnes Foundation)

27 ANDRÉ DERAIN, *Cadaquès,* summer 1910. Oil on canvas, 0.60 x 0.73 m.;

23¹/₂ x 28³/₄ in. Národní galerie, Prague, Kramar Collection (Photo: Galerie Leiris)

28 PABLO PICASSO, *Portrait of Daniel-Henry Kahnweiler*, autumn 1910. Oil on canvas, 1.00 x 0.73 m.; 39⁵/₈ x 28⁵/₈ in. The Art Institute of Chicago, gift of Mrs Gilbert W. Chapman (Photo: The Art Institute of Chicago)

29 Daniel-Henry Kahnweiler, photographed by Picasso in his studio in the Boulevard de Clichy, Paris 1912. (Photo: *L'Oeil*, Paris)

30 GEORGES BRAQUE, *Sacré-Cœur*, Paris 1910. Oil on canvas, 0.55 x 0.405 m.; 21⁵/₈ x 16 in. Private collection, France (Photo: Galerie Leiris)

31 Sacré-Cœur, Paris. (Photo: E. Fry)

32 PABLO PICASSO, *Still-life with Clarinet*, Céret, summer 1911. Oil on canvas, 0.61 x 0.50 m.; 23¹/₄ x 19³/₄ in. Národní galerie, Prague, Vincenc Kramar Collection (Photo: Galerie Leiris)

33 PABLO PICASSO, *Man with Violin*, 1911. Oil on canvas, 1.00 x 0.73 m.; 39¹/₂ x 28⁷/₈ in. Philadelphia Museum of Art, Louise and Walter Arensberg Collection (Photo: Philadelphia Museum of Art)

34 GEORGES BRAQUE, *Still-life with Harp and Violin*, 1912. Oil on canvas, 1.16 x 0.81 m.; 45³/₄ x 31 in. Kunstsammlung Nordrhein-Westfalen, Düsseldorf, Schloss Jägerhof (Photo: Peter Witte, Düsseldorf)

35 JEAN METZINGER, *Nude*, 1910. Oil on canvas, dimensions unknown. Present owner unknown. Formerly in Commerre collection, Paris (Photo: from Apollinaire, *Les Peintres cubistes*, Paris, 1913)

36 ALBERT GLEIZES, *Man on Balcony*, 1912. Oil on canvas, 1.95 x 1.15 m.; 77 x 45¹/₂ in. Philadelphia Museum of Art, Louise and Walter Arensberg Collection (Photo: Philadelphia Museum of Art)

37 FERNAND LÉGER, *Study for 'The Woman in Blue'*, 1912. Oil on canvas, 1.31 x 0.99 m.; 50³/₄ x 39 in. Musée

Léger, Biot (Photo: Galerie Louis Carré)

38 GEORGES BRAQUE, *Still-life with Fruit-dish and Glass*, Sorgues September 1912. Pasted paper and charcoal on paper, 0.62 x 0.445 m.; 24¹/₂ x 17¹/₂ in. Private collection (Photo: Galerie Leiris)

39 PABLO PICASSO, *The Poet*, 1912. Oil on canvas, 0.61 x 0.50 m.; 24 x 19¾ m. Sacher collection, Basle (Photo: Galerie Leiris)

40 GEORGES BRAQUE, *Still-Life with Decanter and Glass*, 1910–11. Oil on canvas, 0.245 x 0.31 m.; 9³/₄ x 12¹/₄ in. Private collection, Strasbourg (Photo: Galerie Leiris)

41 PABLO PICASSO, *Still-life with Chair-caning*, 1912. Oil and paper on canvas, 0.27 x 0.35 m.; 10³/₄ x 13³/₄ in. Collection of Pablo Picasso (Photo: Musée des Arts décoratifs, Paris)

42 GEORGES BRAQUE, *Still-life with Mandoline, Violin and Newspaper (Le Petit Eclaireur)*, 1913. Pasted paper and charcoal on paper. 0.92 x 0.65 m.; 36¹/₄ x 25³/₄ in. Private collection, France (Photo: Galerie Leiris)

43 PABLO PICASSO, *Still-life with Violin and Guitar*, 1913. Pasted cloth, oil, pencil and plaster on canvas, 0.915 x 0.635 m.; 36 x 25 in. Philadelphia Museum of Art, Louise and Walter Arensberg Collection (Photo: Philadelphia Museum of Art)

44 JEAN METZINGER, *Portrait of Albert Gleizes*, 1912. Oil on canvas, 0.65 x 0.54 m.; 25¹/₂ x 21¹/₄ in. Collection of Leonard Hutton, New York (Photo: Leonard Hutton Galleries)

45 Albert Gleizes, c. 1912. (Photo: from Apollinaire: *Les Peintres Cubistes*, Paris 1913)

46 JUAN GRIS, *The Washstand*, 1912. Oil and pasted glass on canvas, 1.30 x 0.89 m.; 50¹/₂ x 35 in. Collection of Vicomtesse de Noailles, Paris (Photo: Galerie Leiris)

47 FERNAND LÉGER, *Contrasts of Forms*, 1913. Oil on burlap, 1.30 x 0.97

m.; 51¼ x 38¼ in. Philadelphia Museum of Art, Louis and Walter Arensberg Collection

48 PABLO PICASSO, *Man leaning on a Table*, 1915. Oil on canvas, 2.00 x 1.32 m.; 78 x 52 in. Private collection (Photo: Arts Council of Great Britain)

49 FERNAND LÉGER, *The Discs*, 1918–19. Oil on canvas, 1.30 x 0.97 m.; 51½ x 38¼ in. Collection Louis Carré, Paris (Photo: Galerie Louis Carré)

50 JEAN METZINGER, *The Blue Bird*, 1913. Oil on canvas, 2.30 x 1.96 m.; 90½ x 77 in. Musée d'Art Moderne de la Ville de Paris (Photo: Bulloz, Paris)

51 PABLO PICASSO, *Still-life with Pipe and Glass*, 1918. Oil and sand on canvas, 0.35 x 0.275 m.; 13⅜ x 10⅜ in. The Solomon R. Guggenheim Museum, New York, N. Y. (Photo: Archives Photographiques, Paris)

52 JUAN GRIS, *The Man from Touraine*, 1918. Oil on canvas, 1.00 x 0.65 m.; 39½ x 25⅜ in. Paris, Musée National d'Art Moderne, gift of André Lefèvre (Photo: Archives Photographiques, Paris)

53 PABLO PICASSO, *Three Dancers*, 1925. Oil on canvas, 2.15 x 1.40 m.; 84½ x 54¼ in. The Tate Gallery, London (Photo: Musée des Arts décoratifs, Paris)

54 Picasso with New Caledonian sculptures in his studio in the Bateau Lavoir, photographed by Gelett Burgess, Montmartre 1908. (Photo: from *The Architectural Record*, New York, May 1910, p. 407)

55 Picasso in his studio at 11 Boulevard de Clichy, Paris *c*. 1911, (Photo: from Fernande Olivier, *Picasso et ses amis*, Paris, 1933, p. 162)

56 Braque's studio in the Hotel Roma, Rue Caulaincourt, Paris 1913, photographed by Daniel-Henry Kahnweiler (Photo: Daniel-Henry Kahnweiler)

57 Georges Braque, photographed by Gelett Burgess, 1908 (Photo: from *The Architectural Record*, New York, May 1910, p. 405)

58 Georges Braque in his studio, 48 Rue d'Orsel, *c*. 1911 (Photo: *L'Oeil*, Paris)

59 Jean Metzinger, *c*. 1912. (Photo: from Apollinaire: *Les Peintres Cubistes*, Paris, 1918)

60 Guillaume Apollinaire, before 1914. (Photo: Viollet, Paris)

61 Pierre Reverdy. (Photo: *Mercure de France*, Paris)

62 André Salmon. (Photo: Viollet, Paris)

Line Blocks in Text

p. 50
Catalogue of Braque exhibition at Galerie Kahnweiler, 9–28 November 1908

p. 51
Gil Blas, Paris, 14 November 1908
The article in which Louis Vauxcelles used the word 'cubes' which gave cubism its name

p. 54
GEORGES BRAQUE, *Study for the 'Grand Nu'*. Drawing, ink on paper, dimensions unknown, present whereabouts unknown. (Photo: from *The Architectural Record*, New York, May 1910, p. 405)

p. 98
La Section d'Or, Paris, 9 October 1912, p. 1. The only issue of this rare periodical.

Catalogue of the exhibition of *La Section d'Or* 1–30 October 1912

p. 104
Gleizes and Metzinger, *Du Cubisme*, Paris, 1912, title page

p. 114
Apollinaire, Guillaume. *Les Peintres Cubistes*, Paris, 1913, title page

Notes

INTRODUCTION

1 See the following exhibitions for cross-sections of the period: *1907*, Amsterdam, Stede-lijk Museum, 1957; *1912*, Köln, Wallraf-Richartz Museum, 1961; *1914*, Baltimore, Museum of Art, 1964. *Years of Ferment*, Los Angeles, UCLA Art Gallery, 1965.
2 Christian Zervos. *Picasso*. Paris, 1932–; 14 volumes published to date. A similar cata-logue of the works of Braque is being published in instalments by the Galerie Maeght, Paris; see also the preliminary catalogue of Braque, by Georges Isarlov: *Georges Braque* Paris. 1932. An as yet unpublished catalogue of the works of Gris has been made by Mr Douglas Cooper.

The History of cubism

1 See D.-H. Kahnweiler, 'Huit entretiens avec Picasso', *Le Point*, Souillac, October 1952, p. 22.
2 See Zervos, *op. cit.*, vol. 2, part 1, text opposite pl. 11.
3 See Alfred Barr, *Picasso, 50 Years of His Art*. New York, 1946, p. 257, note to p. 56.
4 1904 Salon d'Automne, 33 works; 1905 Salon d'Automne, 10 works; 1906 Salon d'Automne, 10 works; 1907 Salon d'Automne, 56 works; Galerie Bernheim Jeune 16–29 June 1907, 79 watercolours; Cézanne was also included by Bernheim Jeune in group exhibitions in 1906 and 1907. The dealer Ambroise Vollard, who had exhibited Picasso as early as 1901, had the largest stock of Cézannes of any dealer during these years.
5 The striated hatchings seen in *Les Demoiselles*, and also in a few still-lifes of the summer of 1907, may quite possibly derive from African sculpture; a Dogon wooden door with this type of striation entered the collections of the Trocadéro in 1906. (Information by courtesy of M. Jean Laude, Paris.) See Marcel Griaule, *Arts de l'Afrique noire*, Paris, 1947, p. 65, pl. 53.
6 D.-H. Kahnweiler, 'Du temps où les cubistes étaient jeunes', *L'Oeil*, Paris, 19 January 1965, p. 28; *cf.* also his 'Cubism: The Creative Years', *Art News Annual*, New York, 1955, pp. 107 ff.
7 See Douglas Cooper, *Georges Braque*, The Arts Council of Great Britain, London, 1956, p. 28.
8 See *L'Intransigeant*, Paris, 20 March 1908; also *The Architectural Record*, New York, May 1910, p. 405.
9 A postcard from Picasso at La Rue-des-Bois to Gertrude Stein is postmarked 14 August 1908; Picasso-Stein correspondence, Yale University.
10 Quoted by Guy Habasque, in his 'Cubisme et phénoménologie', *Revue d'Esthétique*, (Paris), April–June 1949, p. 154 note 1.
11 See Gertrude Stein, *Autobiography of Alice B. Toklas*, New York, 1933, p. 110; see also *Transition*, No. 11, Paris, February 1928, p. 91.
12 See Douglas Cooper, *Fernand Léger et le Nouvel Espace*, Geneva, 1948, p. 36.
13 It was first exhibited in the Salon des Indépendants, spring 1911.
14 Louis Vauxcelles, in *Gil Blas*, Paris, 30 September 1911.

15 Picasso–Stein correspondence.
16 In many of their other cubist still-lifes Picasso and Braque painted not a clarinet, as is usually stated, but an oboe.
17 Information given to Mr Douglas Cooper by the artist. But this still-life has recently been dated 9 November 1912, supposedly on Picasso's word. See David Duncan, *Picasso's Picassos*. New York and London, 1961, p. 207.
18 See William Seitz, *The Art of Assemblage*, New York, 1961.
19 See Douglas Cooper, *Georges Braque*, London (The Arts Council of Great Britain), 1956, p. 35.
20 Picasso used a piece of pasted paper in a drawing of 1908 (Guggenheim Museum, New York, collection J. K. Thannhauser; illustrated in Zervos, *op. cit.*, vol. 2, part 1, 66), but it was to make a repair in the drawing. In the Musée des Beaux Arts, Strasbourg, there is a collage containing a strip of newspaper, by André Utter (1886–1948), who inhabited Montmartre and knew Picasso. It is dated falsely 1909; the newspaper clipping is from *Le Journal*, Paris, of 14 March, 1914.
21 The newspaper clippings in this work are from *Le Journal*, Paris, 6 and 9 December 1912.
22 A line, or the dimension of a painting, is divided by the golden section if the smaller part is to the larger part as the larger part is to the whole; taking the whole as 1, the larger part equals approximately 0.618. See William Camfield, 'Juan Gris and the Golden Section', *Art Bulletin*, New York, March 1965, pp. 128–34.
23 Gris and Matisse became friends during 1914 and spent part of that summer together; and in a few of his subsequent paintings, notably the *Piano Lesson* of 1916, Matisse used the golden section.
24 See Daniel Robbins, 'From Symbolism to Cubism: the Abbaye of Créteil', *Art Journal*, New York, winter 1963–4, pp. 111–16.
25 There is no significant connection with Maeterlinck's 1910 play of the same name.
26 See Judith Cladel, *Maillol*, Paris, 1937, p. 127.
27 Irene Patai, *Encounters. The Life of Jacques Lipchitz*, New York, 1961, pp. 181–2.

Cubism as a stylistic and historical phenomenon

28 See Maurice Merleau-Ponty, 'Cézanne', in *Sens et Non-Sens*, Paris, 1948, pp. 15–49.
29 See George H. Hamilton, 'Cézanne, Bergson, and the Image of Time', *College Art Journal*, New York, 1956, pp. 2–13.
30 See his 'Sobre el punto de vista en las artes', *Revista de Occidente*, Madrid, February 1924, pp. 129–60; note especially pp. 159–60. English translation, 'On Point of View in the Arts', *Partisan Review*, New York, August 1949, pp. 822–36; also included in Ortega y Gasset, *The Dehumanization of Art and Other Writings on Art and Culture*, New York, 1956.
31 See his 'Cubisme et phénoménologie', *Revue d'Esthétique*, Paris, April–June 1949, pp. 151–61.
32 *Ideen zu einer reinen Phänomenologie und phänomenologischen Philosophie*, Halle, 1913; English translation London 1931, re-edited New York 1962: *Ideas: General Introduction to Pure Phenomenology*.
33 See Gaston Berger, *Le Cogito dans la Philosophie de Husserl*, Paris, 1941, p. 36.
34 *Ideen*, section 59.
35 *Ibid.*, section 24.
36 *Ibid.*, section 2.
37 As, in contrast to cubism, is true of the 'purism' of Ozenfant and Jeanneret (see text 47). Cf. *Ideen*, section 59.
38 *Ideen*, section 75.
39 Paris, 1931; English translation, *Cartesian Meditations*, The Hague, 1960. For a later critique of Husserl's ideas, see Maurice Merleau-Ponty's *Phénoménologie de la Perception*, Paris, 1945, especially the introduction. (English translation, *Phenomenology of Perception*, London, 1962.)
40 *Méditations*, section 17.
41 See Leo Stein, *Appreciation. Painting, Poetry, and Prose*. New York, 1947, p. 177.
42 See Husserl, *Ideen*, section 61.

43 See text 23. Note also Picasso's remark on the pre-existing idea, quoted by Kahnweiler in his *Juan Gris*, Paris, 1946, p. 83; English edition, New York, 1947, p. 40.
44 See his statement on Negro art in *Action*, Paris, April 1920, p. 24; Quoted by Kahnweiler, *Juan Gris*, p. 276 (French edition; English edition, p. 137). See also Michel Leiris, 'Les Nègres d'Afrique et les arts sculpturaux', in *L'Originalité des Cultures*, Paris, UNESCO, 1953, p. 358.
45 See Henri van Lier, *Le Nouvel Age*, Tournai, 1962, pp. 35 ff.
46 See Anne Armstrong Wallis, 'A Pictorial Principle of Mannerism', *The Art Bulletin*, New York, 1939, pp. 280–3.
47 In *Die Welt als Labyrinth*, (Rowohlt 50/51), Hamburg, 1957, pp. 112 ff.
48 See a general discussion by Werner Hofmann, 'Manier und Stil in der Kunst des 20. Jahrhunderts', *Studium Generale*, Berlin, January 1955, pp. 1–11.
49 See Henri van Lier, *op. cit.*, pp. 159–62.

DOCUMENTARY TEXTS

Text 1

1 See Pierre Aubery, 'Mécislas Golberg et l'art moderne', *Gazette des Beaux-Arts*, Paris, December 1965, pp. 339–44.
2 See Daniel Robbins, 'From Symbolism to Cubism: the Abbaye of Créteil', *Art Journal*, New York, winter 1963–4, pp. 111–61.

Text 2

1 *Mercure de France*, Paris, 16 April 1911, p. 882; see also Marie Laurencin, *Carnet des Nuits*, Geneva, 1956, p. 40; see also text 40 of this volume.
2 'Negro Art', *Burlington Magazine*, London, April 1920, p. 166.
3 Zervos, *op. cit.*, vol. 2, part 1, plate 11.
4 *Juan Gris*, Paris, 1946, p. 156, note; English edition N. Y. 1947, p. 75.
5 *Les Soirées de Paris*, Paris, Galerie Knoedler, May–June 1958, 37; see also *Ill.* 70 of this volume.
6 Robert Goldwater, *Primitivism in Modern Painting*, New York, 1938, p. 85, note.
7 Kahnweiler, *loc. cit.*
8 See 'Souvenirs sur Picasso', *Cahiers d'Art* (Paris), 1927, p. 202; retold in his *Chronique des Temps Héroiques*, Paris, 1956 (the text is dated at the end, 1936), p. 64.
9 *Autobiography of Alice B. Toklas*, New York, 1933, pp. 77–78.
10 In the *Nouveau Spectateur*, Paris, 25 May 1919; see also Goldwater, *op. cit.*, p. 85.
11 See André Warnod, 'Matisse est de retour', *Arts*, No. 26, Paris, 27 July 1945.
12 *Paris-Journal*, 26 October 1911.
13 See *Tournant Dangereux, Paris*, 1929, pp. 88–9.
14 Goldwater, *op. cit.*, p. 74.
15 See *Lettres à Vlaminck*, Paris, 1955, pp. 138–43.
16 In *Portraits avant Décès*, Paris, 1943, pp. 105–7.
17 In *Bouquet de Bohème*, Paris, 1947, pp. 136–7; see also his *Au Beau Temps de la Butte*, Paris, 1949, pp. 117–8.
18 *Op. cit.* pp. 118 and 74.
19 *Cf.* Francoise Gilot and Carleton Lake, *Life with Picasso*, New York, 1964, p. 266. According to this somewhat unreliable account, Picasso claims to have discovered primitive art at the Trocadéro, which he visited at Derain's urging.
20 In *Souvenirs sans fin*, vol. 3, Paris, 1961, p. 253.
21 *Portraits avant décès*, Paris, 1943, p. 106.
22 In *Peintres et Sculpteurs que j'ai connus*, New York, 1942, p. 13.
23 Première Exposition (du 19 novembre au 5 decembre 1916), Kisling, Matisse, Modigliani, Ortiz de Zarate, Picasso. Sculptures nègres. Lyre et Palette, 6 Rue Huyghens, Paris 14. This exhibition included twenty-four African and Oceanic sculptures from the collection of Paul Guillaume.
24 The forthcoming study of M. Jean Laude, on the influence of African sculpture on early twentieth-century art, will provide definitive solutions for many of these problems.

Text 9

1 See André Salmon, *Paris-Journal*, 30 September 1911.
2 See *Paris-Journal*, 13 October 1911.
3 See Albert Gleizes, 'Jean Metzinger', *Revue Indépendante*, Paris, September 1911, pp. 161–172.
4 See Gertrude Stein, *Autobiography of Alice B. Toklas*, New York, 1933, pp. 28–29.
5 See Fernande Olivier, *Picasso et ses Amis*, Paris, 1933, pp. 138 and 165.
6 In *Les Berceaux de la Jeune Peinture*, Paris, 1925, p. 87.
7 The widow of the cubist painter Marcoussis, who lived in Montmartre before World War I; see her *Hier*, Paris, 1946, p. 44.
8 At the Galerie Barbazanges in Paris, 28 February–13 March 1912.
9 See his *Juan Gris*, Paris, 1946, pp. 147–148; English edition, New York, 1947, p. 71.

Text 10

1 See Allard's review of the 1911 Salon des Indépendants in *La Rue de Paris*, No. 10, 24 April 1911, a review whose co-editor was Mercereau.

Text 12

1 16 July 1910; later in this same year the essay was issued as a pamphlet with the same title, Paris, no date.
2 The term cubism came into general use after this Salon; Apollinaire accepts it, in the name of his friends the painters, in his introduction to an exhibition at Brussels held during the summer of 1911: 'Les Indépendants. Cercle d'Art, VIIIme Salon, 10 juin–3 juillet'.
3 No. 6713 in the catalogue: *Nu dans un Paysage*. Kahnweiler and others have mistakenly written that it was exhibited in the 1910 Indépendants. It is illustrated in Allard's review of the 1911 Indépendants, in *Les Marches du Sud-Ouest*, Paris, June 1911, p. 62.

Text 13

1 See *Vers et Prose*, No. 27, Paris, October–November–December 1913, p. 139.
2 *Gil Blas*, Paris, 22 June 1912.
3 Paris, 26 November 1911.
4 See André Salmon, *Paris-Journal*, 30 November, 1911.
5 In *L'Eclair*, Paris, 29 June 1913.

Text 14

1 1910–12 for *Paris-Journal*, May 1912–World War I for *Gil Blas*.
2 In 'Testimony against Gertrude Stein', *Transition*, Paris, February 1935, p. 14.

Text 16

1 On Hourcade see *Vers et Prose*, No. 31, Paris, October–December 1912, p. 162.
2 See *Le Journal*, Paris, 20 October 1912.
3 For a distinction between Kant's idealism and the reduction to essences, which in my opinion characterizes cubism, see Edmund Husserl, *Ideen . . .*, Halle, 1913, especially the Introduction and section 74.

Text 18

1 See the announcement in *Gil Blas*, Paris, 14 October, 1912.

Text 21

1 See *Gil Blas*, Paris, 19 October 1912.
2 *Gil Blas,* Paris, 14 October 1912.
3 *Le Journal*, Paris, 10 October 1912.
4 *Soirées de Paris*, February 1912, pp. 1–4; reprinted in *Les Peintres Cubistes*, part II (see text 25). See also text 22.
5 See also *Gil Blas*, Paris, 1 October 1912.

Text 22

1 See André Derain, *Lettres à Vlaminck*, Paris, 1955.

Text 23

1 See Albert Gleizes, *Souvenirs: Le Cubisme 1908–1914*, Lyon, 1957, p. 11.
2 Information communicated by Marcel Duchamp to Mr Daniel Robbins.
3 *Revue d'Europe et d'Amérique*, Paris, 1 March 1912, p. 383.
4 *Paris-Journal*, 26 October 1912; the book was reviewed in *L'Opinion*, Paris, 7 December, 1912.
5 See *Gil Blas*, Paris, 26 November 1911.
6 'Exposition Gleizes, Metzinger, Leger.' Paris, Galerie Berthe Weill, 17 January–1 February 1913; No. 19.

Text 25

1 See Leroy Breunig, ed., *Chroniques d'Art*, Paris, 1960.
2 See Leroy Breunig and Jean Chevalier, *Les Peintres Cubistes*, Paris, 1965; see also their article 'Apollinaire et *Les Peintres Cubistes*', *Revue des Lettres Modernes*, No. 104–7, Paris, 1964, pp. 88–112.
3 *Soirées de Paris*, February 1912, pp. 1–4.
4 Given at a cubist exhibition, 3 Rue Tronchet, Paris, 25 November 1911; see *Gil Blas*, Paris, 26 November 1911.
5 'La peinture nouvelle', *Soirées de Paris*, April, 1912, pp. 89–92; Apollinaire had used the term 'Fourth Dimension' in his November 1911 lecture.
6 See his 'The Space-Time Concept in the Work of Picasso', *Magazine of Art*, Washington, D. C., January, 1948, pp. 26–32; and his 'Cubism and Science', *Journal of Aesthetics and Art Criticism*, New York, March, 1949, pp. 243–6.

Text 27

1 See Douglas Cooper, *Fernand Léger et le Nouvel Espace*, Geneva, 1949, p. 36.
2 Information from Mme Sonia Delaunay, Paris.
3 See Delaunay's ideas as quoted by Apollinaire in 'Réalité, peinture pure', *Soirées de Paris*, December 1912, pp. 147–51; *cf.* Leroy Breunig, *Chroniques d'art*, Paris, 1960, pp. 266–70.

Text 30

1 *Comœdia*, Paris, 15 July 1913.
2 See Pär Bergmann, *'Modernolatria' et 'Simultaneità'*, Uppsala, 1962, for a brilliant and thoroughly documented study of this question.
3 See his 'L'Art poétique d'un idéal nouveau', *Poème et Drame*, Paris, May, 1913, pp. 14–26.
4 *Poème et Drame*, Paris, September–October 1913, p. 4.
5 In *Soirées de Paris*, 15 June 1914, pp. 322–5.
6 See also Apollinaire's comment on his own portrait by Picasso, in *Paris-Midi*, 29 May 1913.
7 See Marc Vromant, *Comœdia*, Paris, 15 April and 2 June 1914.

Text 31

1 See Jean Metzinger, 'Alexandre Mercereau', *Vers et Prose*, No. 27, Paris, October–November–December 1913, pp. 122–9.
2 See Albert Gleizes, *Souvenirs: Le Cubisme 1908–1914*, Lyon, 1957, pp. 7–12.

Text 34

1 *Afrikanische Plastik*, Berlin, no date (1921); French translation, Paris, 1922.

Text 35

1 Paris, 1919; edition of 364 copies.
2 See André Salmon, *L'Air de la Butte*, Paris, 1945, pp. 81–82.

3 See D.-H. Kahnweiler, 'Reverdy et l'art plastique', *Mercure de France*, Paris, January, 1962, pp. 169–77.
4 See the introduction, dated September, 1916, of his *Cornet à Dés*, Paris, 1917; also his 'Les mots en liberté', *Nord-Sud*, No. 9, Paris, 1917; and *L'Art Poétique*, Paris, 1922.
5 See such poems as his 'L'Explorateur', in *Le Laboratoire Central*, Paris, 1921, part 1.
6 See D.-H. Kahnweiler, 'Mallarmé et la peinture', *Les Lettres*, No. 9-10-11, Paris, 1948, pp. 63–8; also Gino Severini, 'Symbolisme plastique et symbolisme littéraire', *Mercure de France*, Paris, 1 February 1916, pp. 466–76; also Jean Cassou, 'Cubisme et poésie', *Vie des Lettres*, Paris, October 1920, pp. 183–5.
7 In his *Picasso*, Munich, 1921, pp. 61–2; French edition, Paris, 1922, pp. 52–3. By the context Raynal is referring to a pre-1912, Montmartre period in the artist's life.

Text 36

1 See Jean Leymarie, 'Evocation de Reverdy. Auprès de Braque et de Picasso.' *Mercure de France*, Paris, January 1962, p. 301.

Text 38

1 For an illuminating parallel between this text and the synthetic cubism of Jacques Villon, see G. H. Hamilton, 'The Dialectic of Later Cubism. Villon's Jockey' (see bibl. 134).

Text 39

1 See Ozenfant and Jeanneret, *Après le Cubisme*, Paris, 1918; Piet Mondrian, *Le Neo-Plasticisme*, Paris, 1920; Gino Severini, *Du Cubisme au Classicisme*, Paris, 1921.
2 In *L'Élan* No. 9, Paris, February 1916 (edited by Ozenfant).
3 Paris, 1946, pp. 81–95; English edition, New York, 1947, pp. 40–45.
4 For a parallel to the differences between the signs in synthetic cubism and the depiction of visual reality in 1913–14 collage cubism, see Edmund Husserl, *Ideen*, section 43.

Text 41

1 In 'Der Kubismus', *Die Weissen Blätter*, Zurich–Leipzig, September 1916, pp. 209–22.
2 See his *Entretiens*, Paris, 1961, pp. 68–9.

Text 42

1 No. 5, Paris, February 1921, p. 520.

Text 43

1 See John Golding, *Cubism, A History and an Analysis, 1907–1914*, London, 1959, pp. 130–1, and pl. 47 B.

Text 45

1 See Maurice Raynal, *Picasso*, Munich, 1921, p. 29; French edition, Paris, 1922, p. 27.
2 Translated from the original interview in Spanish between Picasso and Marius de Zayas.

Text 47

1 'L'Esprit nouveau et les poètes', *Mercure de France*, Paris, 1 December 1918, pp. 385–96.
2 In *L'Élan* (edited by Ozenfant), No. 10, Paris, 1 December 1916; for a purist attitude in literature, see Paul Dermée, 'Quand le symbolisme fut mort', *Nord-Sud* (Paris), 15 March 1917, pp. 2–4.
3 See Maurice Raynal, *Picasso*, Munich, 1921, pp. 67–68; Paris, 1922, p. 58.
4 See, for example, Albert Gleizes, *Du Cubisme et les Moyens de le Comprendre*, Paris, 1920; Gino Severini, *Du Cubisme au Classicisme*, Paris, 1921; also Gleizes' 'La peinture et ses lois. Ce qui devait sortir du cubisme', *Vie des Lettres et des Arts*, Paris, March 1923, pp. 26–77.
5 *Bulletin de la Vie Artistique*, Paris, 1 November 1924, p. 485.
6 See also their short essay in *Bulletin de la Vie Artistique*, Paris, 15 January 1925, pp. 35–7; note also a reference to the crystal in Frank Rutter, *Evolution in Modern Art*, New York no date (1926), p. 83.

Text 48

1 Information by courtesy of Mr Daniel Robbins.

Index

Italic numbers refer to black and white illustrations; roman numerals to the colour plates.